Lee Bontecou

A Retrospective

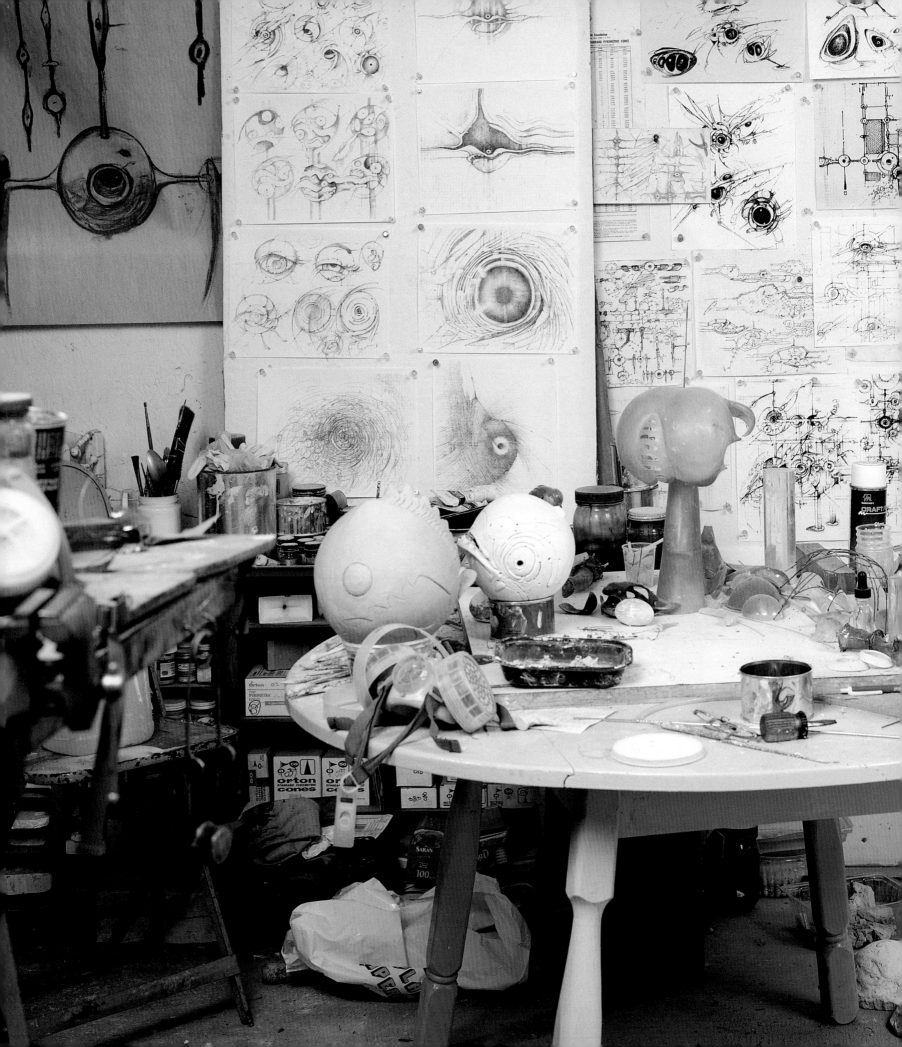

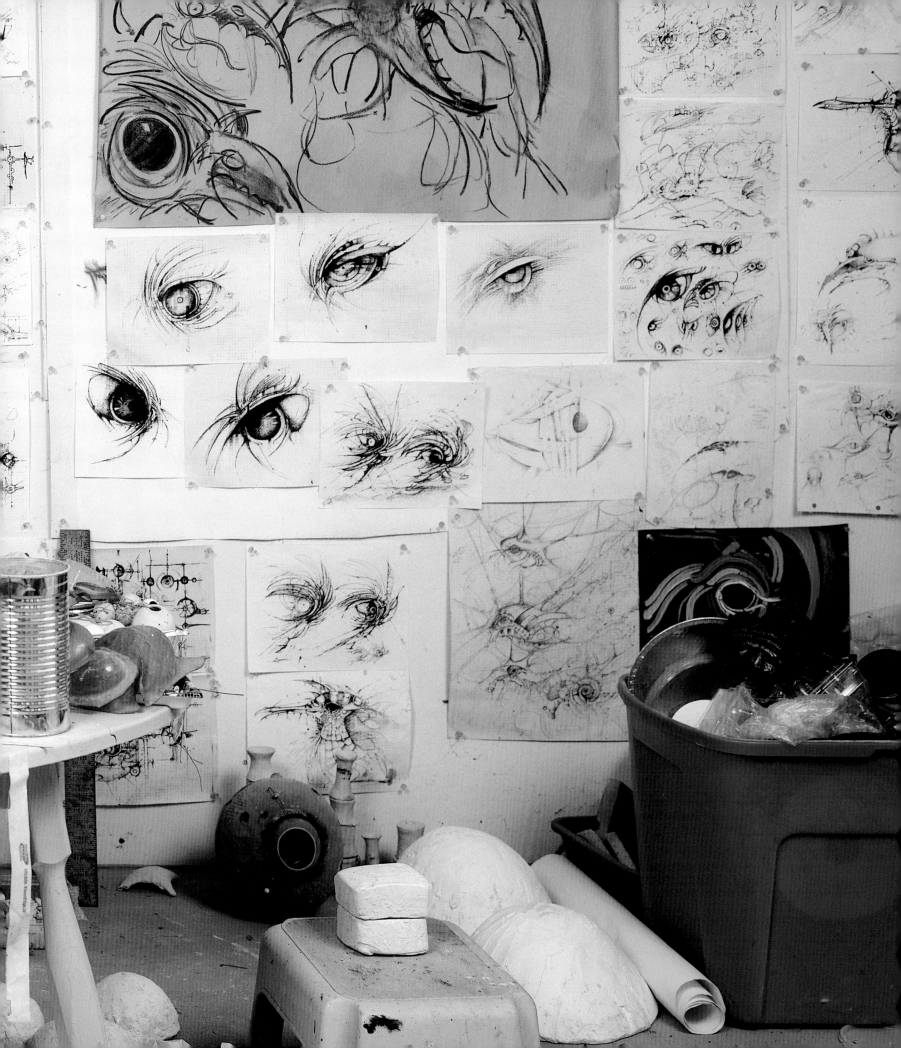

Lee

A Retrospective

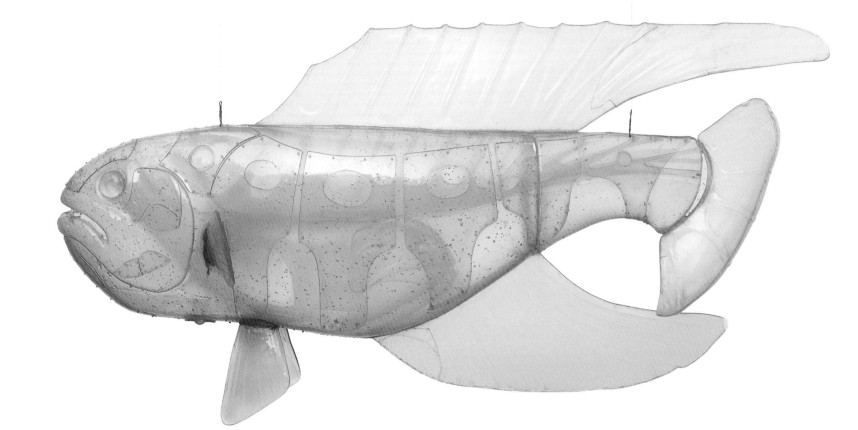

Bontecou

Exhibition Curator
Elizabeth A. T. Smith

in association with
Ann Philbin

Essays
Donna De Salvo
Mona Hadler
Donald Judd
Elizabeth A. T. Smith
Robert Storr

Museum of
Contemporary Art,
Chicago, and
UCLA Hammer Museum,
Los Angeles,
in association with
Harry N. Abrams, Inc.,
Publishers

This catalogue was published in conjunction with the exhibition *Lee Bontecou: A Retrospective*, which was co-organized by the Museum of Contemporary Art, Chicago, and the UCLA Hammer Museum, Los Angeles.

The exhibition was presented at

UCLA Hammer Museum, Los Angeles
October 5, 2003 – January 11, 2004

Museum of Contemporary Art, Chicago
February 14 – May 30, 2004

The Museum of Modern Art, New York
July 28 – September 27, 2004

This exhibition is sponsored by

 Altria

The national tour is made possible by

The Henry Luce Foundation

The National Endowment for the Arts

The Horace W. Goldsmith Foundation

Friedrike Merck

Sarah-Ann and Werner H. Kramarsky

This catalogue was made possible, in part, by

Agnes Gund and Daniel Shapiro

The Ruth and Murray Gribin Foundation

The Chicago presentation is made possible by

 SaraLee
Foundation

Additional generous suport has been provided by

Helen and Sam Zell

Marilynn B. Alsdorf

Beatrice Cummings Mayer

The Museum of Contemporary Art, Chicago (MCA), is a nonprofit, tax-exempt organization. The MCA's exhibitions, programming, and operations are member supported and privately funded through contributions from individuals, corporations, and foundations. Additional support is provided through the Illinois Arts Council, a state agency. Air transportation services are provided by American Airlines, the official airline of the Museum of Contemporary Art.

UCLA at the Armand Hammer Museum of Art and Cultural Center (UCLA Hammer Museum) is operated by the University of California, Los Angeles, and receives institutional support from the University. Occidental Petroleum Corporation has partially endowed the Museum and constructed the Occidental Petroleum Cultural Center Building, which houses the Museum. The Hammer's exhibitions, programming, and operations are made possible through the support of its members and contributions from corporations, foundations, public agencies, and individuals.

© 2003 by the Museum of Contemporary Art, Chicago, and the Regents of the University of California.

Published in 2003 by the Museum of Contemporary Art, Chicago, and UCLA at the Armand Hammer Museum of Art and Cultural Center, Los Angeles, in association with Harry N. Abrams, Incorporated, New York.

ISBN 0-8109-4618-1 (Abrams: hardcover)
ISBN 0-933856-806 (Museum: softcover)

Library of Congress Catalog Number:
2003 108103

Produced by the Publications Department of the Museum of Contemporary Art, Chicago, Hal Kugeler, Director; Kari Dahlgren, Associate Director.

Edited by Kari Dahlgren
Designed by Hal Kugeler

For Harry N. Abrams, Inc.
Deborah Aaronson, Editor

Color separations by Professional Graphics, Rockford, Ill.
Printed in Germany by GZD – Grafisches Zentrum Drucktechnik

10 9 8 7 6 5 4 3 2 1

The hardcover edition of this catalogue is available from

Harry N. Abrams, Inc.
100 Fifth Avenue
New York, N.Y. 10011

Abrams is a subsidiary of

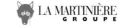 LA MARTINIÈRE
G R O U P E

COVER
Untitled (detail), 1998
See plates 160 and 161

BACK COVER
Untitled (detail), 1970
See plate 105

PAGES 2–3, 8–9, AND 12
Bontecou's Pennsylvania studio, 2003
Photographs by Will Brown

PAGE 5
Plate 99

Contents

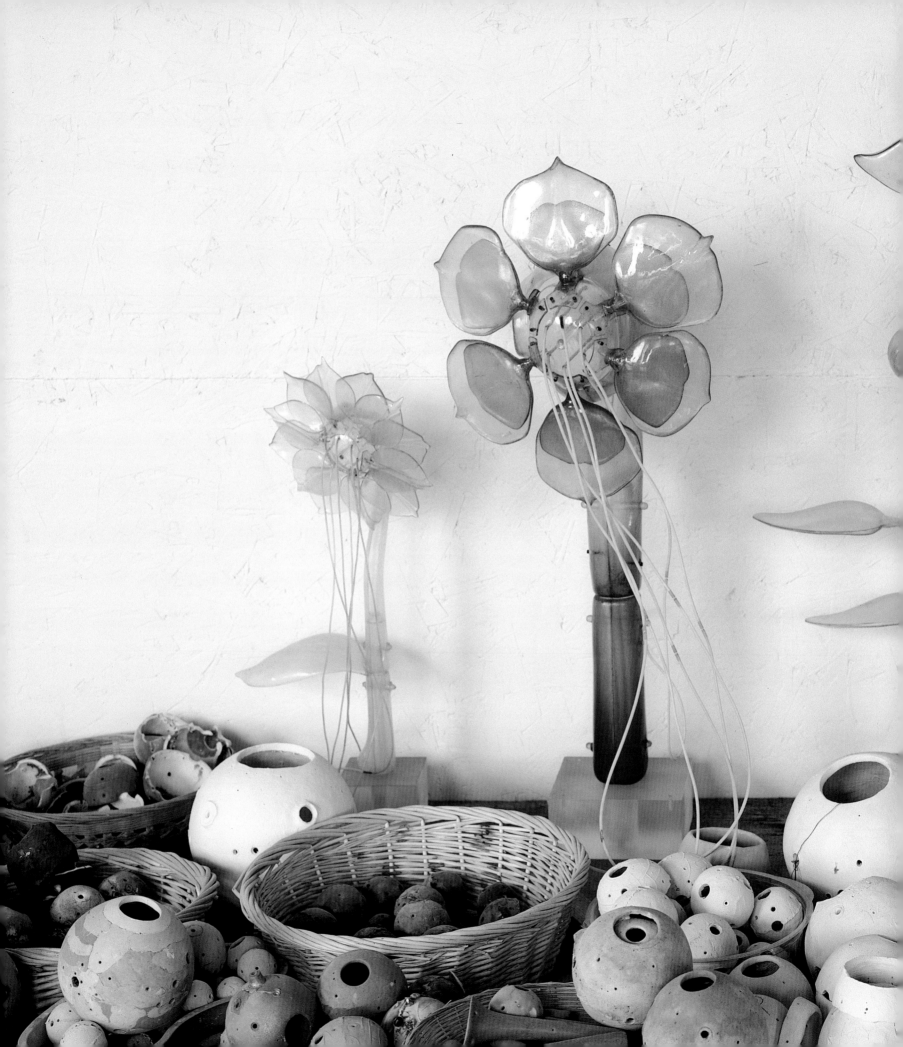

Sponsor's Statement

When an opportunity arises to bring greater recognition to one of the most compelling artists of our time, one should seize it. At Altria Group, Inc., we are fortunate that we could do just that. As we have seen in our sponsorship of the arts for more than forty-five years, the arts unite and vitalize communities and inspire us to envision and explore new possibilities. In this spirit, we are proud to sponsor *Lee Bontecou: A Retrospective*, the first major exhibition in more than three decades celebrating this groundbreaking and visionary American artist.

Lee Bontecou's innovation and boldness of spirit electrified the art world in the 1960s and early 1970s with works that continue to inspire a new generation of artists. However, the large-scale sculpture and intimate drawings she has created in relative seclusion during the past three decades have remained largely unseen, until now.

Altria is honored to be part of the collaboration that is bringing Bontecou's powerful art to light once more. We thank the UCLA Hammer Museum in Los Angeles and the Museum of Contemporary Art, Chicago, for their truly visionary leadership in organizing this landmark exhibition, and thank The Museum of Modern Art for bringing the exhibition to our hometown of New York City. But most important, we applaud and salute the boundless strength and creativity of Lee Bontecou, whose passion and conviction inspire us all.

Jennifer Goodale
Vice President, Contributions

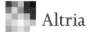 Altria

Foreword

It is an extraordinary privilege for our institutions to have collaborated to produce this long-awaited exhibition of the work of Lee Bontecou, a leading artist of her generation whose work was critically acclaimed, actively collected, and powerful in its impact on other artists when first shown in New York in the early 1960s. More than forty years later, this exhibition and catalogue — the first major publication devoted to Bontecou — reposition this artist's extraordinary work within the history of recent art. Following an extensive period since the mid-1970s during which Bontecou was notably absent from the art world, it reintroduces her as a significant figure whose practice continues to hold relevance and interest for a generation of younger artists. We are grateful to Elizabeth Smith, James W. Alsdorf Chief Curator at the MCA, for her leadership in bringing this project to fruition and for her dedication to the work of Lee Bontecou.

We are extremely pleased that this exhibition is being presented in three major American cities — Los Angeles, where interest in Bontecou's work became revived during the past decade; Chicago, where her work was the subject of a survey exhibition at the MCA in 1972; and New York, where she lived and worked at the outset of her career and where her reputation was first established. We are grateful to our colleague Glenn Lowry, Director of The Museum of Modern Art, New York, for his support and enthusiasm in presenting the exhibition.

Numerous donors from both the public and private sectors stepped forward to support this project. Altria Group, Inc., the lead corporate sponsor for the exhibition and its tour, has given crucial support for which we are extremely grateful. The Henry Luce Foundation provided a generous initial grant for its research and development. The National Endowment for the Arts, a federal agency; The Horace W. Goldsmith Foundation; Friedrike Merck; and Sarah-Ann and Werner H. Kramarsky also made generous gifts for this project. This catalogue was made possible, in part, by Agnes Gund and Daniel Shapiro and The Ruth and Murray Gribin Foundation. The Sara Lee Foundation provided lead corporate sponsorship for the Chicago presentation of the exhibition. Helen and Sam Zell, Marilynn B. Alsdorf, and Beatrice Cummings Mayer provided additional generous support. To all of the above we wish to express profound appreciation; their enthusiasm for the project has been a testament to the power and interest of Bontecou's deeply significant work in sculpture and drawing and to our commitment to reassessing and presenting it to today's audiences.

Robert Fitzpatrick
Pritzker Director
Museum of Contemporary Art, Chicago

Ann Philbin
Director
UCLA Hammer Museum, Los Angeles

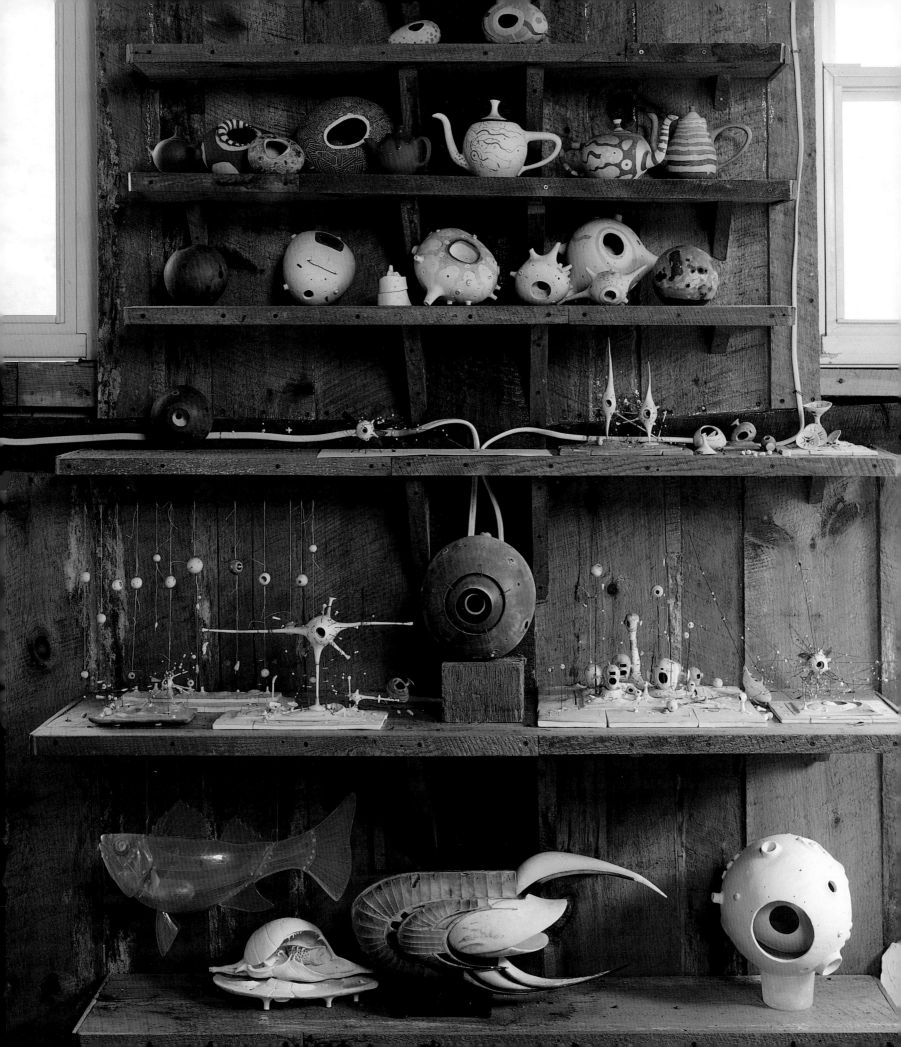

Introduction and Acknowledgments

During the course of recent decades, our understanding of what constitutes sculpture has undergone remarkable transformations, as has our recognition that the significance of a work of art shifts in relationship to evolving contexts and interpretations. Lee Bontecou first established her reputation in the 1960s, an era during which the definition of sculpture expanded, according to Lucy Lippard, to include "dust, literature, accident, nature, scientific illustration, theater, dance, or pedagogy." Throughout that decade and up to the present Bontecou's dedication to the object and its physicality has continued to be inspirational to a generation of younger artists, especially sculptors, who have also worked in a zone between abstraction and representation and who are intensely committed to materiality.

Growing out of and transforming an abstract expressionist tradition, Bontecou's work is marked not only by an originality of vision but also a fierce independence; it never fit comfortably within the lineage of artists ranging from Kurt Schwitters to Louise Nevelson with whom she was positioned in the 1961 exhibition *The Art of Assemblage*, at The Museum of Modern Art, New York. She admired artists such as Julio González and Alberto Giacometti, yet was also drawn to the art of ancient and non-Western cultures and was equally fascinated with and influenced by technology and scientific advances early in her career. An impulse to record and draw inspiration from the natural world has reverberated throughout her entire corpus of work, leading one critic to comment as early as 1971, "She has, it seems, been a strange naturalist all along."

An artist who has always stood apart from the mainstream, and whose work has confounded and resisted easy interpretation, Bontecou has nonetheless operated in a realm of affinity with others of her generation. In their writings in this catalogue, Robert Storr and Donna De Salvo examine the artistic context in which Bontecou's work was made, pointing to precedents and impulses as diverse as futurism, surrealism, arte povera, and minimalism as touchstones for an understanding of her work's place in recent art history, while Mona Hadler analyzes the role of science as a cultural phenomenon significant to Bontecou that underpinned some of her earliest explorations. All of the contributors to this book touch on the shifting nature of critical reception to Bontecou's work as they seek to assess its place in the panorama of recent art and its history. Donald Judd's commentary is especially important to an understanding of the significance of Bontecou's sculpture for other artists in the early 1960s; his 1965 essay on Bontecou, originally published in *Arts Magazine,* is reprinted in its entirety in this volume.

Bontecou's work continues to hold great importance for many younger artists and historians. Echoing and extending the comments of Bontecou's contemporaries ranging from Judd to Eva Hesse, Charles Ray recently noted that the variety of references within her work is less significant than how the work is made, and that, in his view, it is the authority she imparts to her materials that gives these objects their power and their sense of "sculpturalness." Not only do aspects of her work prefigure and show strong affinities to that of a wide spectrum of later artists, but her eschewing of

the trappings of the art world following the establishment of a successful career has cast her in a heroic light. Artist Kiki Smith has commented that Bontecou is "a model of an artist — particularly for women — who left the art world and survived."

A project of this magnitude could not have been realized without the participation of many key individuals who have played important roles over the years of its research and development. I wish to extend foremost thanks to my partners at the UCLA Hammer Museum, especially my collaborator on this project, Ann Philbin, Director, whose unbridled enthusiasm for Bontecou's work planted the seed for our collaboration, and Russell Ferguson, Deputy Director of Exhibitions / Chief Curator, who offered valuable guidance and with whom it has always been an enormous pleasure to work. I also express profound gratitude to Aimee Chang, Curatorial Assistant, who diligently managed many aspects of the loan process and a myriad of other key aspects of the show's opening presentation. Susan Lockhart, Registrar, capably and conscientiously saw to the complex arrangements pertaining to the care of Bontecou's work throughout its tour. In addition, I wish to acknowledge the important contributions of the following UCLA Hammer staff members: Jennifer Wells, Director of Development; Mitch Browning, Chief Preparator/ Exhibition Designer; Steffen Boddeker, Communications Director; Gloria Gerace, Deputy Director;

Sarah Stifler, Public Programs Coordinator; Judith Quinones, Assistant to the Director; Sarah Sullivan, Development Assistant; and Heidi Zeller, Communications Associate; as well as Cynthia Wornham and Dominic Morea of Ruder Finn in Los Angeles for their work with the Hammer on publicity relative to the exhibition.

To my colleagues at the MCA, I extend deepest appreciation to Tricia Van Eck, Curatorial Coordinator, for her consummately important role in this project's development, particularly with regard to organization of key materials and documentation for the checklist and catalogue. I am profoundly grateful to Kari Dahlgren, Associate Director of Publications, and Hal Kugeler, Director of Design and Publications, for the superb book they have produced and for their always-collaborative spirit. To Greg Cameron, Associate Director and Chief Development Officer; Patrick McCusker, former Director of Development; Lela Hersh, former Director of Collections and Exhibitions; Suzanne Lampert, Manager of Public Programs; Jennifer Harris, Coordinator of Rights and Reproductions; Julie Rodrigues Widholm, Curatorial Assistant; Karla Loring, Director of Media Relations; Phillip Bahar, Director of Marketing; Jennifer Draffen, Chief Registrar and Exhibitions Manager; and to Scott Short, Senior Preparator, Exhibitions, and the staff of Preparators responsible for installation of the show, I wish to express deep appreciation. And to Robert Fitzpatrick, Pritzker Director, I am

truly grateful for encouraging my development of the idea for this project, shortly after my arrival at the MCA, into a major exhibition.

Many other individuals have contributed important assistance to the realization of this exhibition and book. First, we extend profound thanks to Frank Del Deo and Ann Freedman of Knoedler & Company, New York, for their gracious and generous assistance with matters relative to the catalogue and to the checklist of works in the exhibition. Daniel Weinberg of Daniel Weinberg Gallery, Los Angeles, also provided crucial early assistance and invaluable encouragement to the project's research and development phase. To Michael Rosenfeld and halley k harrisburg of Michael Rosenfeld Gallery, New York; Lawrence Markey of Lawrence Markey Gallery, New York; Anthony Grant and Marc Selwyn of Grant Selwyn, New York and Beverly Hills, we wish to express appreciation for their efforts in assisting with the location of works for the exhibition. Barbara Castelli and Diana Turco of Castelli Gallery, New York, also assisted with information and images that were extremely useful and important to our research, for which we are most grateful.

Lenders who made important works available to the exhibition, both from institutional and private collections, deserve our deepest gratitude. Among the many individuals who have parted with works from their private collections, all of whom are listed on page 240, we wish especially to thank Tony and Gail

Ganz, Agnes Gund and Daniel Shapiro, and Joel Wachs for their generosity in allowing multiple loans and graciously contributing other crucial forms of support to the project. Institutional lenders have also been most cooperative; to The Museum of Modern Art, New York, we owe particular thanks for their significant number of loans to the exhibition. In addition, we wish to express deep appreciation to MOMA and its Director, Glenn Lowry; Jennifer Russell, Deputy Director for Exhibitions and Collection Support; Gary Garrels, Chief Curator, Drawings; John Elderfield, Chief Curator of Painting and Sculpture; Lilian Tone, Assistant Curator, Department of Painting and Sculpture; and former curator Robert Storr for their enthusiasm for Bontecou's work and for their role as hosts to the exhibition's New York presentation.

The contents of this catalogue — the first major publication on Bontecou — were contributed by several key scholars of late twentieth-century art, all of whom have had a long-standing interest in and knowledge of Bontecou's work. We are grateful to Mona Hadler, Professor of Art History at Brooklyn College and The Graduate Center of the City University of New York; Donna De Salvo, Senior Curator, Tate Modern, London; and Robert Storr, Rosalie Solow Professor of Modern Art at The Institute of Fine Arts, New York University, for their insightful treatment of Bontecou's work and its context in art from the 1950s to today. In addition, we thank the Chinati Foundation for permission

to reprint the text of Donald Judd's most significant writing on Bontecou's work. We extend gratitude to Will Brown, who photographed the majority of works in Lee Bontecou's studio for this publication, and to other photographers and contributors of various aspects of catalogue contents and research including present and former MCA curatorial interns Lindsay Bosch, Emilie Colker, Shana Forlani, Anna Gray, Mary Gustaitis, Matthew Sams, Lauren Wright, and Jennifer Zukerman, as well as Bontecou scholars Jo Applin, Elyse Deeb, and Victoria Estrada-Berg. Assistant Editor Diana Fabian, editorial interns Rachel Johnson and Kay Manning, and design intern Emily Wubben provided invaluable assistance with this catalogue.

Numerous other individuals have been extremely helpful and supportive of the research and development of this project over the years. I wish to thank the following for the myriad forms of assistance they have each offered: Richard Armstrong, Anne Arnold, Stephanie Barron, Jay Barrows, Stefano Basilico, Jonathan Binstock, John Bowsher, Kerry Brougher, Lynne Cook, Paula Cooper, Colette Dartnall, Lois Dodd, Tom and Jane Doyle, Jeff Feld, Dr. Arnold Friedman-Kien, Ava Gerber, Valerie Giles, Robert Gober, Judith Goldman, Alison de Lima Greene, Jeff Grove, Kathy Halbreich, Lynda Hartigan, Delmar Hendricks, Antonio Homem, Laura Hoptman, Paul Randall Jacobson, Jasper Johns, Ivan Karp, Trudy Kramer, Alvin Lane, Karen Lennox, Leah Levy, Joshua Mack,

Arabella McCarry, Elisabeth St. B. McCarthy, Esq., Melissa de Medeiros, Anthony Meier, Bob Monk, Terry Myers, Hans-Ulrich Obrist, Alexandra Parigoris, Mark Pascale, Jennifer Pastor, Robert Pincus-Witten, Marla Prather, Charles Ray, Rona Roob, Thomas and Barbara Ruben, Sarah Seager, Ileana Sonnabend, Kiki Smith, Judith Tannenbaum, Tony Towle, and Charles Young. In addition, I would like to underscore the thanks expressed by Robert Fitzpatrick and Ann Philbin to the project's funders. Without their enthusiasm and commitment, which translated into such generous support, this project could not have come to fruition.

Finally, I want to express my deepest and most profound appreciation to Lee Bontecou and to her husband, William Giles. Her work inspired me more than a decade ago to delve into research of its place in the panorama of recent art, leading to my first exhibition of her sculpture and drawing of the 1960s at The Museum of Contemporary Art, Los Angeles. The experience of deep involvement with Lee's work has been defining to the direction of my work as a curator and has indelibly reshaped my thinking about contemporary art and artists.

Elizabeth A.T. Smith
James W. Alsdorf Chief Curator
Museum of Contemporary Art, Chicago

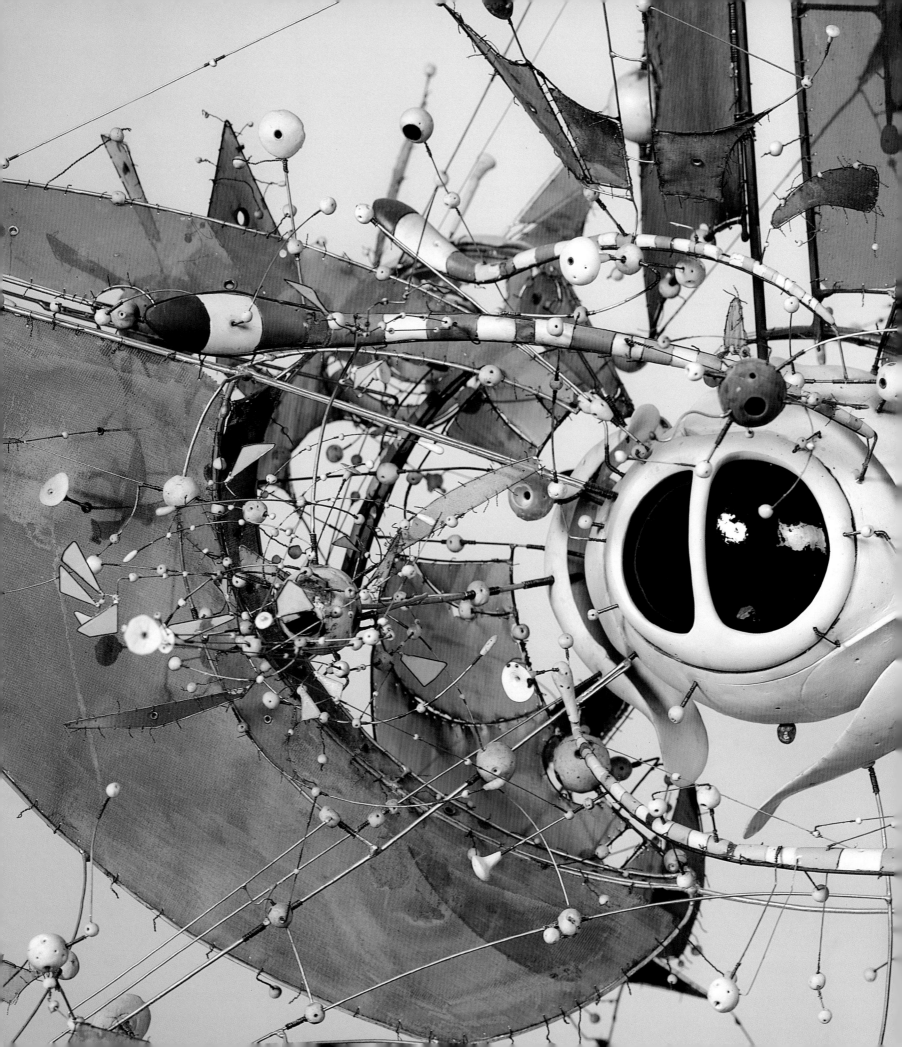

Plates

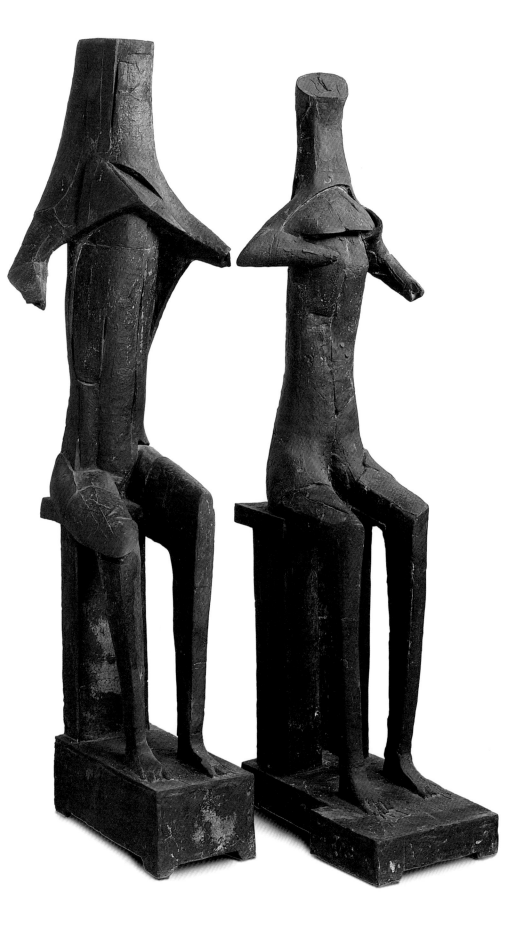

Plate 1
1957

OVERLEAF
Untitled
(detail),
1990–2000
See plate 165.

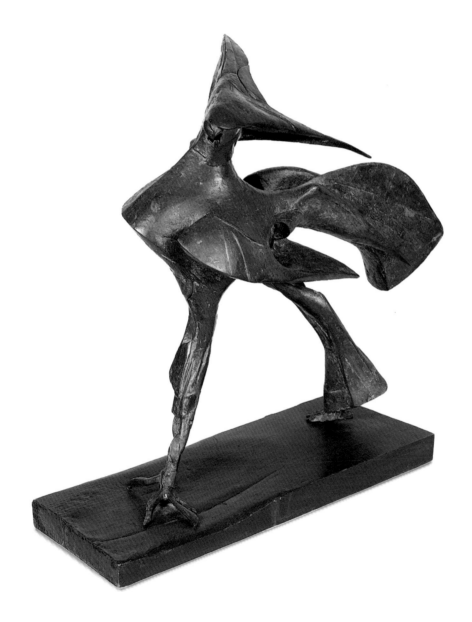

Plate 2
1957

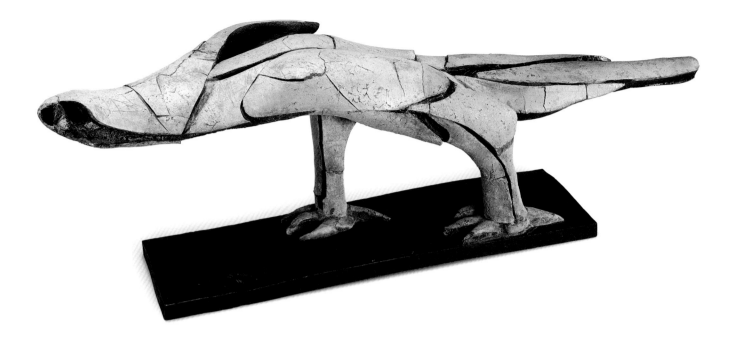

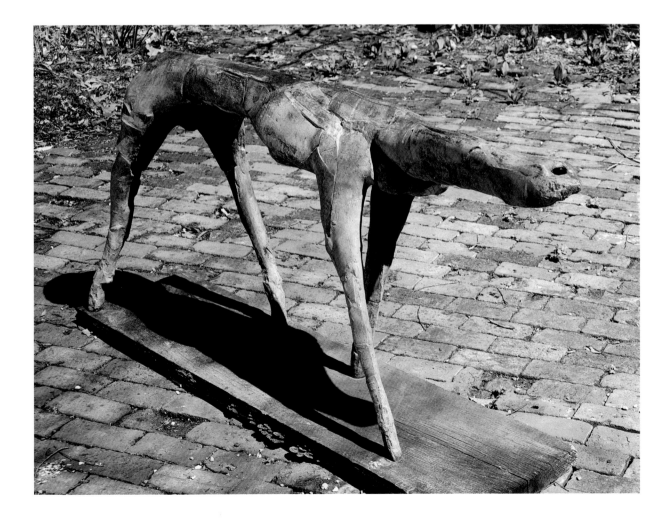

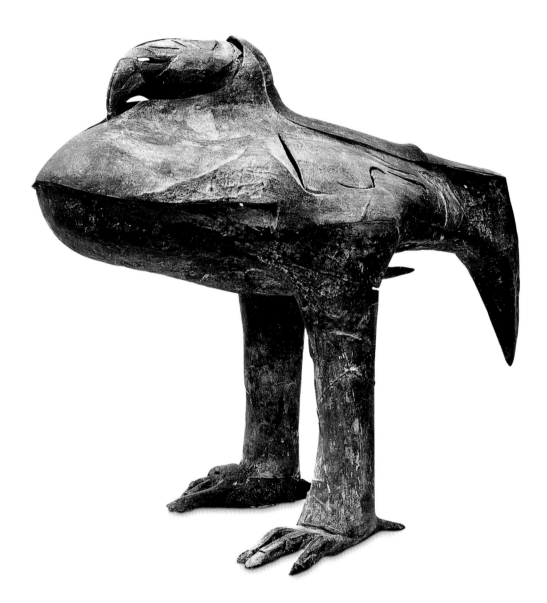

Plate 5
1957

Plate 6
1958

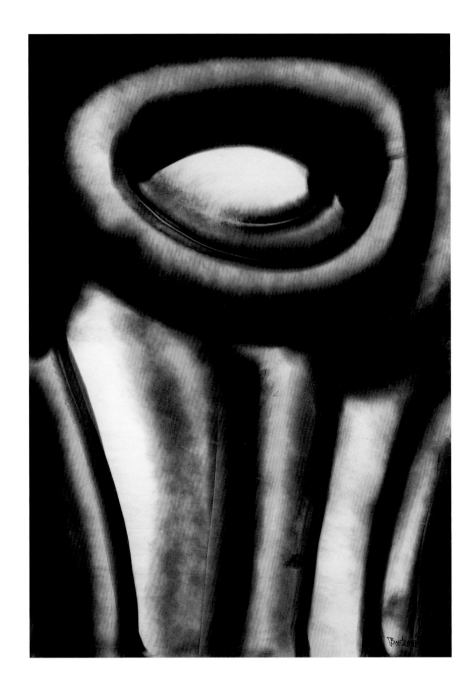

Plate 7
1958

Plate 8
c. 1958

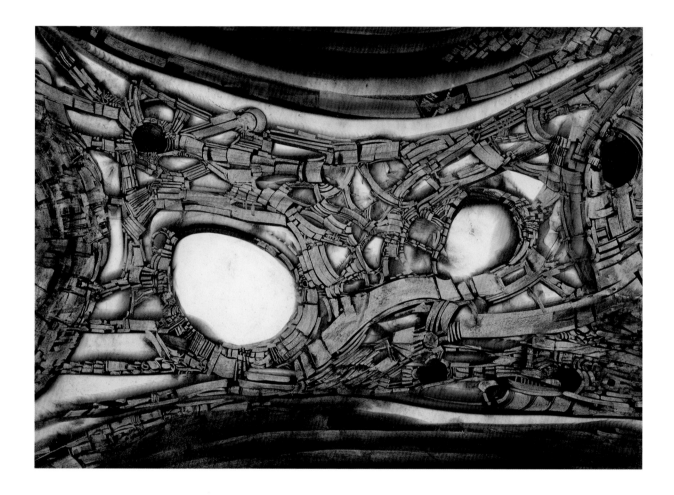

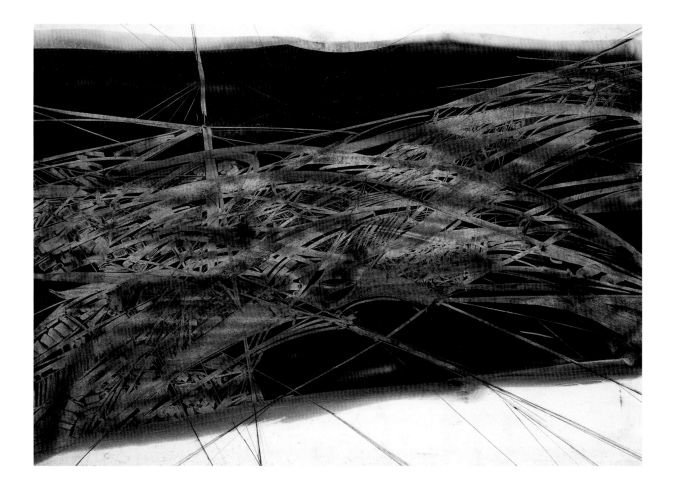

Plate 9
c. 1958

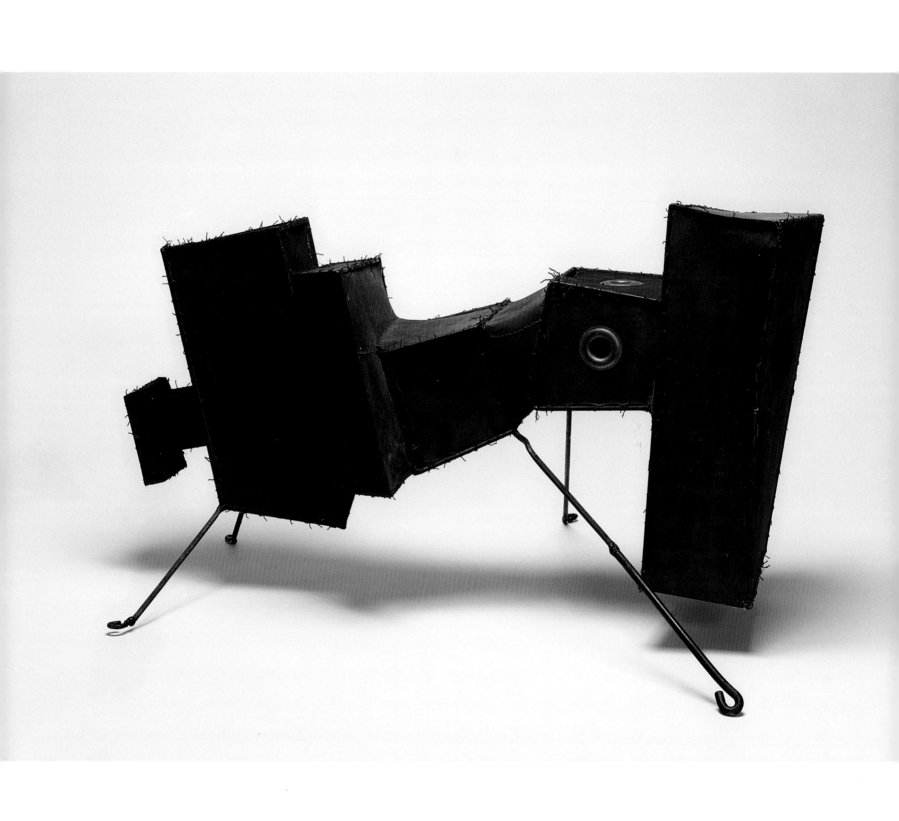

Plate 10
1958

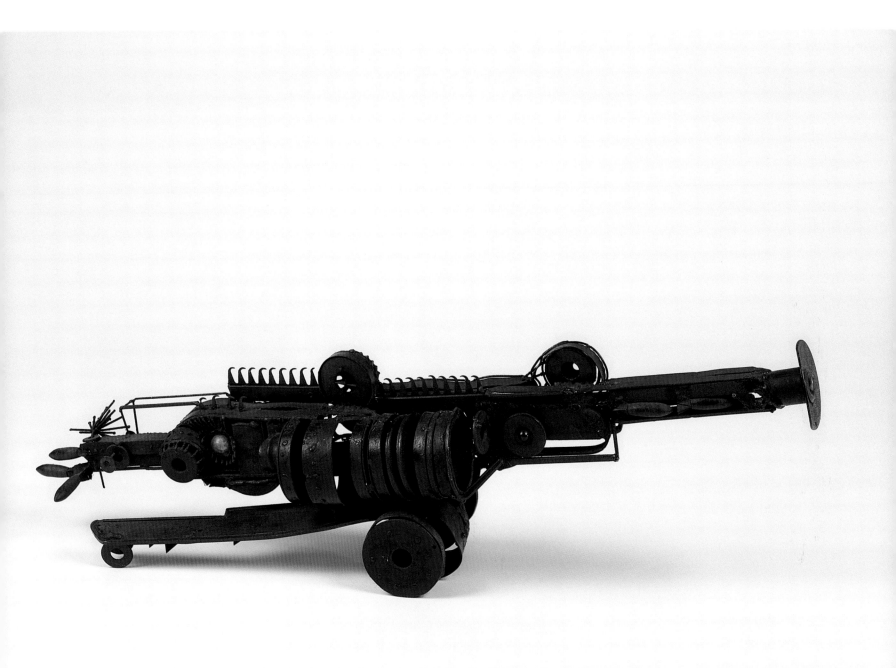

Plate 11
1959

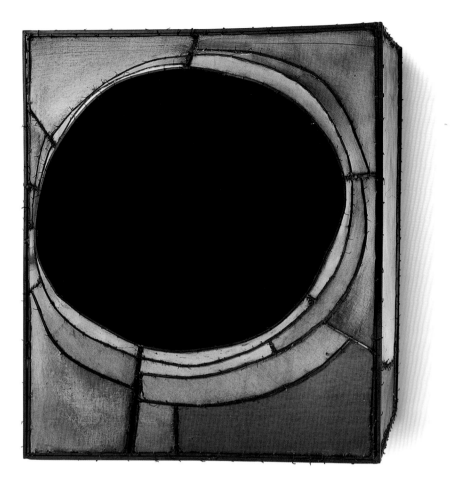

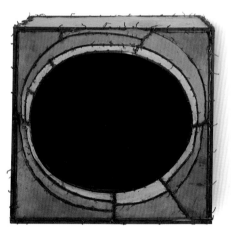

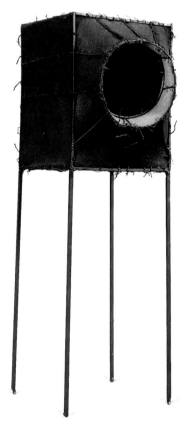

CLOCKWISE
FROM TOP

Plate 12
1959

Plate 13
1959

Plate 14
1959

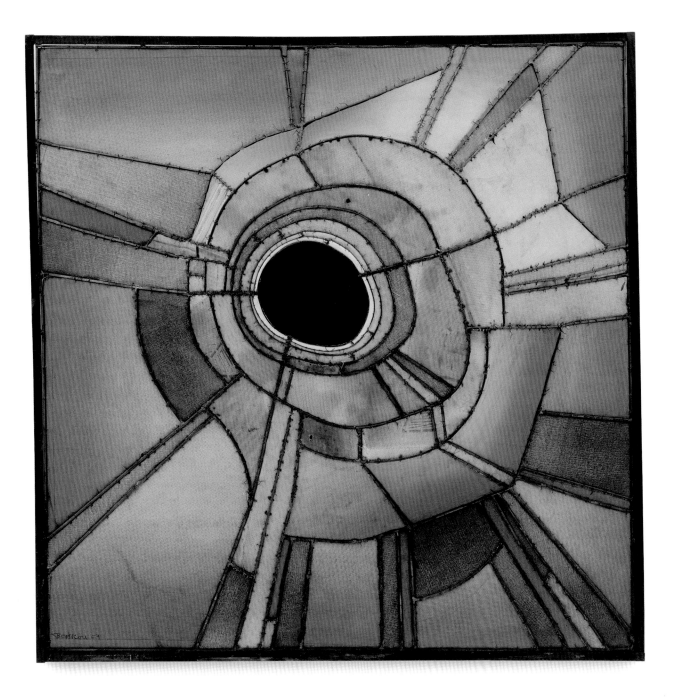

Plate 15
1959

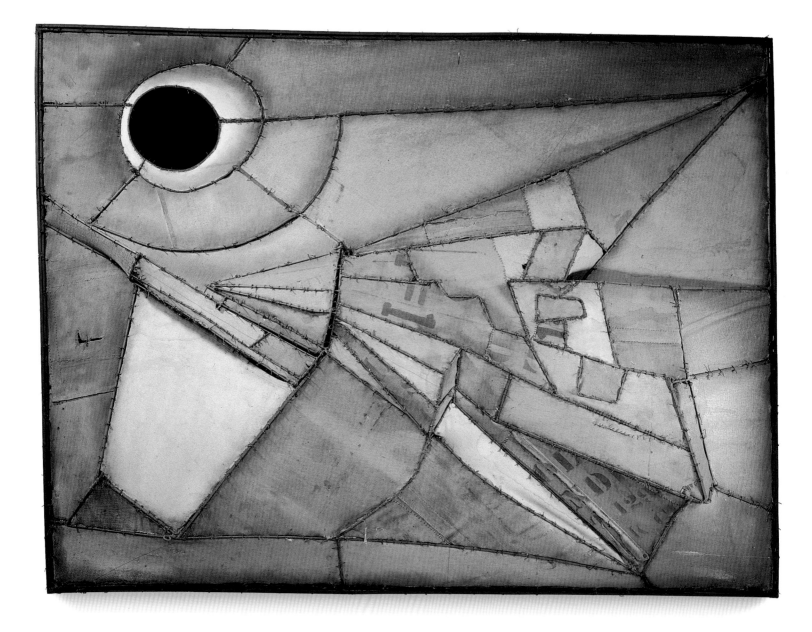

Plate 16
1959

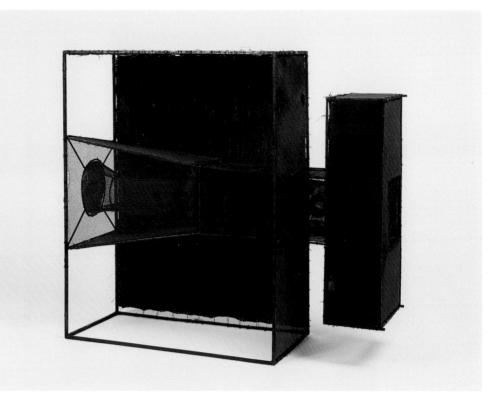

Plate 17
1958

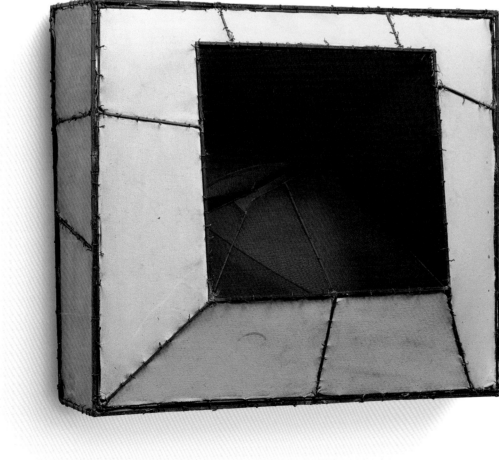

Plate 18
1959

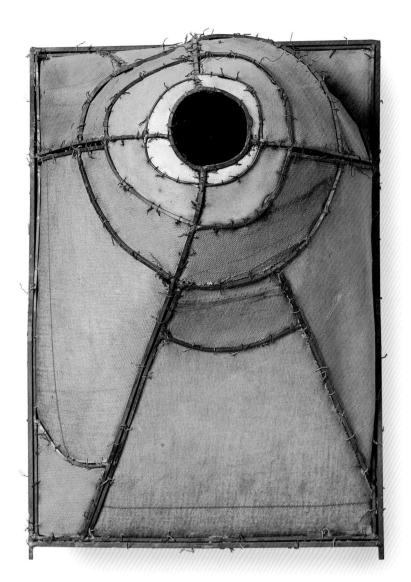

Plate 19
1959

Plate 20
1959

OPPOSITE

Plate 21
1960

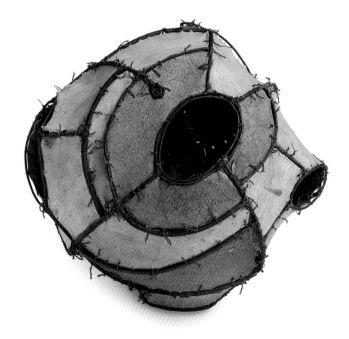

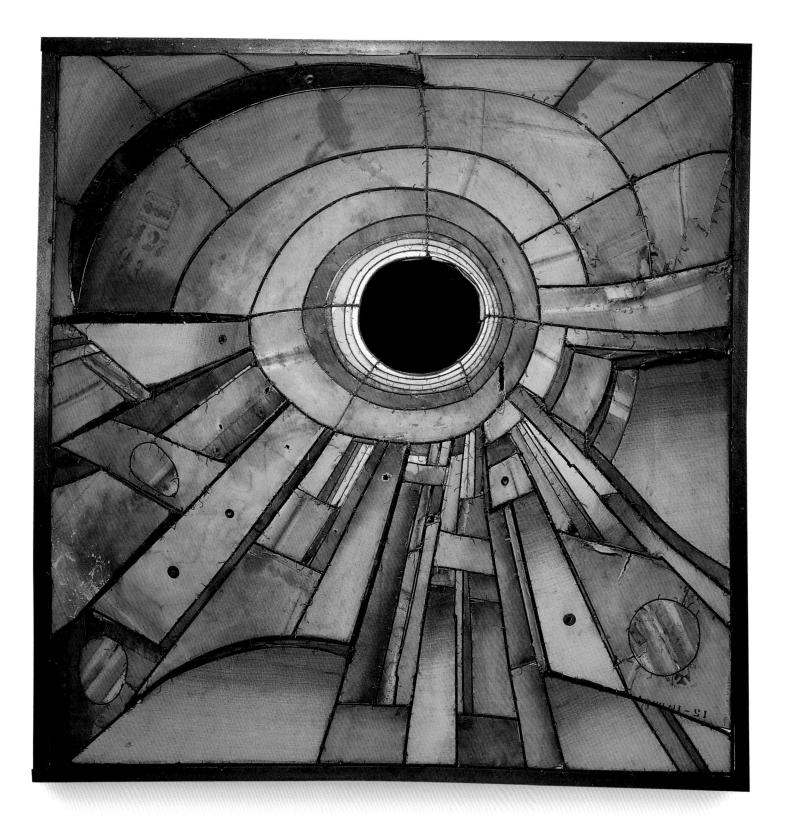

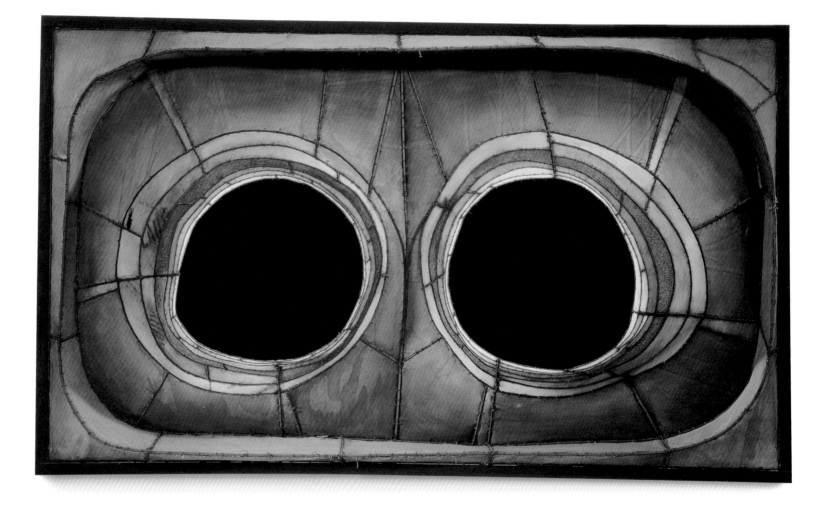

Plate 22
1959/1960

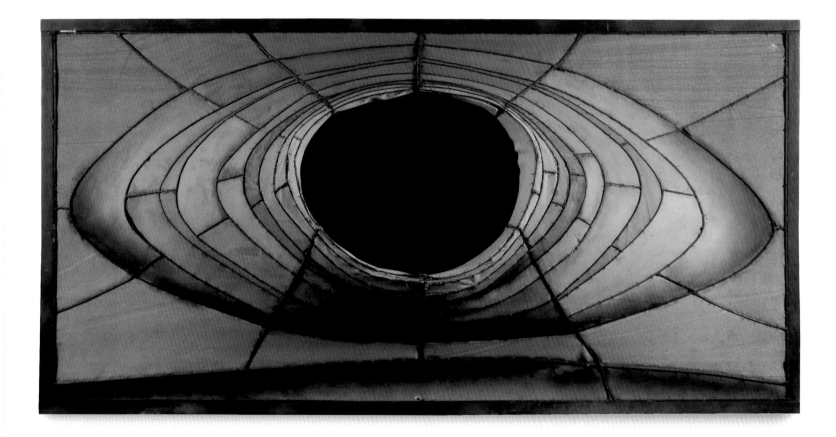

Plate 23
1960

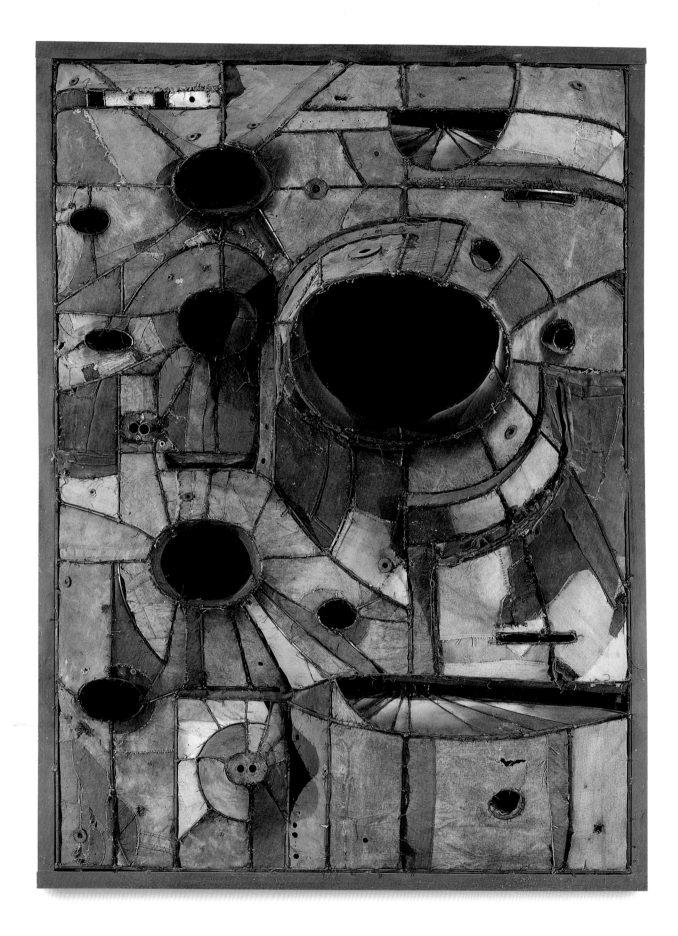

Plate 27
1960

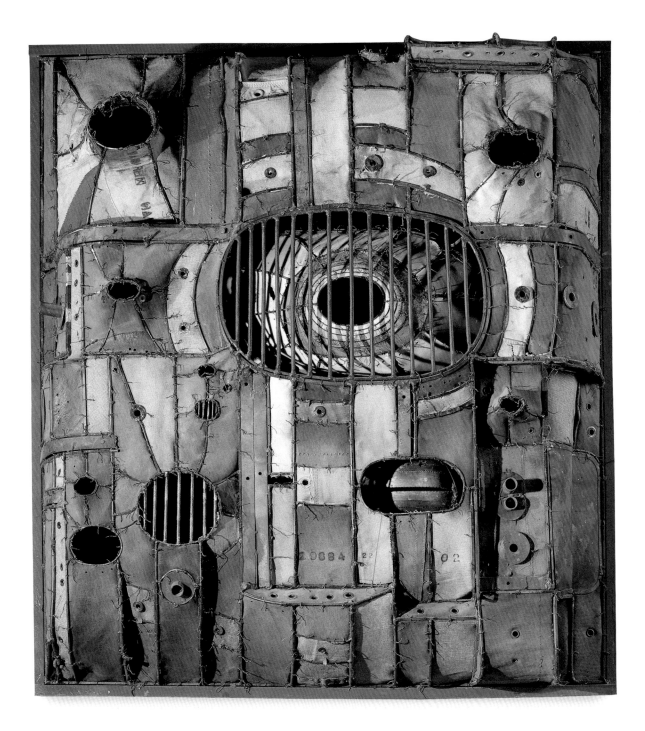

Plate 28
1961

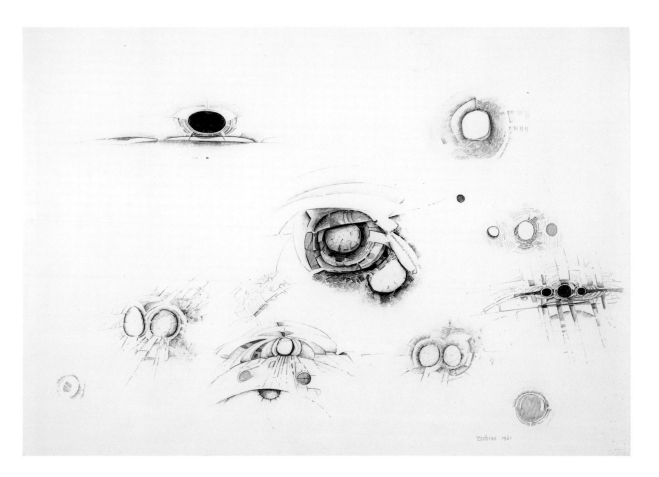

Plate 29
1961

Plate 30
1961

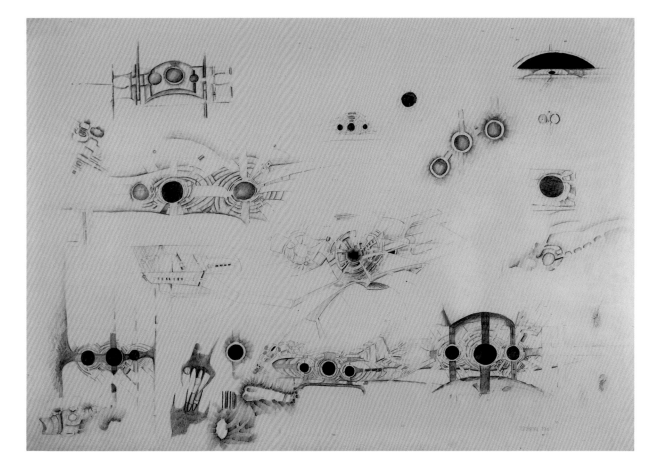

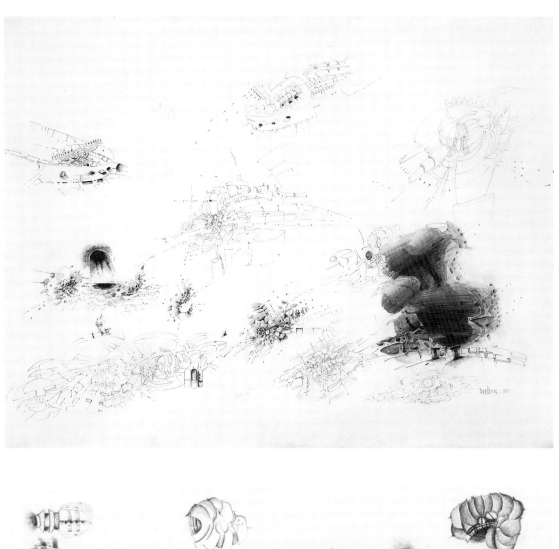

Plate 31
1961

Plate 32
1961

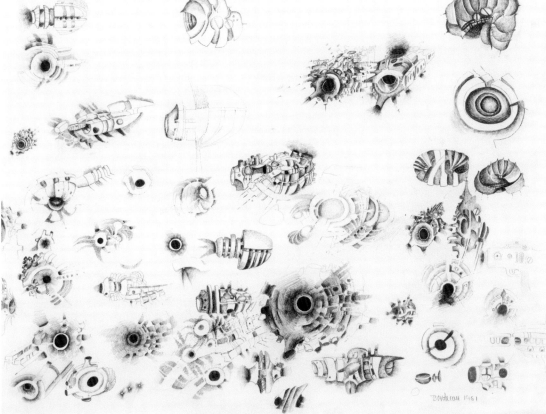

Plate 33
1961

OPPOSITE

Plate 34
1961

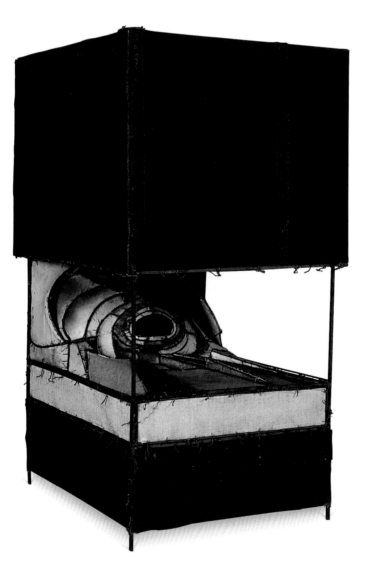

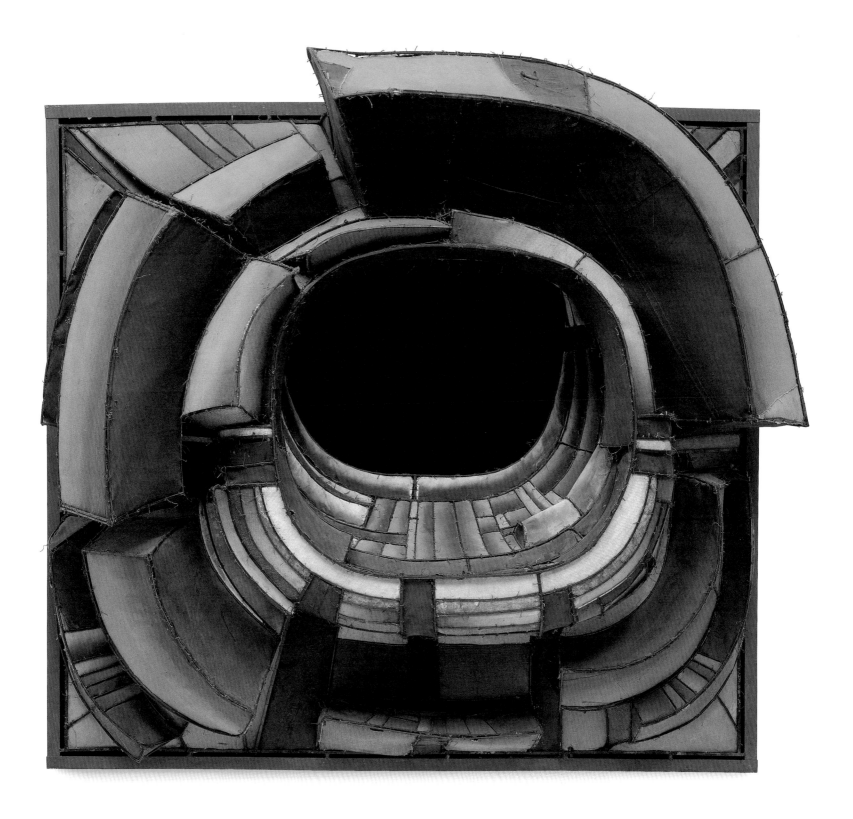

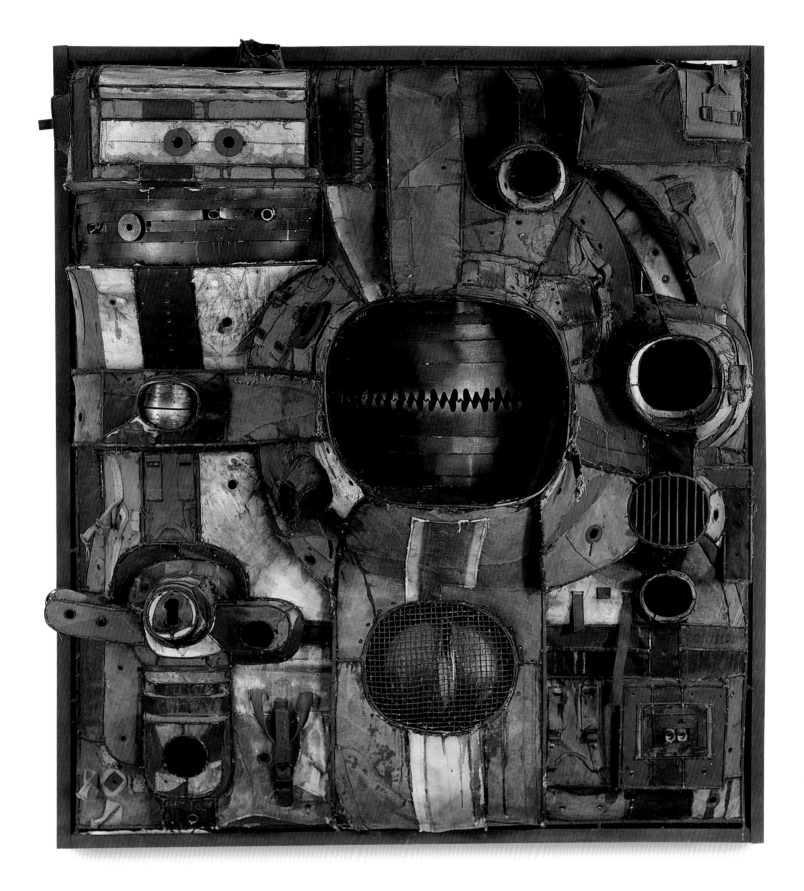

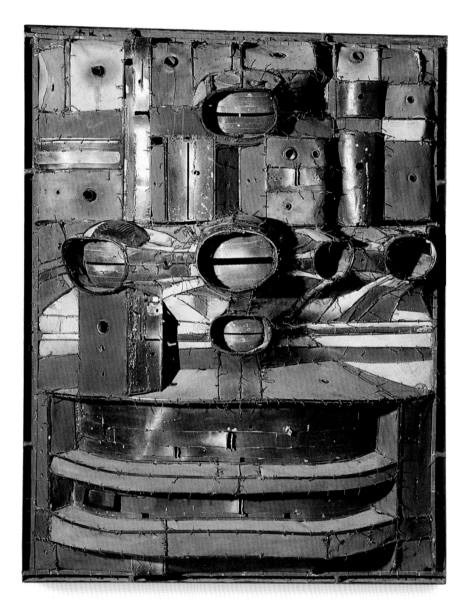

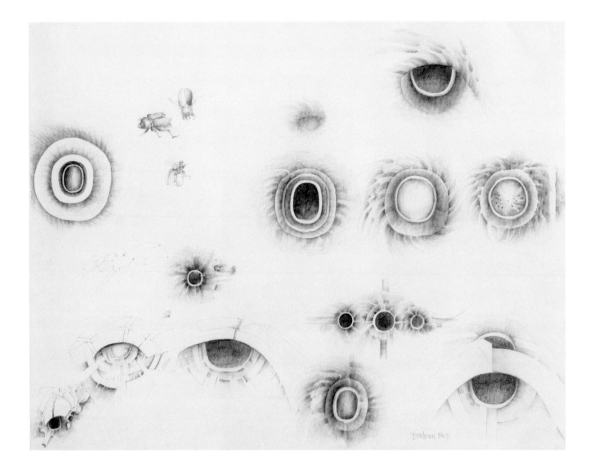

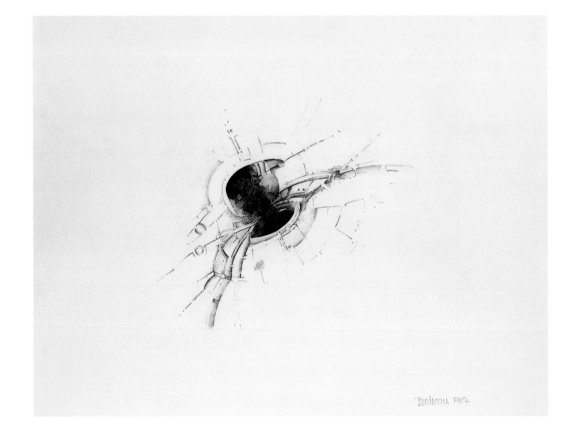

Plate 42
1962

Plate 43
1962

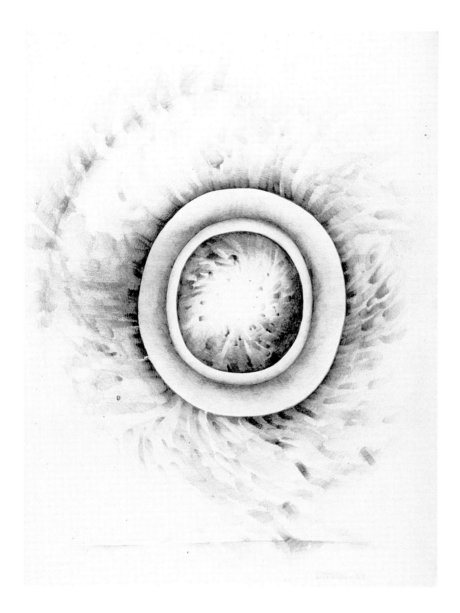

Plate 44
1962

Plate 48
1962

OPPOSITE

Plate 49
1962

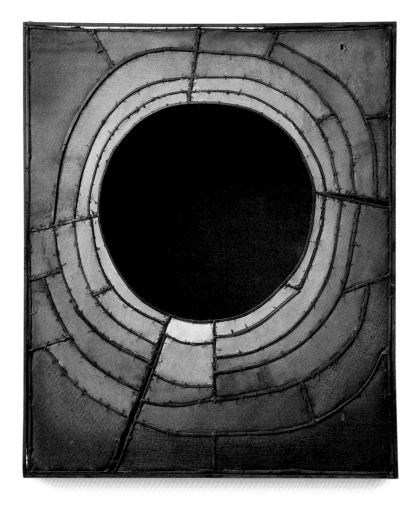

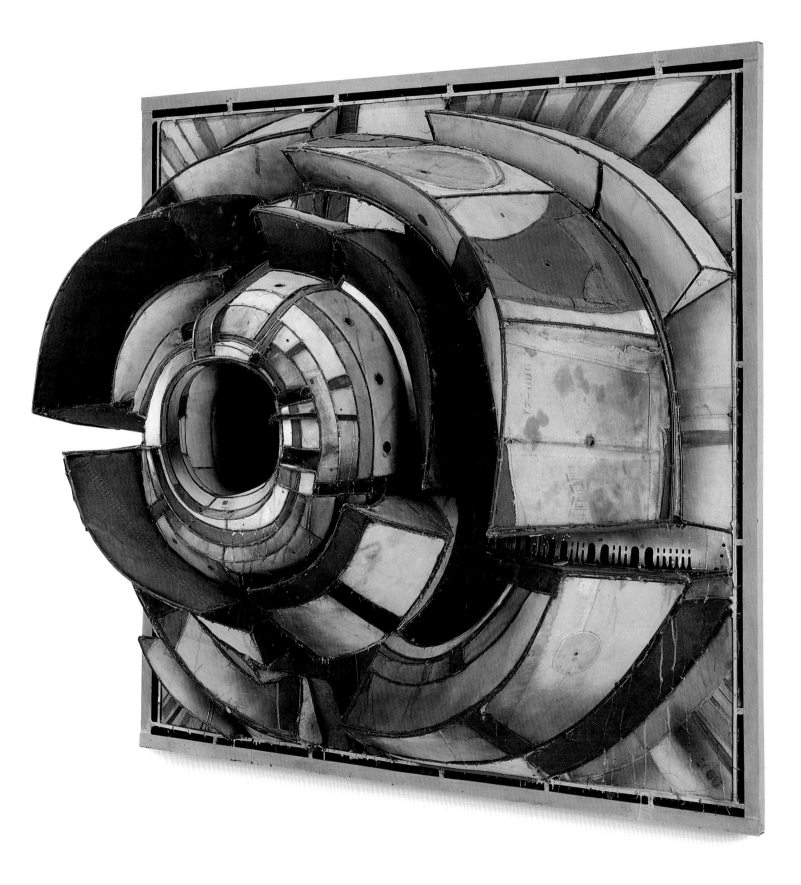

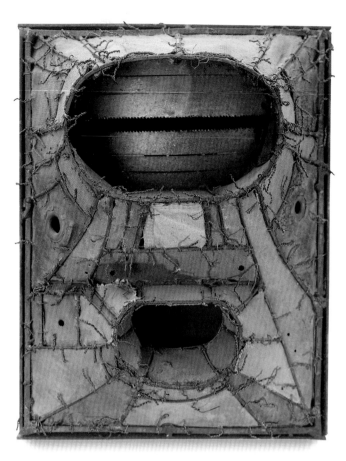

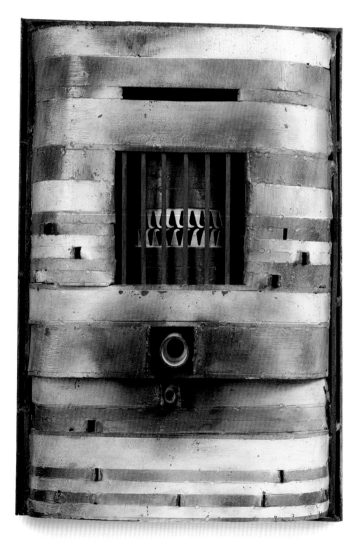

ABOVE
Plate 50
1962

LEFT
Plate 51
1963

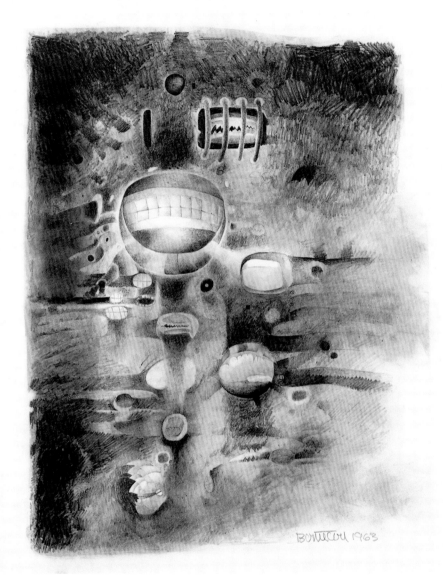

Plate 52
1963

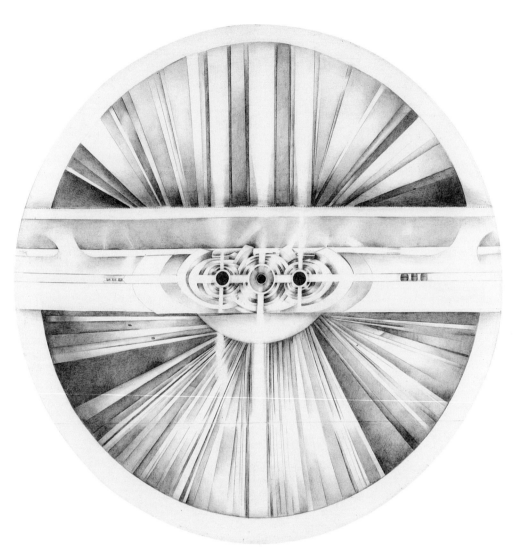

Plate 53
1963

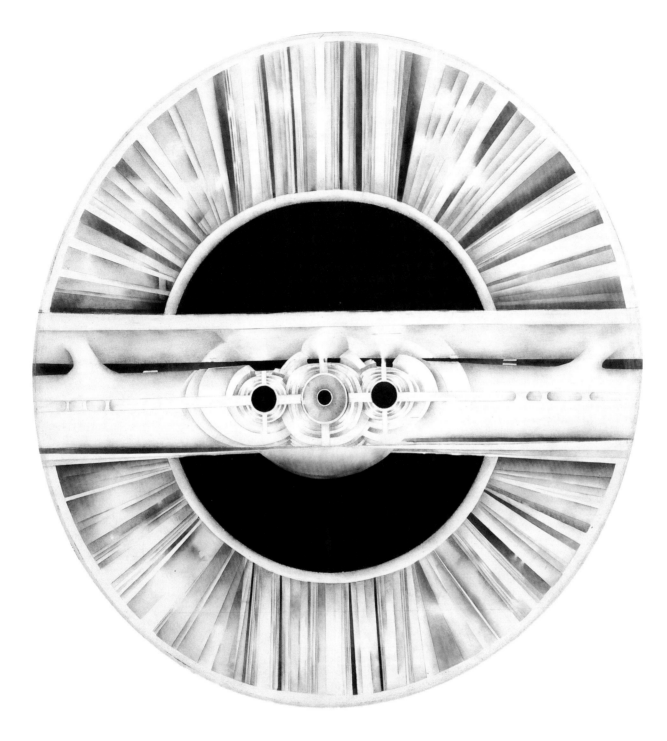

Plate 54
1963

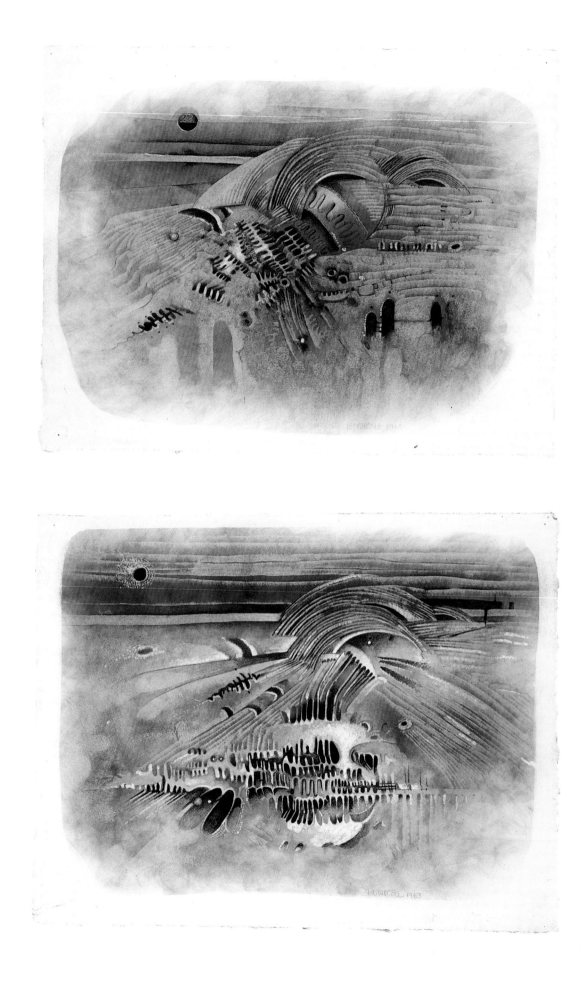

Plate 55
1963

Plate 56
1963

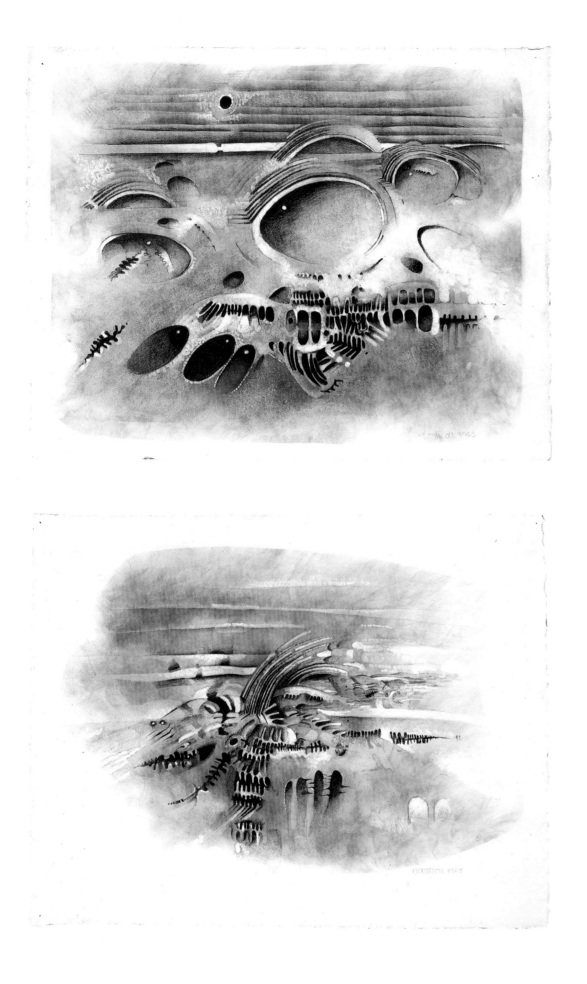

Plate 57
1963

Plate 58
1963

Plate 59
1963

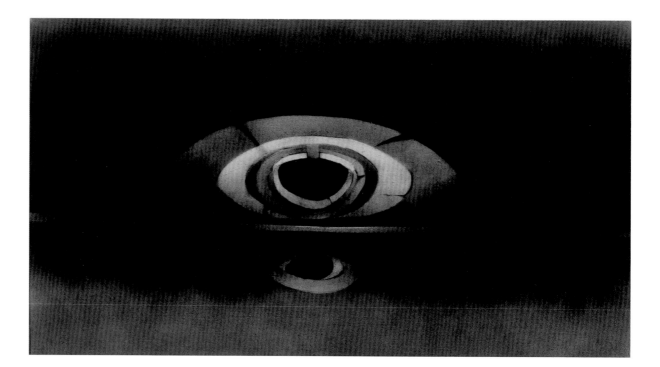

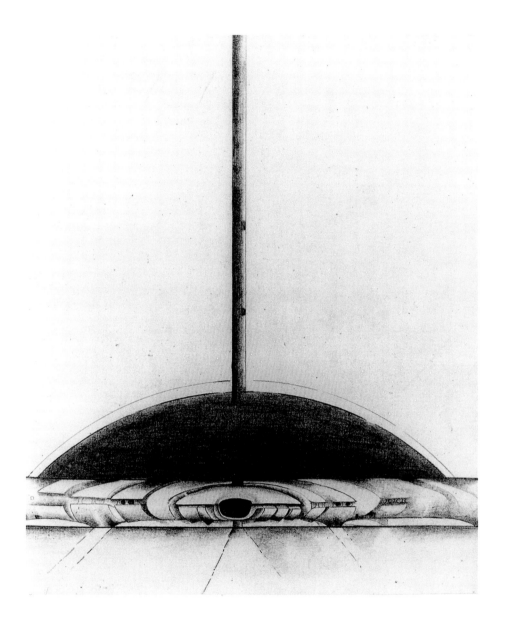

Plate 60
1963

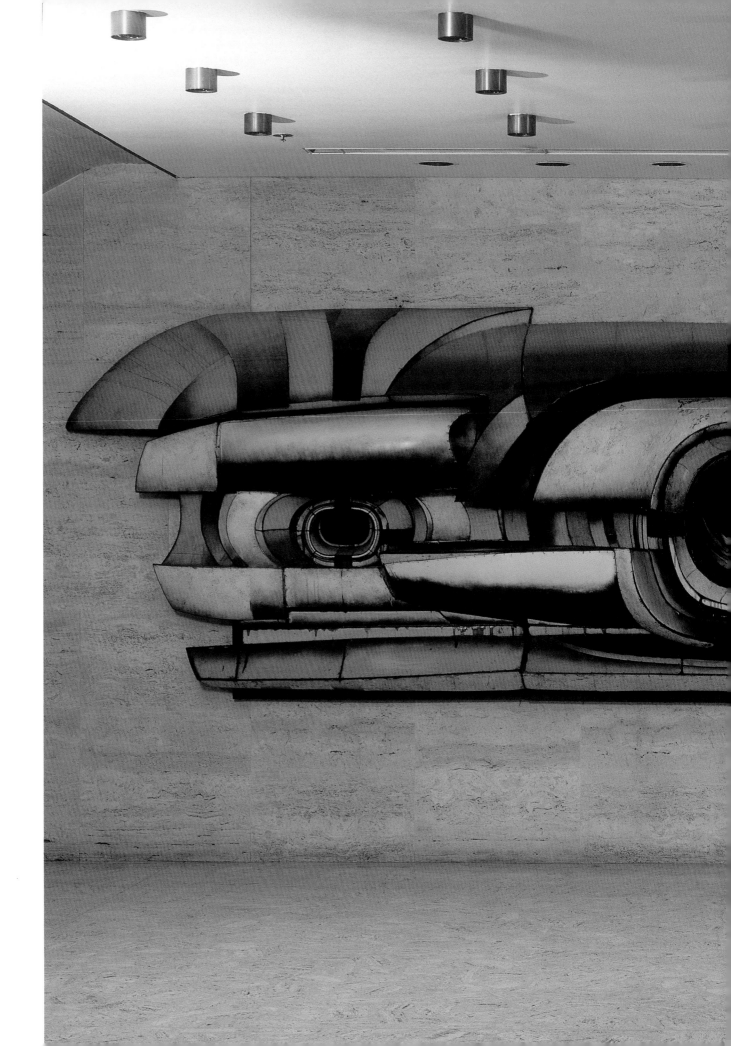

Plate 61
1964

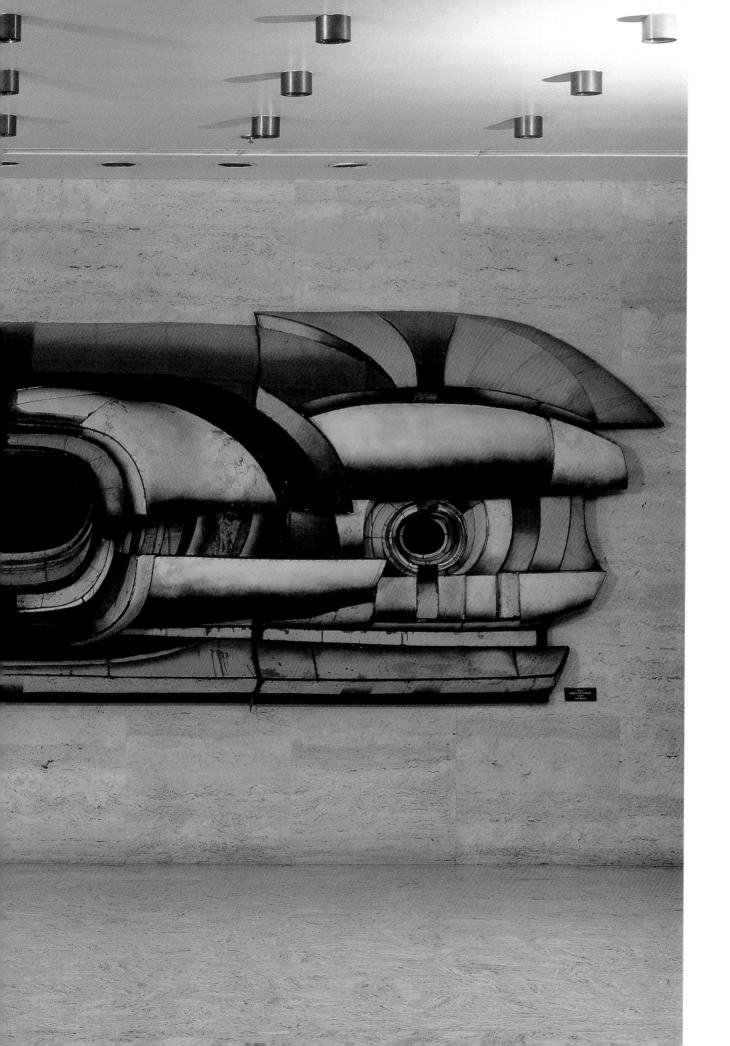

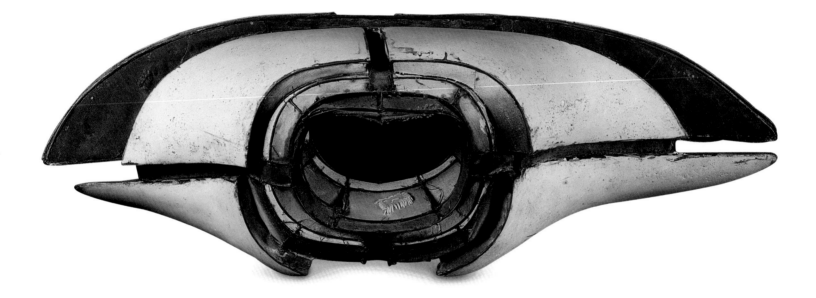

Plate 62
1964

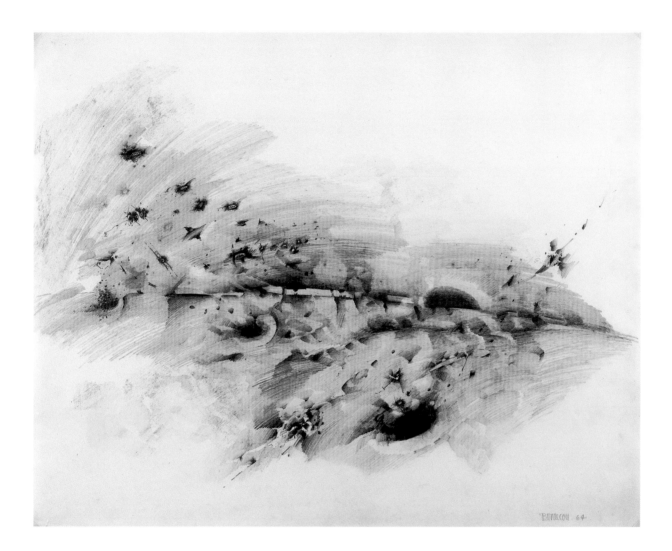

Plate 63
1964

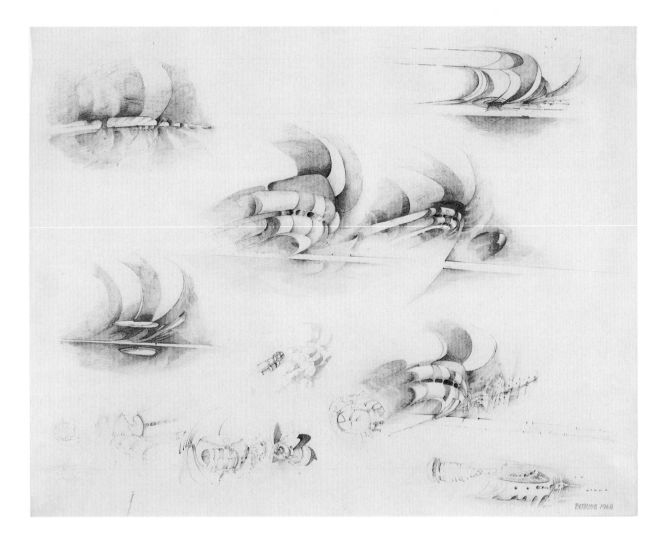

Plate 64
1964

OPPOSITE

Plate 65
1964

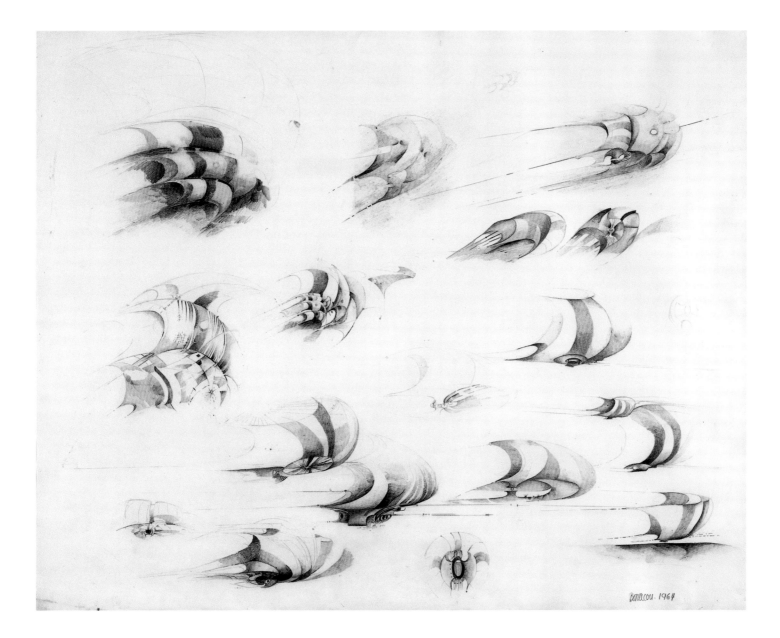

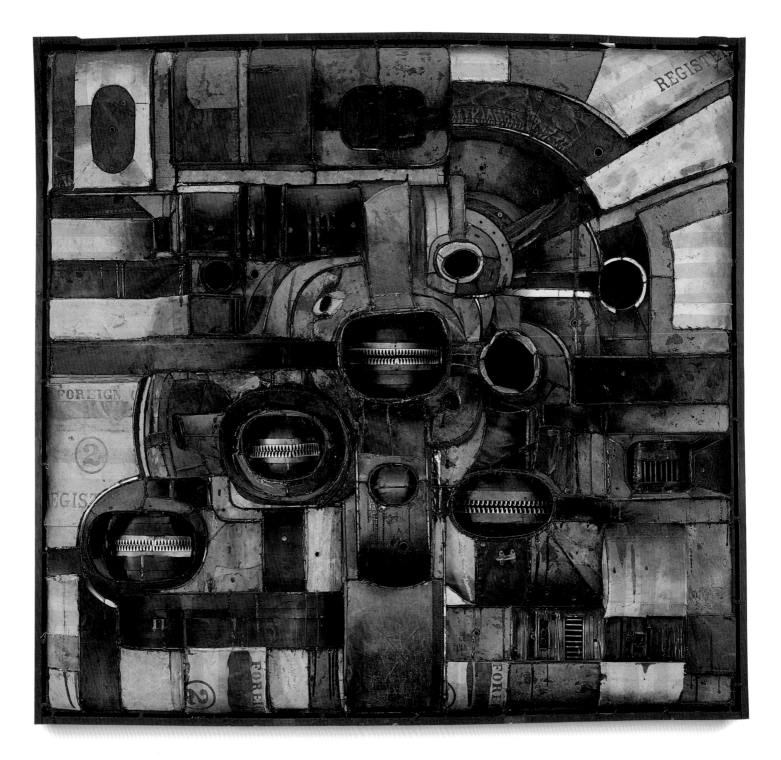

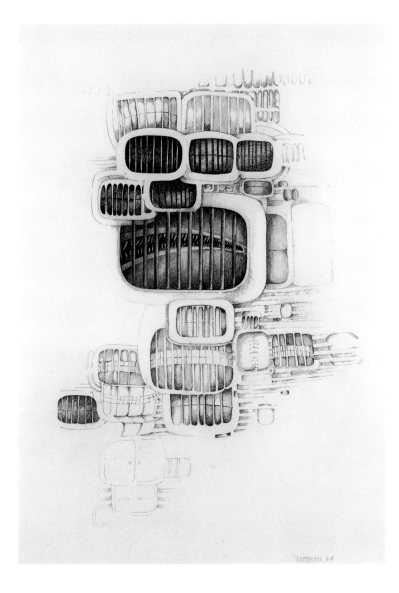

Plate 67
1964

OPPOSITE

Plate 66
1964

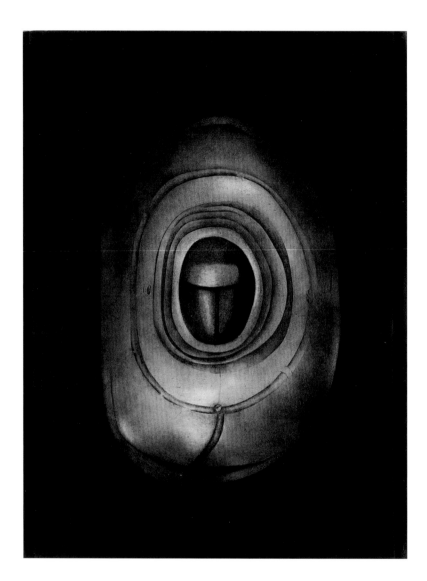

Plate 68
1964

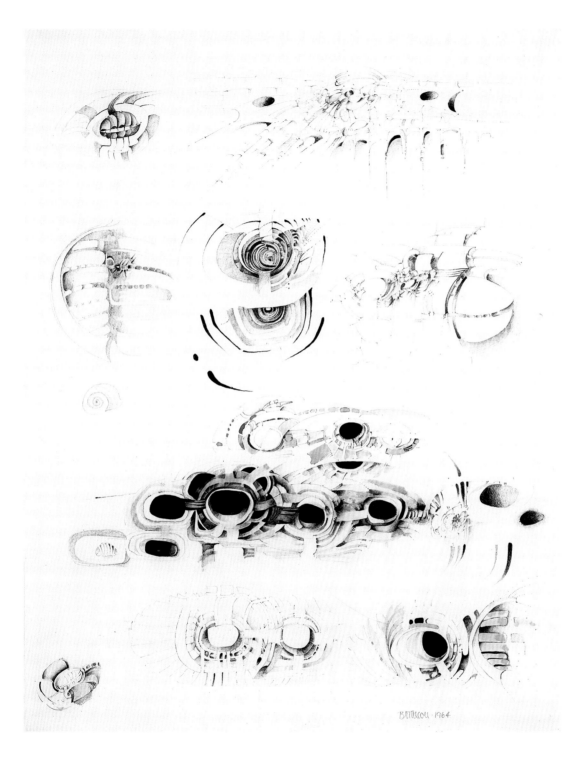

Plate 69
1964

BERTISCOU - 1964

73

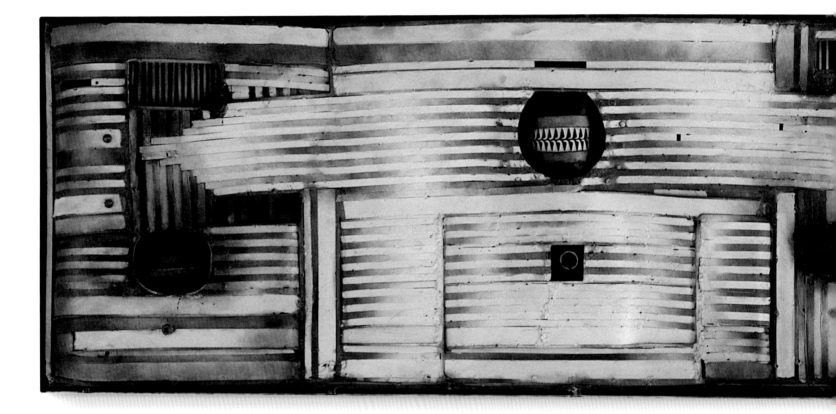

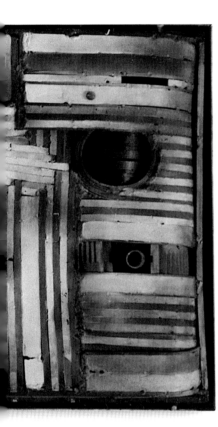

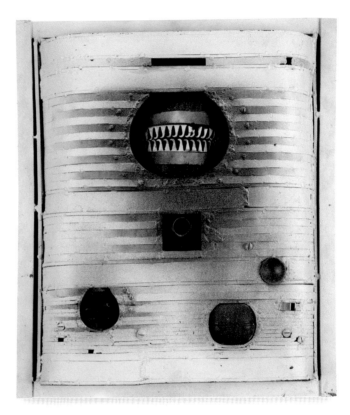

Plate 70
1965

Plate 71
1965

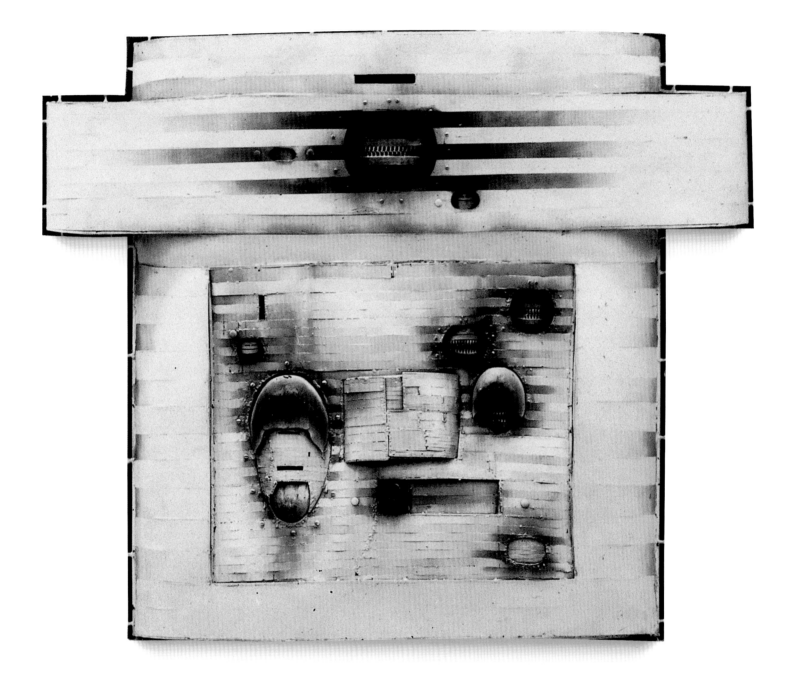

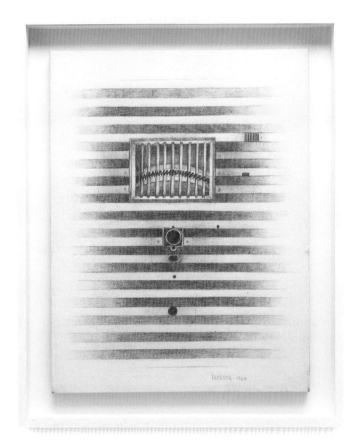

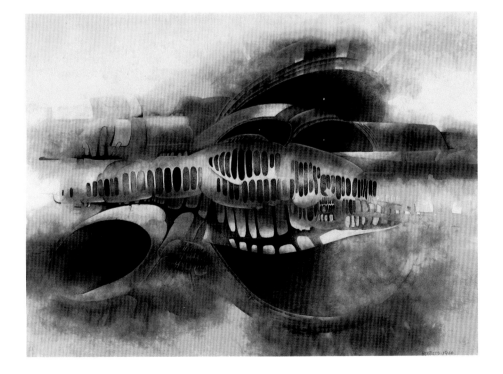

Plate 73
1964

Plate 74
1966

OPPOSITE

Plate 72
1966

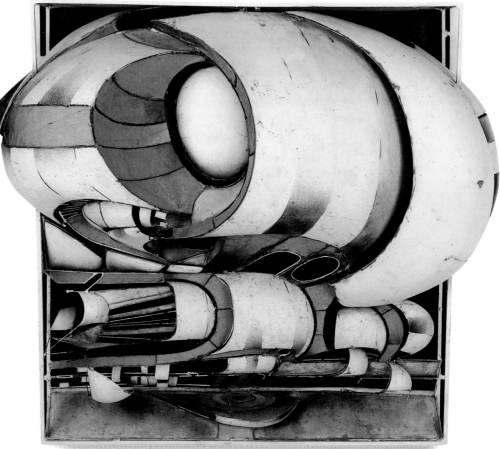

Plate 75
1966

OPPOSITE

Plate 76
1966

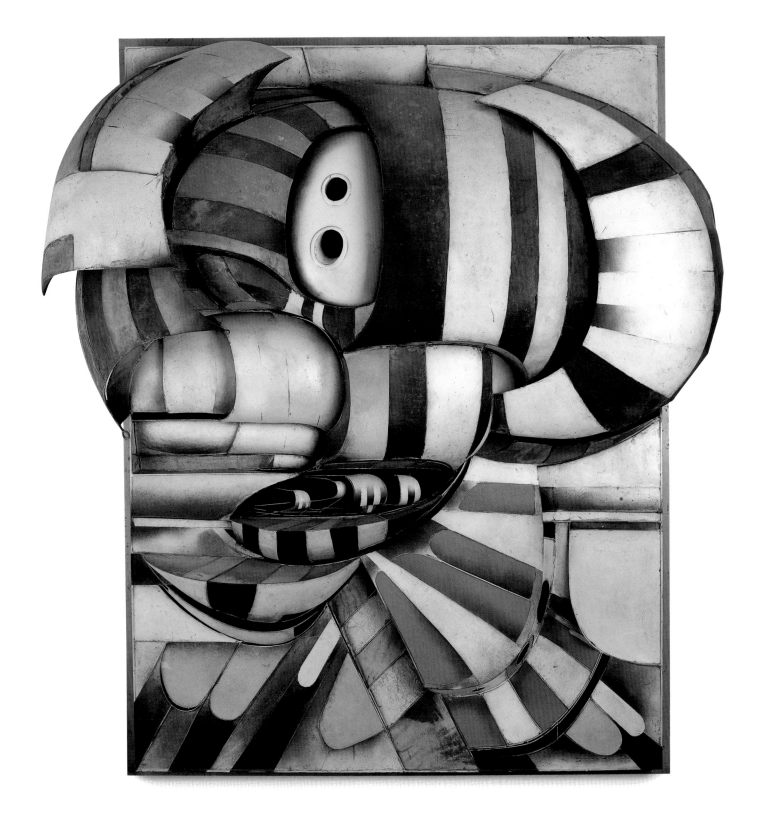

Plate 77
1966

Plate 78
1966

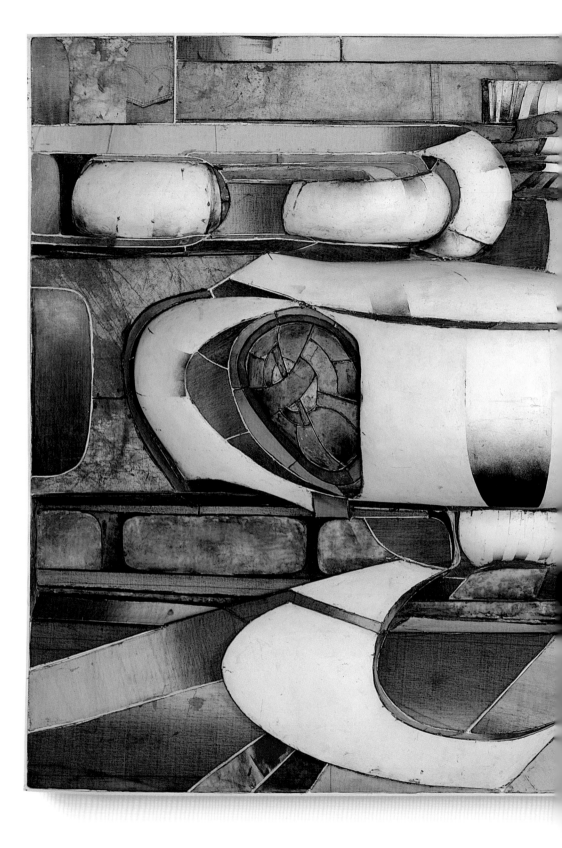

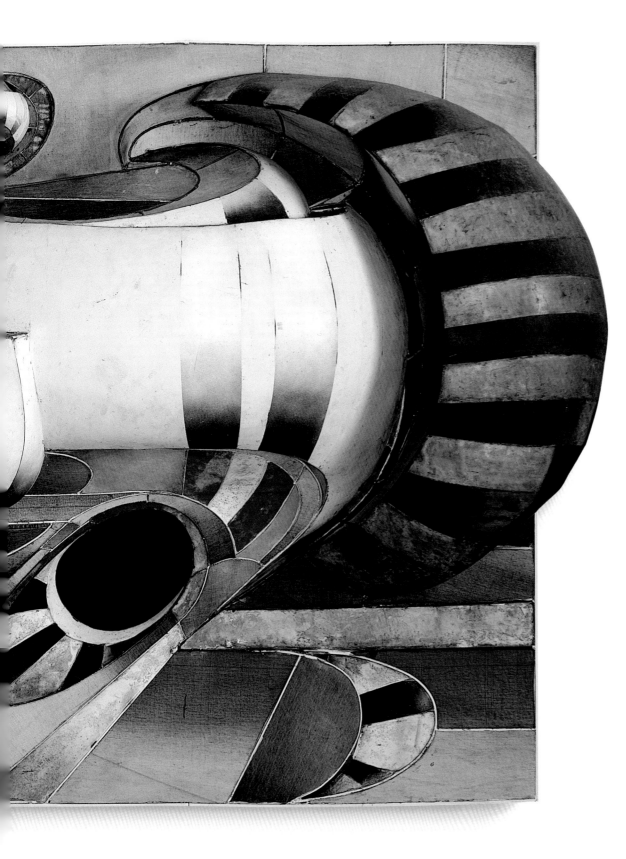

Plate 79
1967

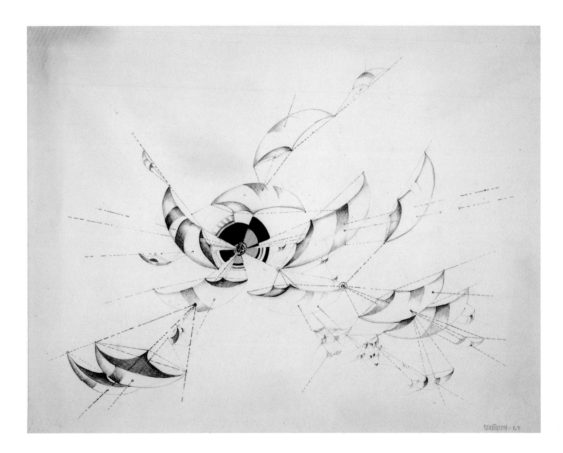

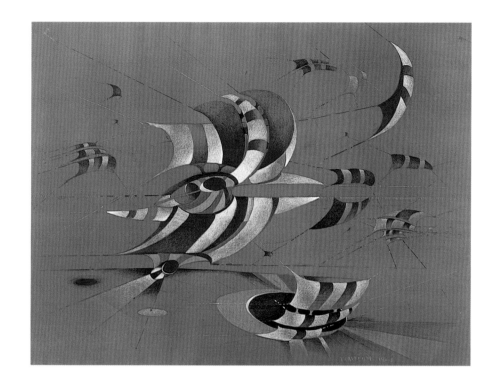

Plate 80
1967

Plate 81
1967

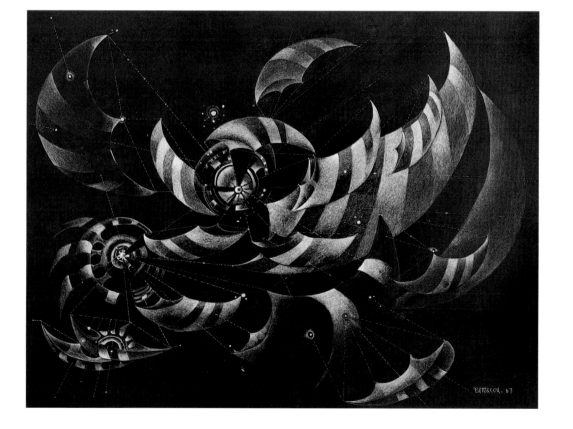

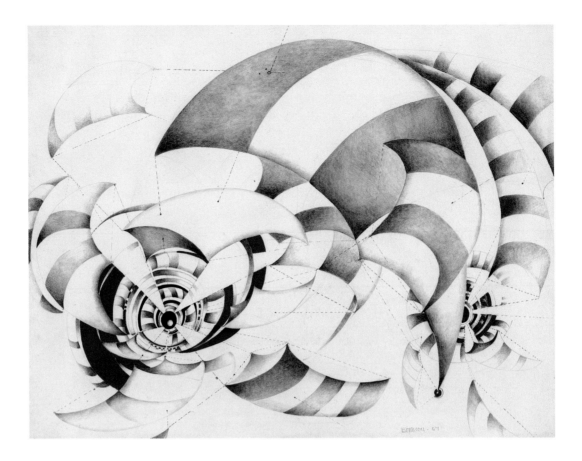

Plate 82
1967

Plate 83
1967

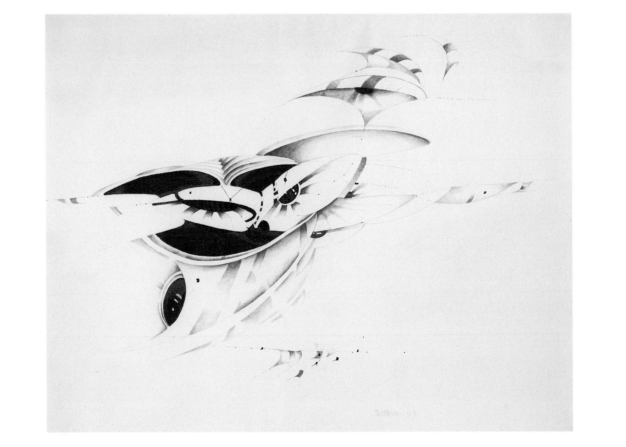

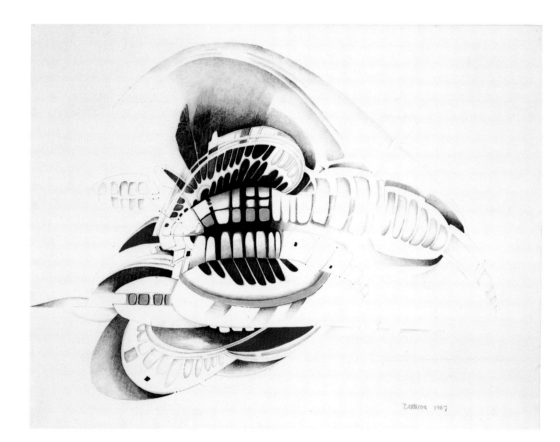

Plate 84
1967

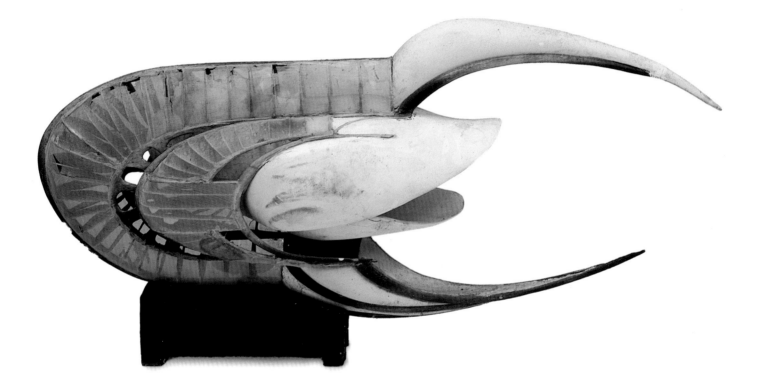

Plate 85
1967

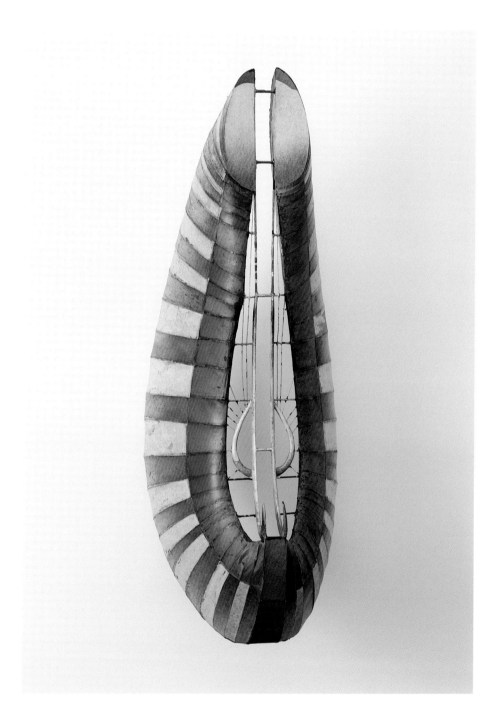

Plate 86
1967

Plate 87
1967

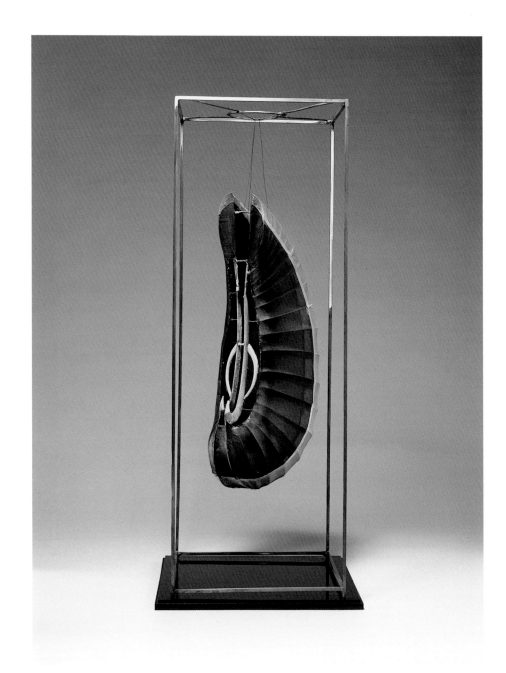

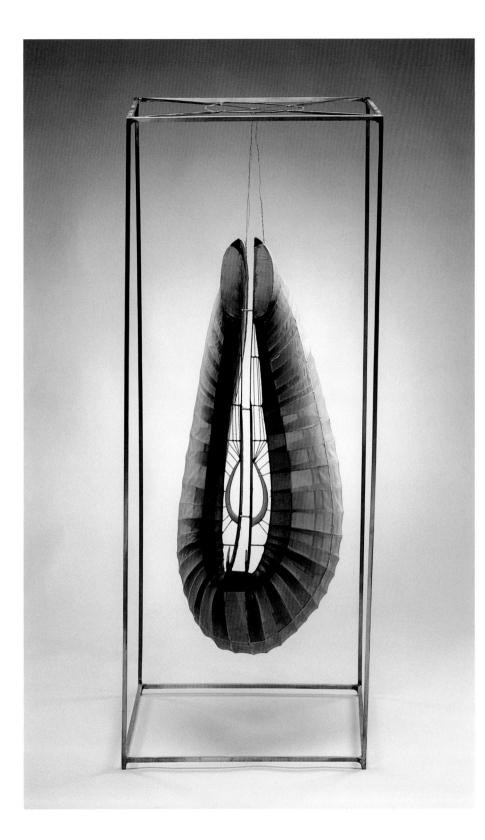

Plate 88
1967

Plate 89
1969

Plate 90
1967

Plate 91
1969

Plate 92
1968

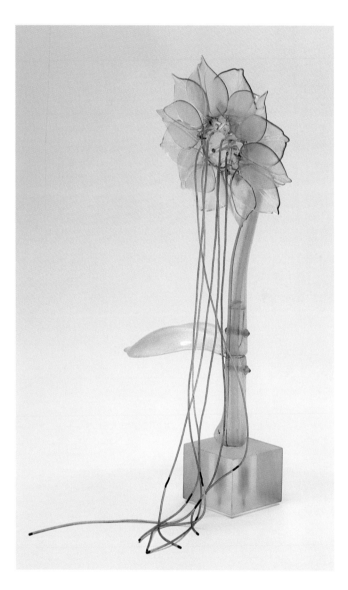

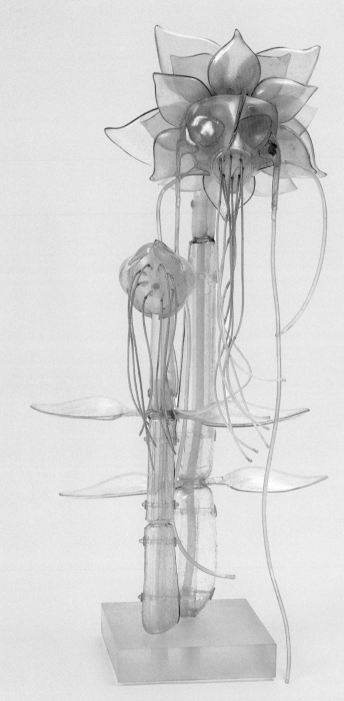

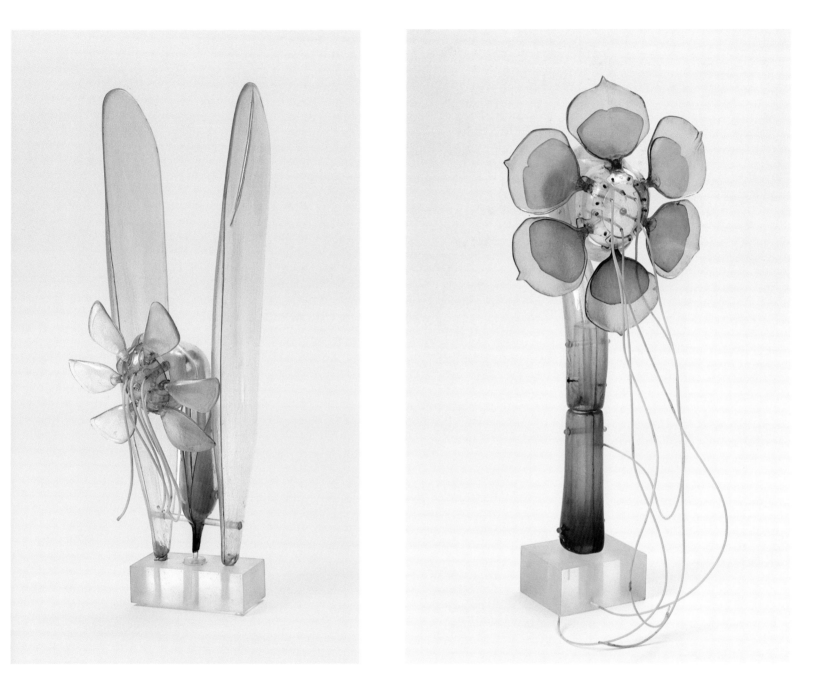

Plate 93
1969

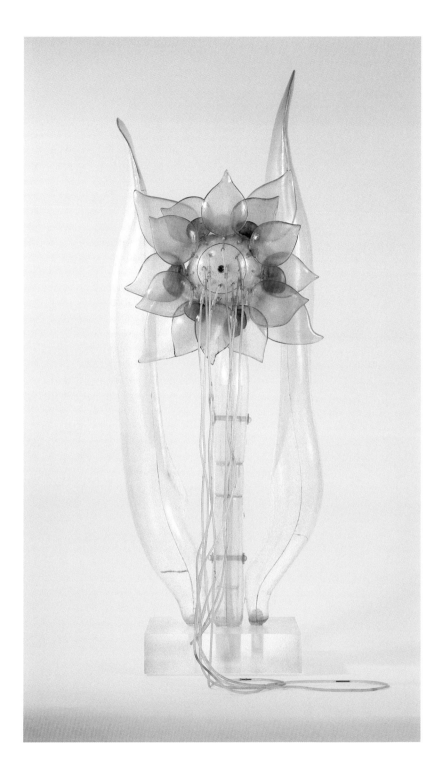

Plate 94
1969

Plate 95
1969

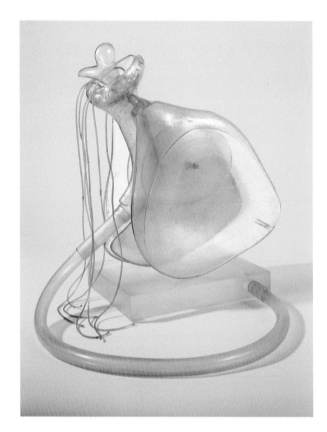

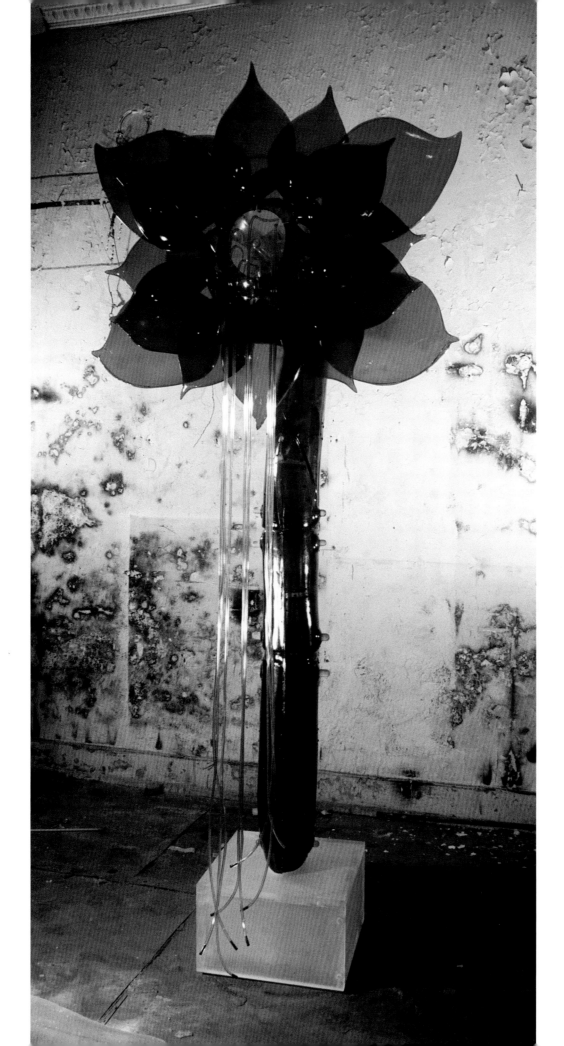

Plate 96
1969

Plate 97
1970

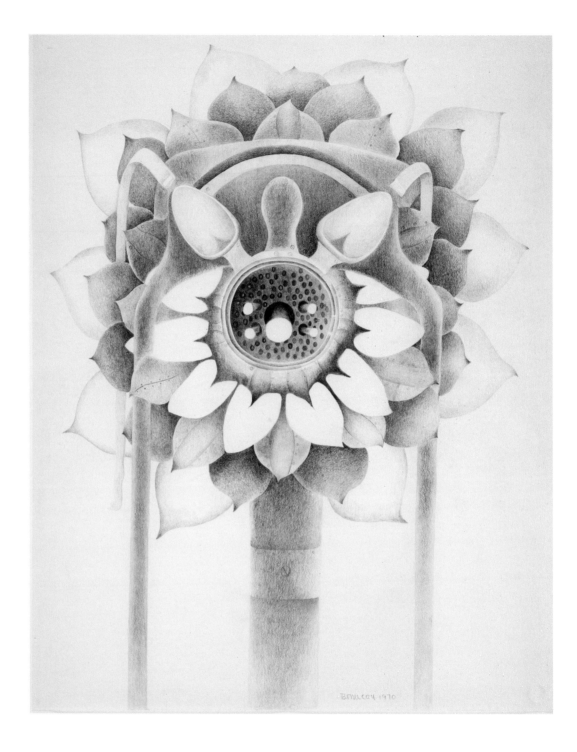

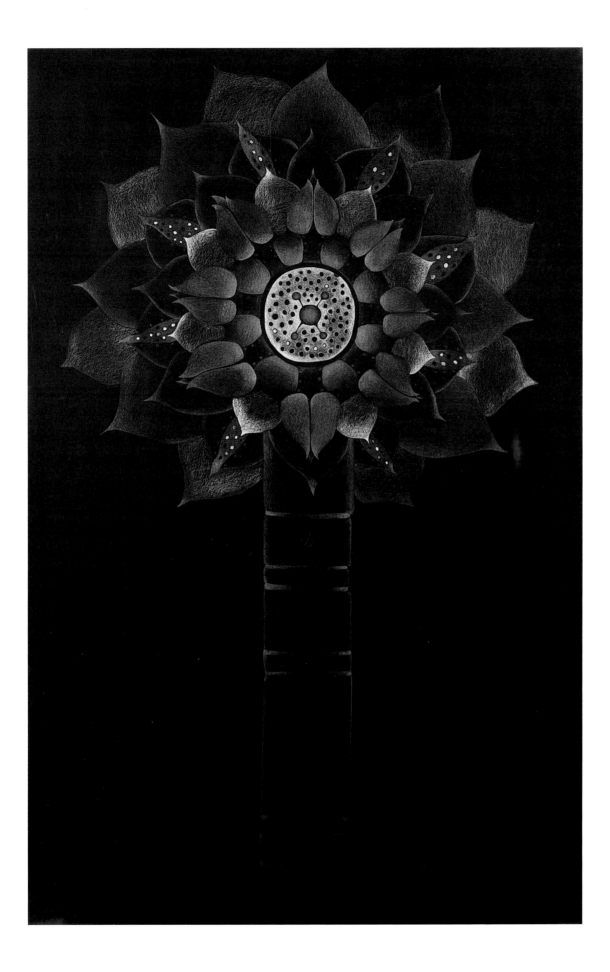

Plate 98
1970

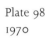

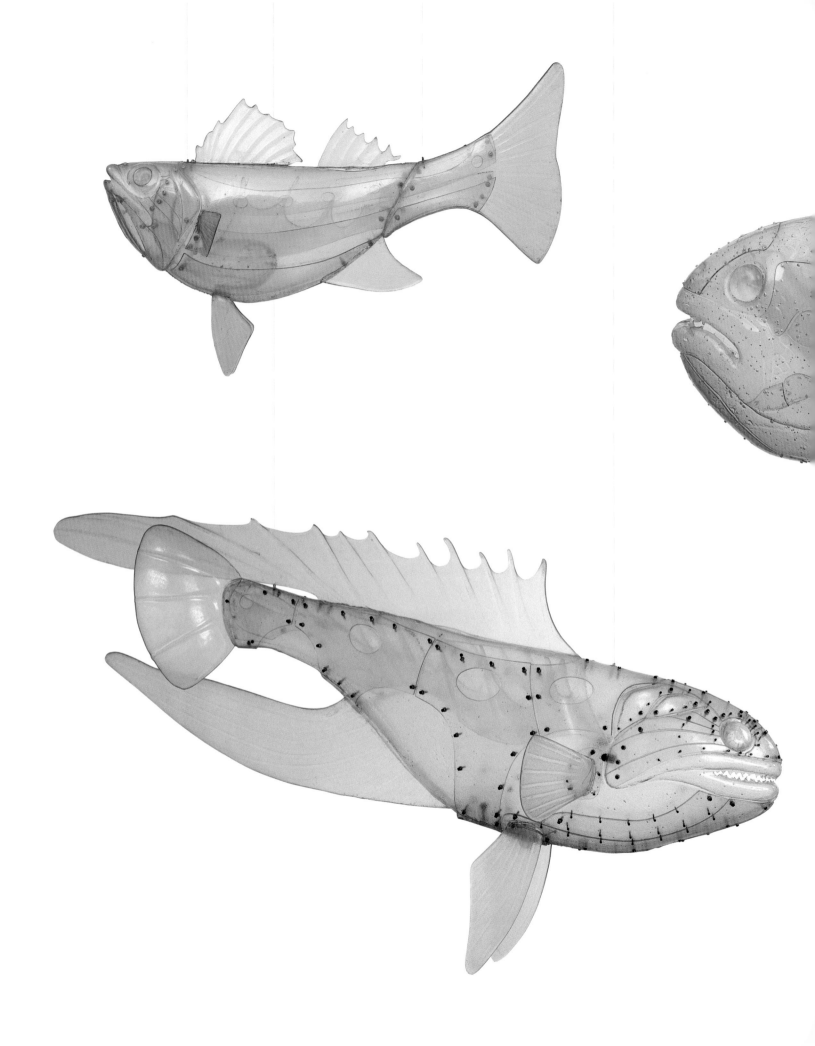

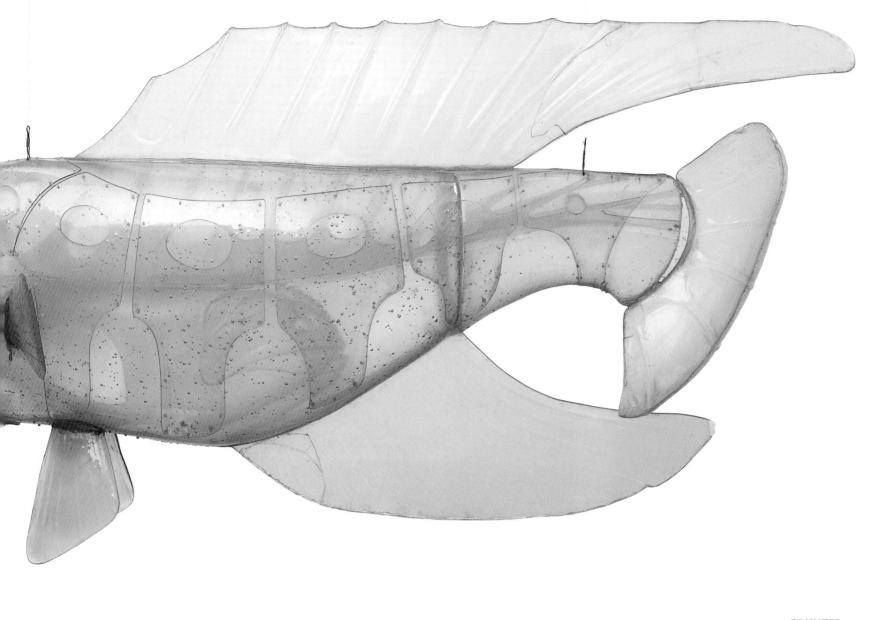

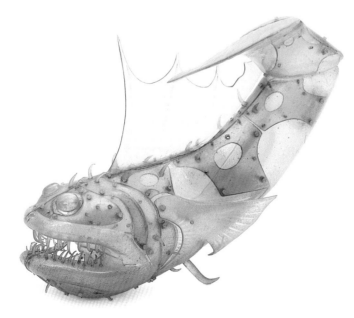

COUNTER-
CLOCKWISE
FROM
TOP RIGHT

Plate 99
1969

Plate 100
1970

Plate 101
1969

Plate 102
1970

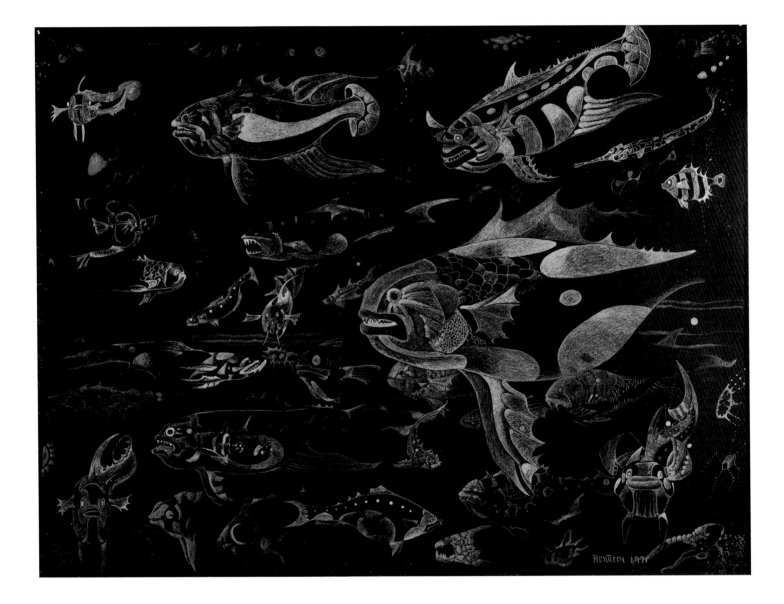

Plate 103
1971

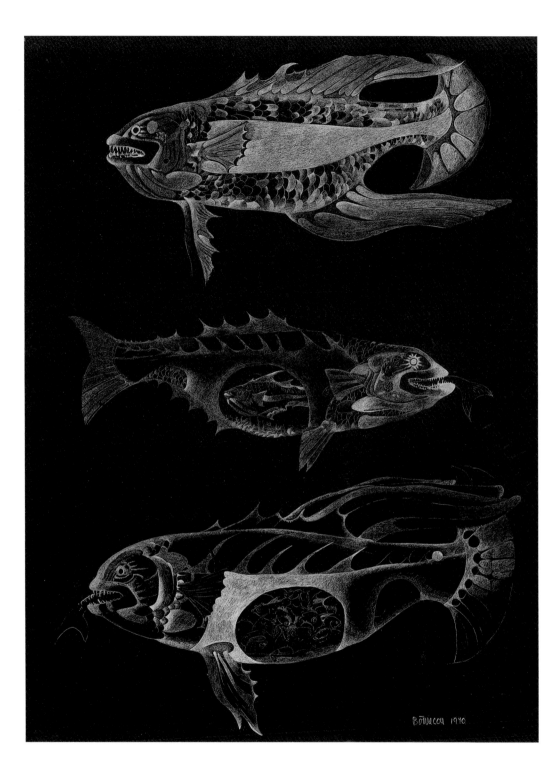

Plate 104
1970

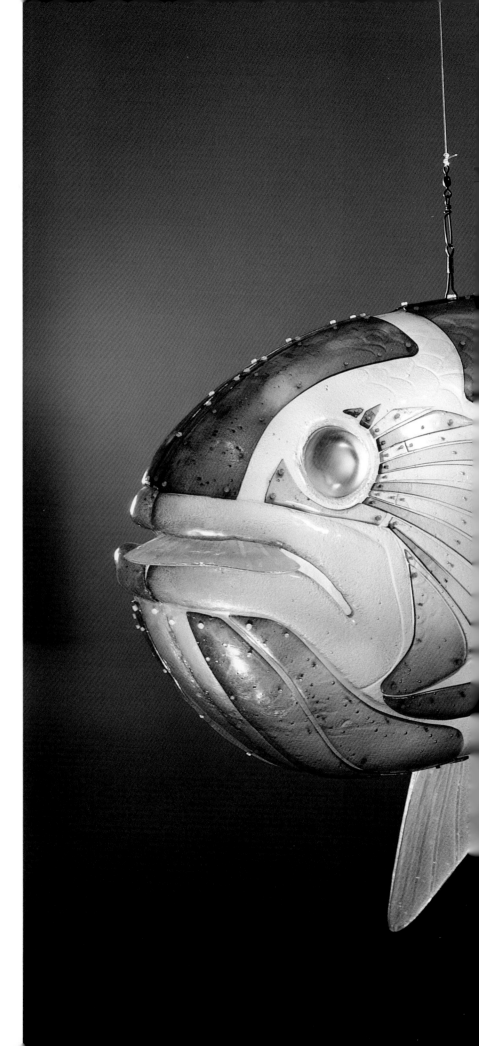

Plate 105
1970

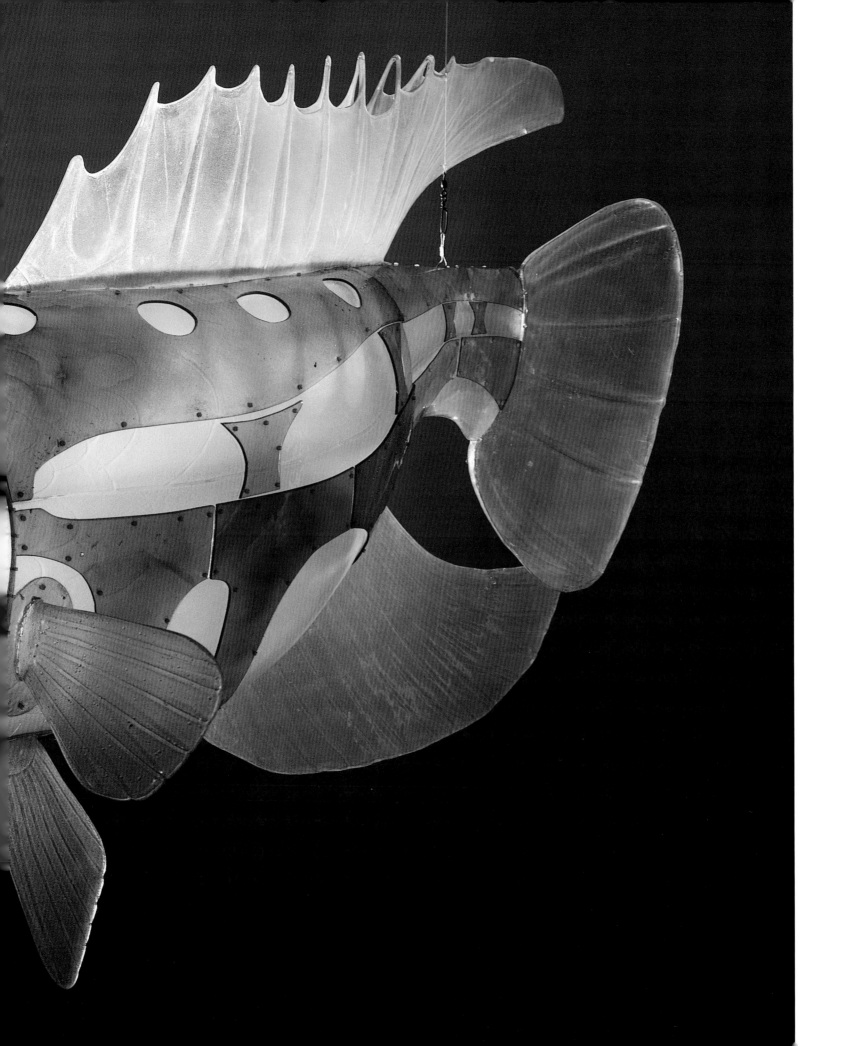

Plate 106
1970

Plate 107
1970

Plate 108
1970

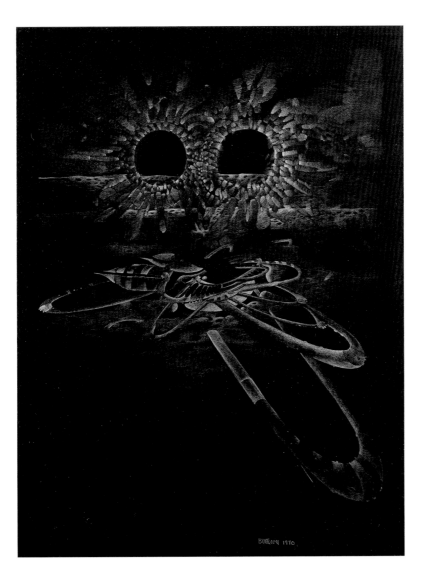

Plate 109
1970–75

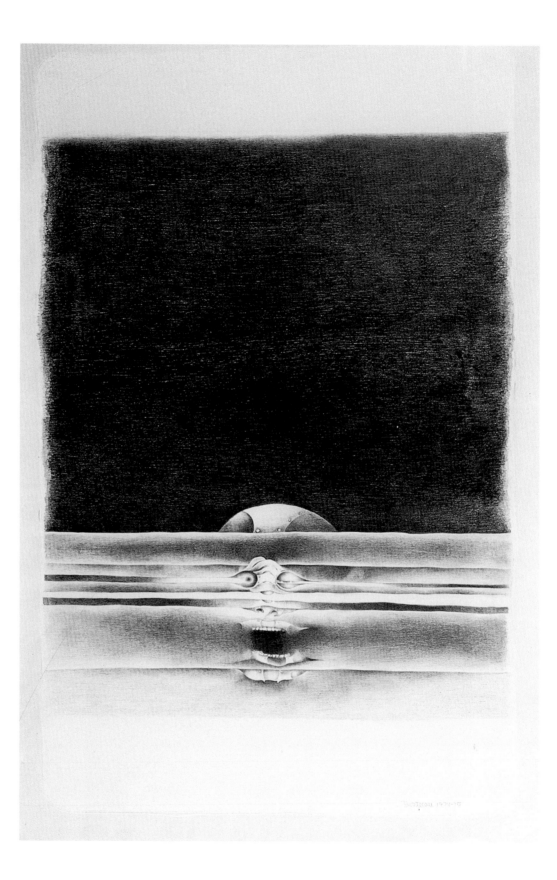

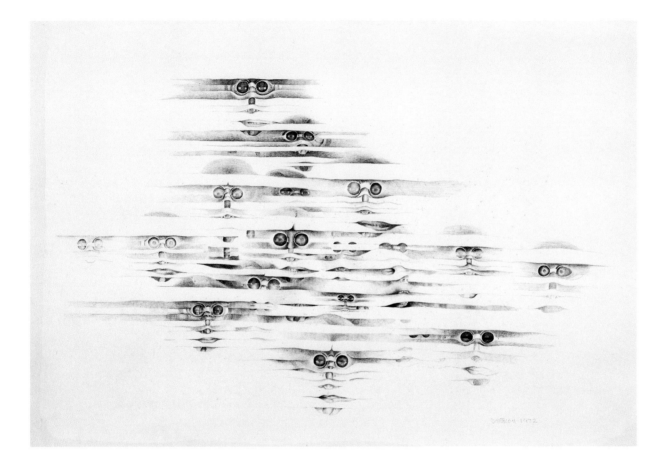

Plate 110
1972

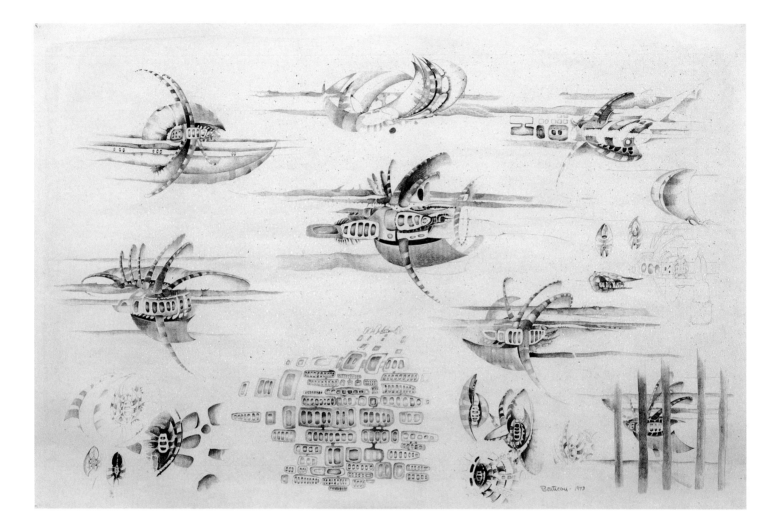

Plate 111
1973

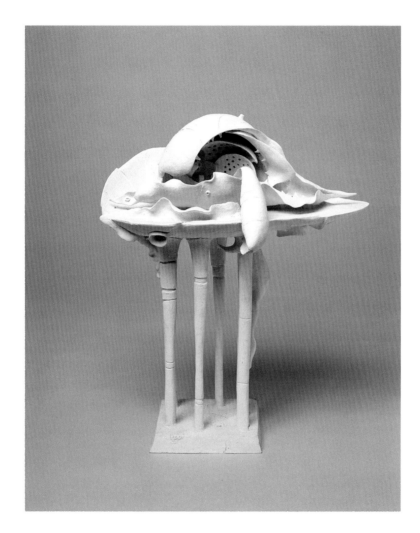

Plate 112
1977

Plate 113
1982

Plate 114
1982

Plate 115
1982

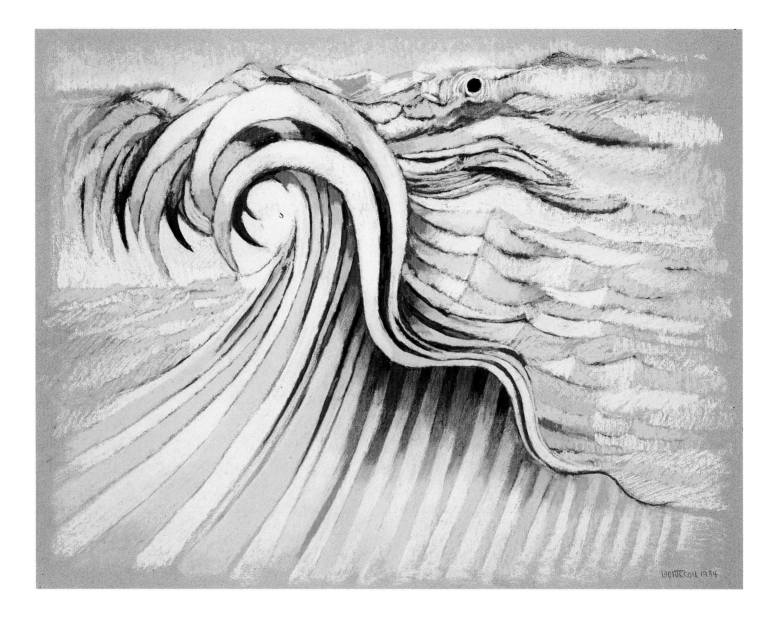

Plate 116
1984

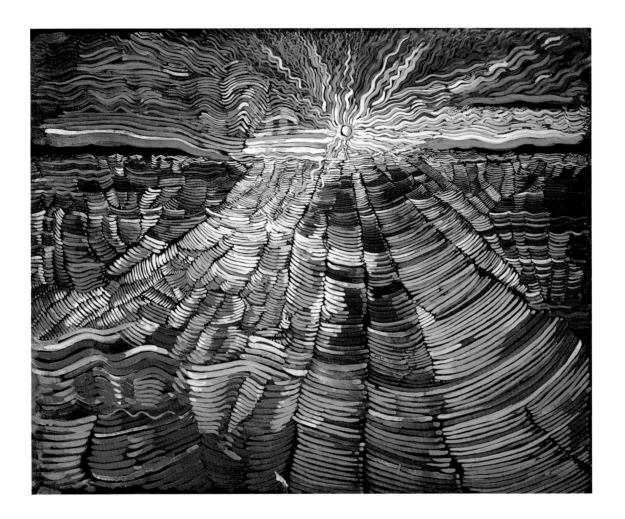

Plate 117
1982

Plate 118
1983

OPPOSITE

Plate 119
1983

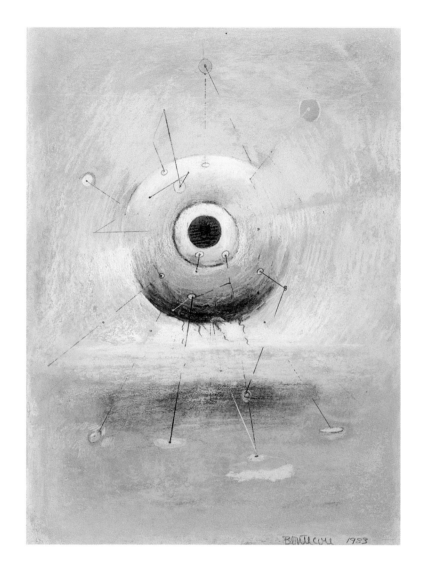

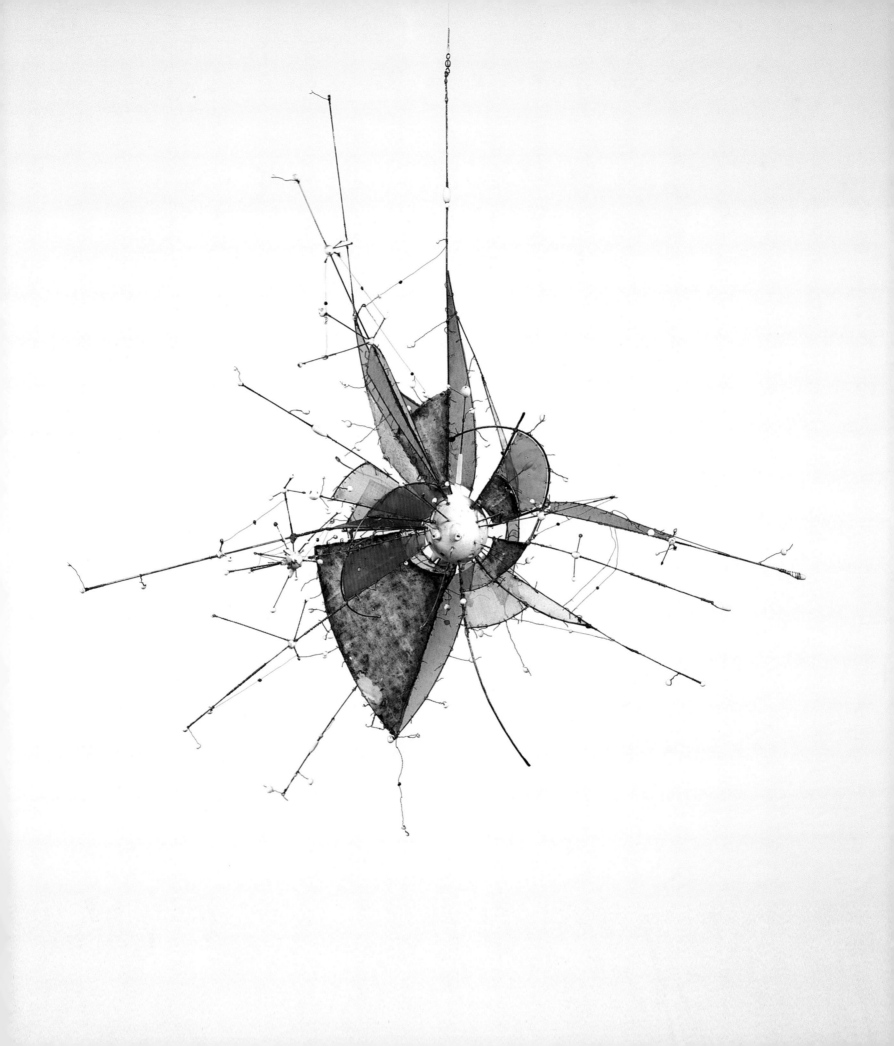

Plate 120
1982

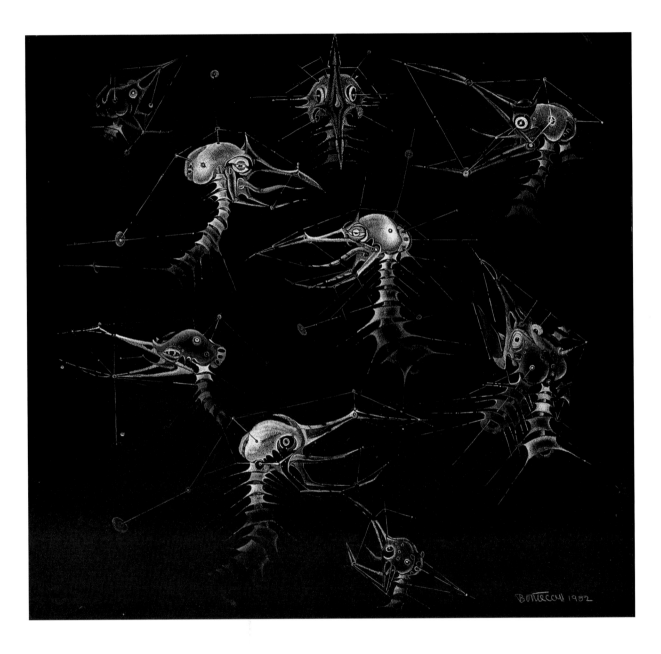

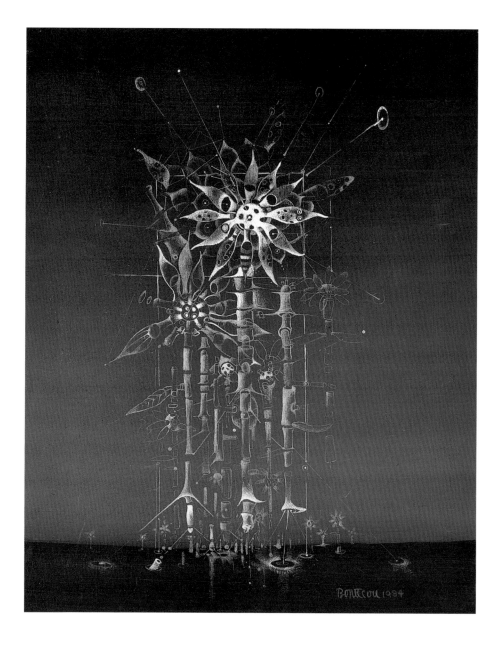

Plate 121
1984

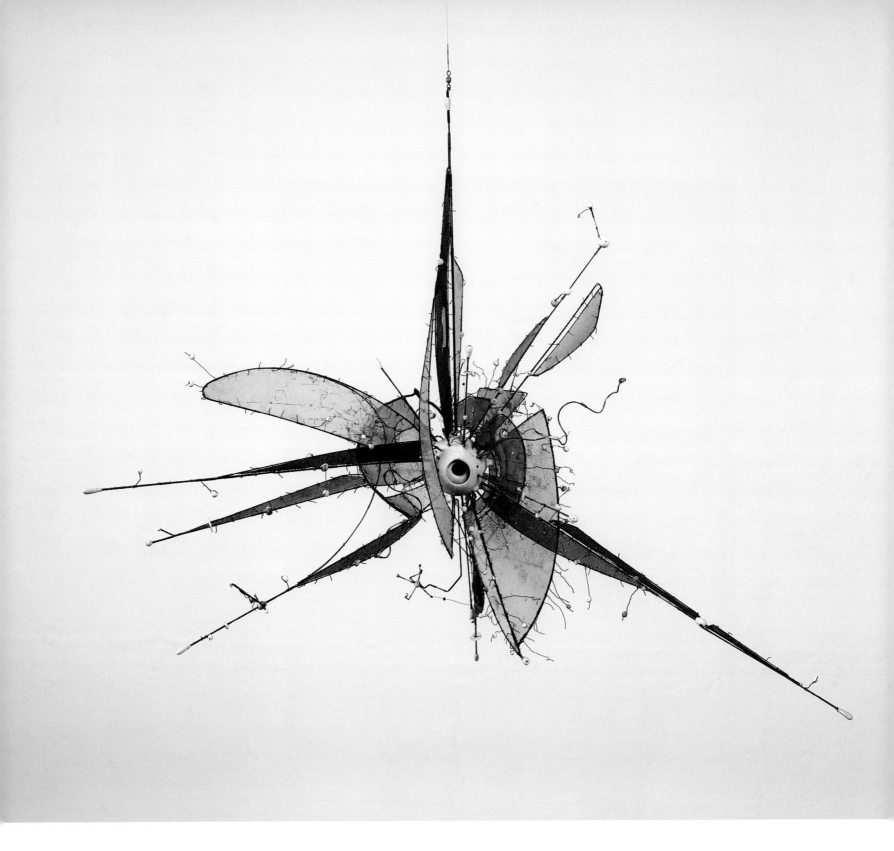

Plate 122
1985

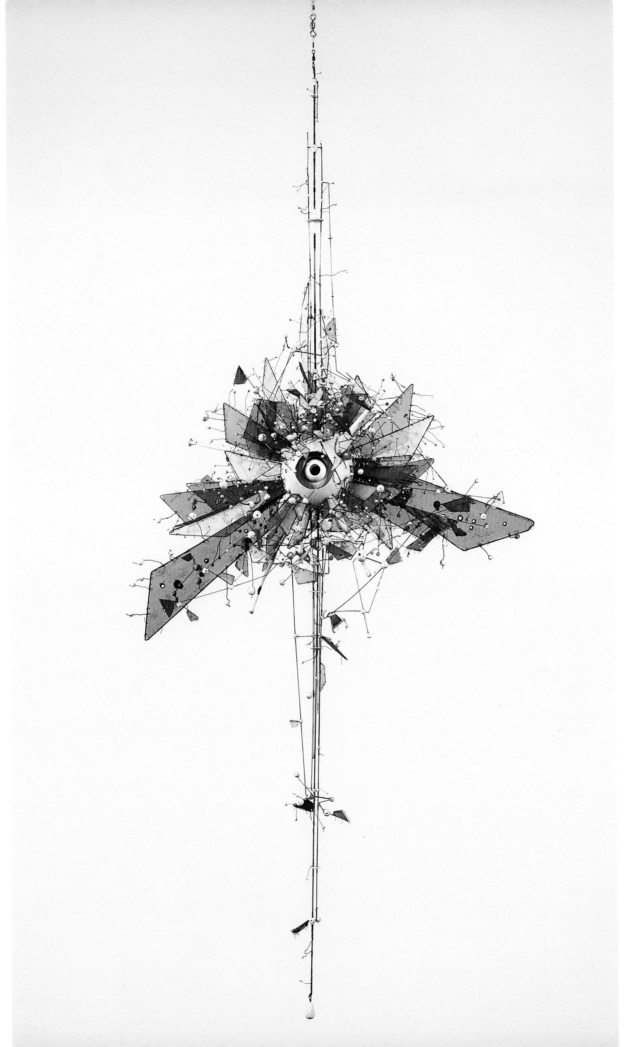

Plate 123
1985

Plate 124
1987

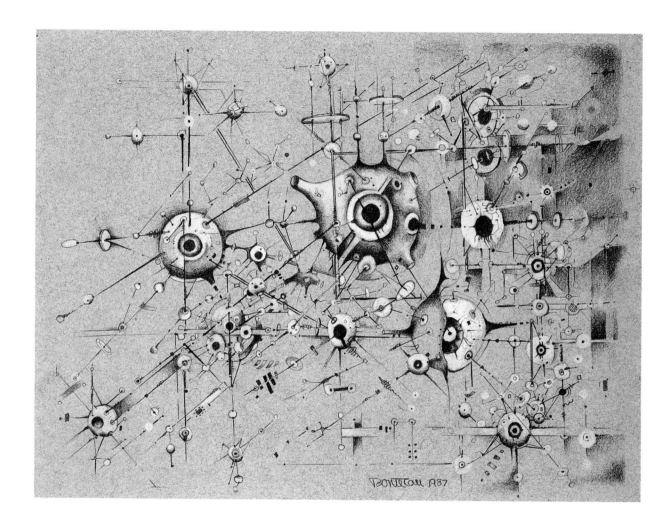

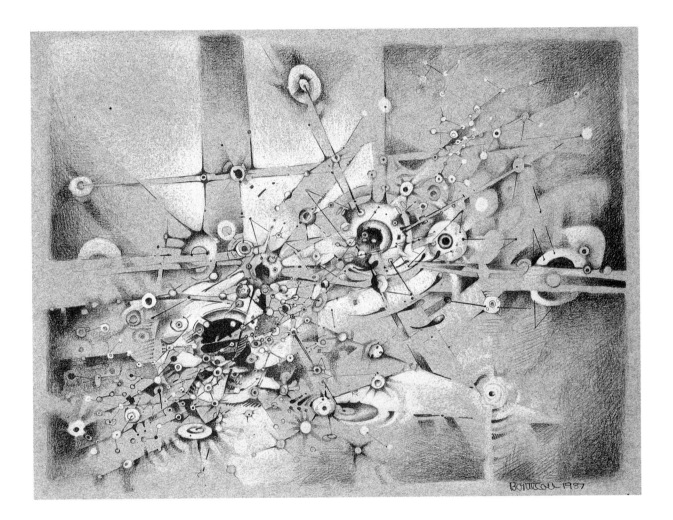

Plate 125
1987

Plate 126
1986–87

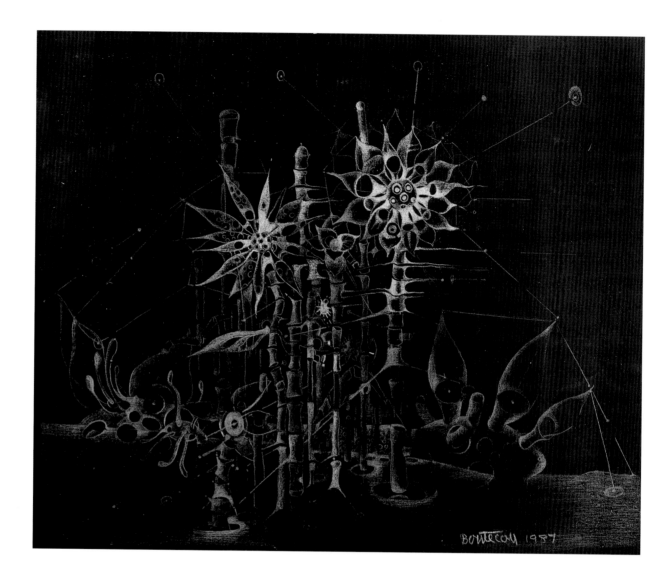

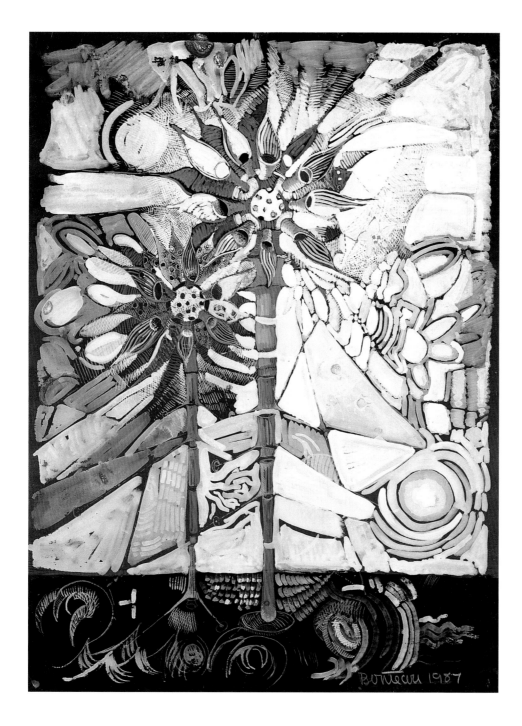

Plate 127
1987

Plate 128
1987

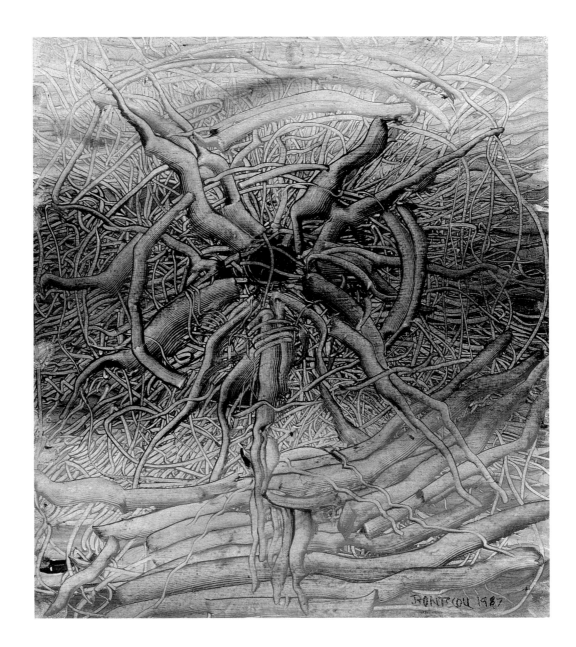

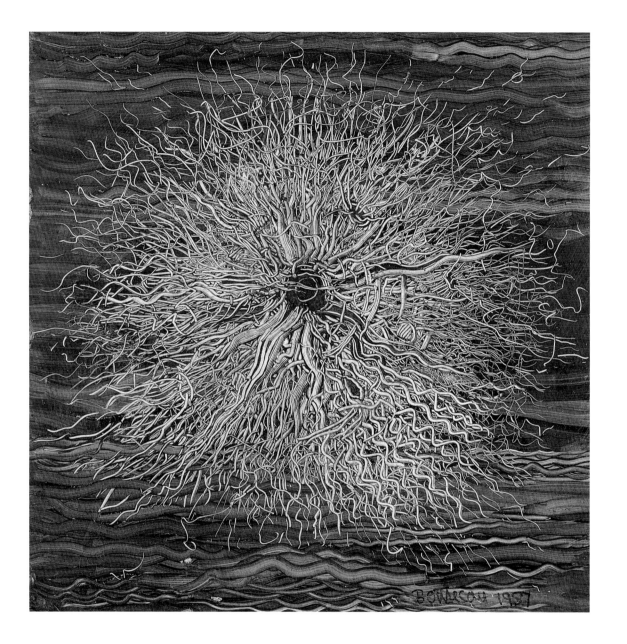

Plate 129
1987

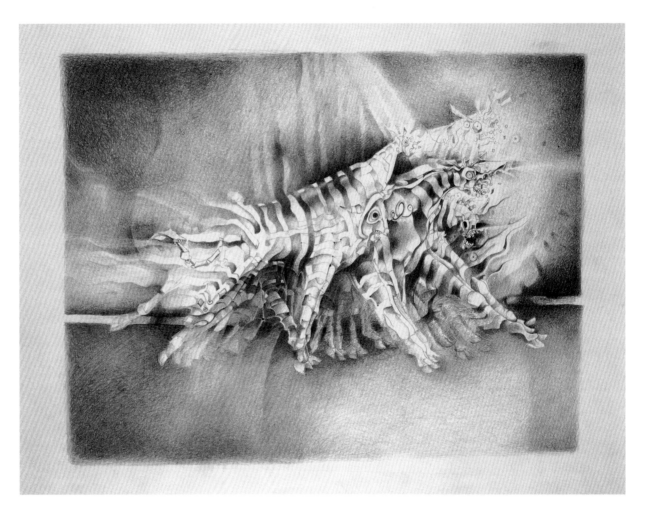

Plate 130
1989

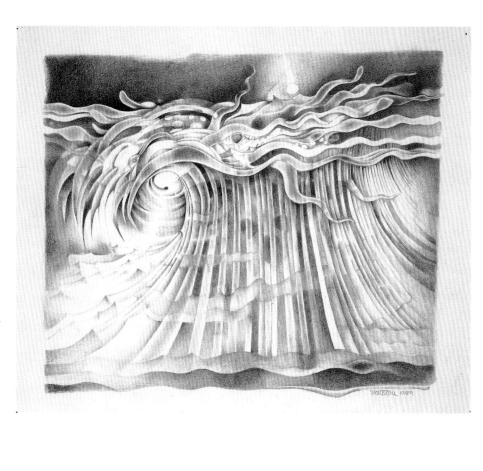

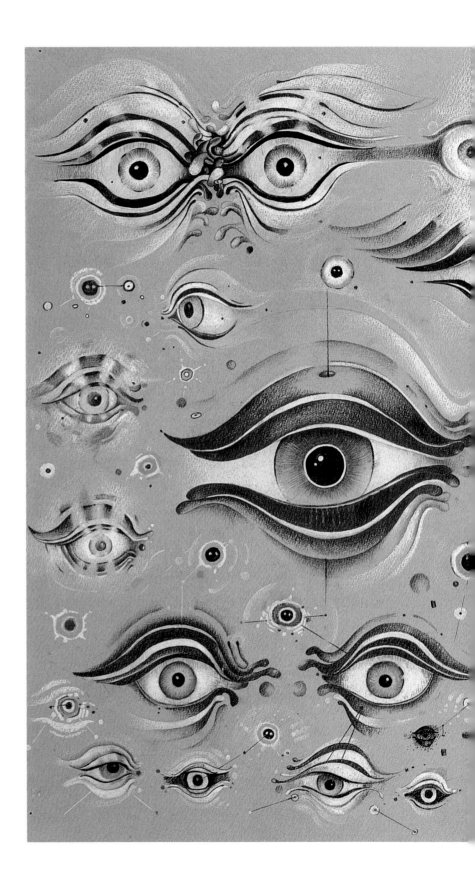

Plate 133
1989

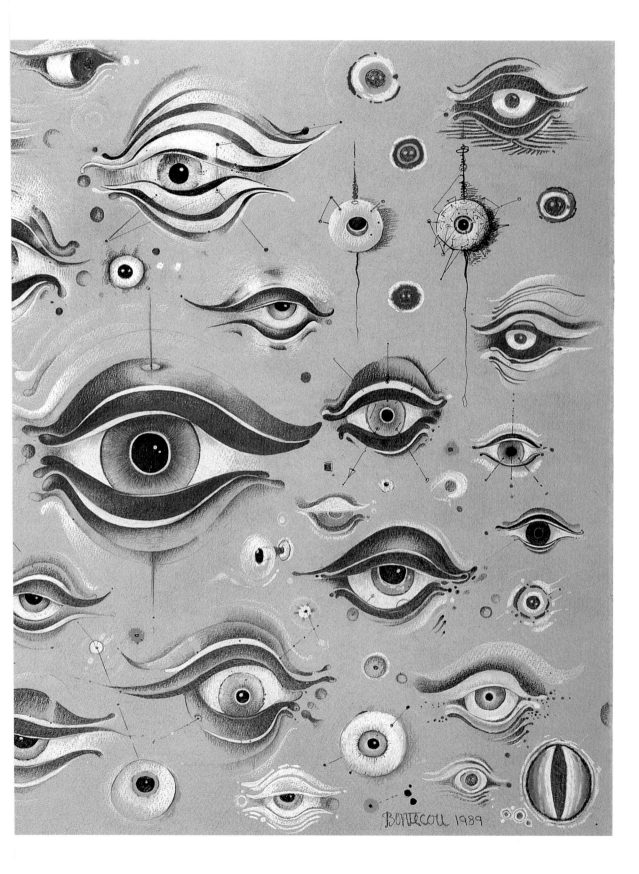

BONTECOU 1989

Plate 136
1993

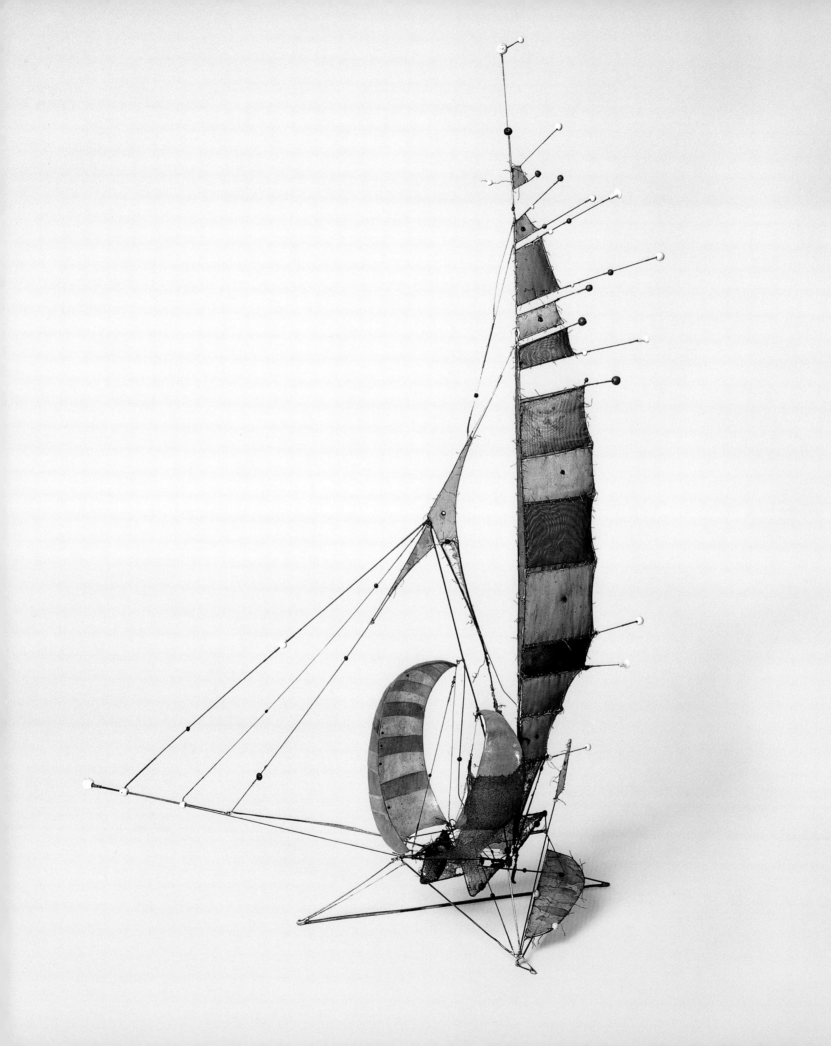

Plate 137
1993

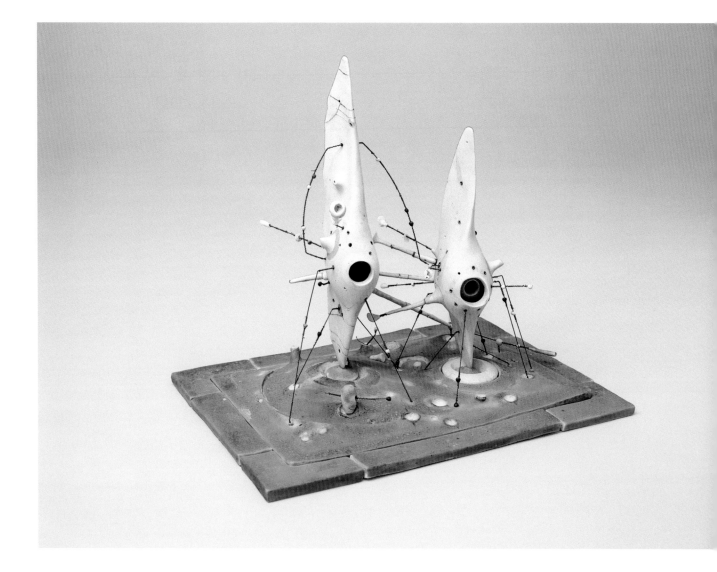

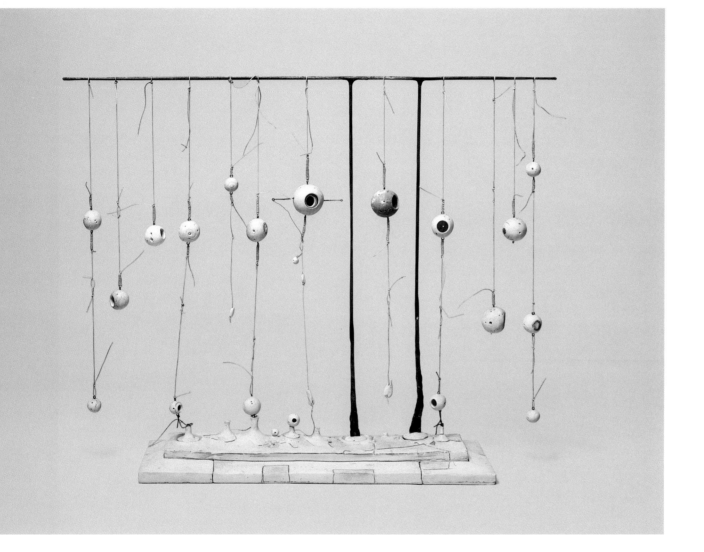

Plate 138
1994

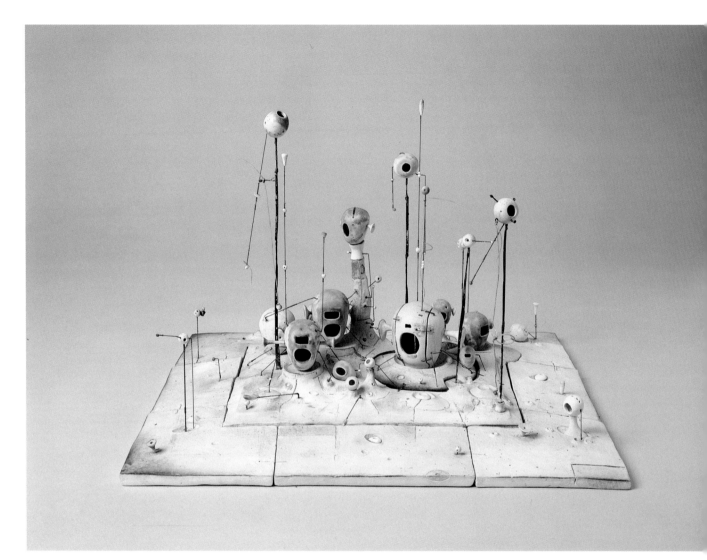

Plate 139
1994

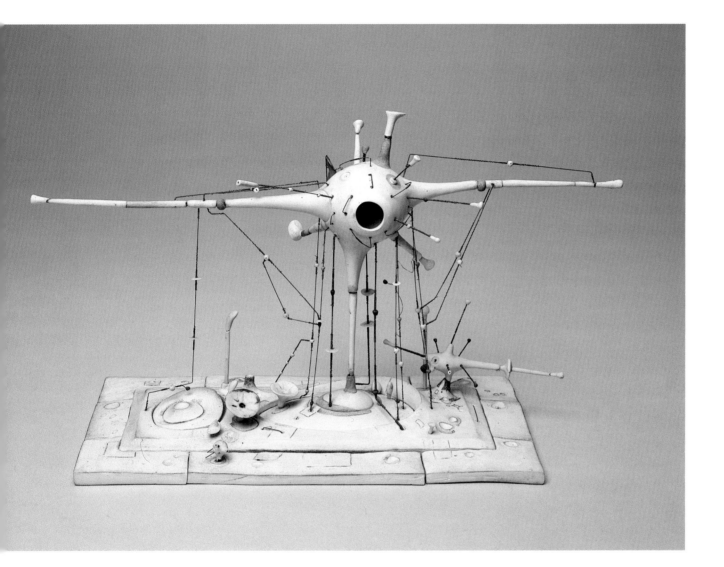

Plate 140
1993

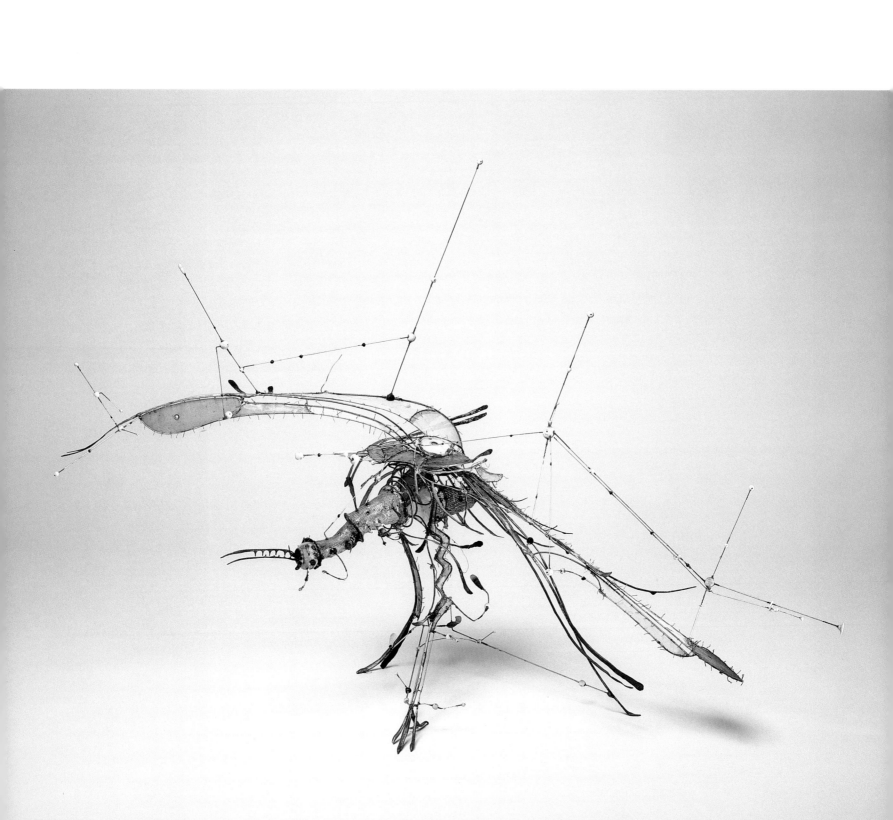

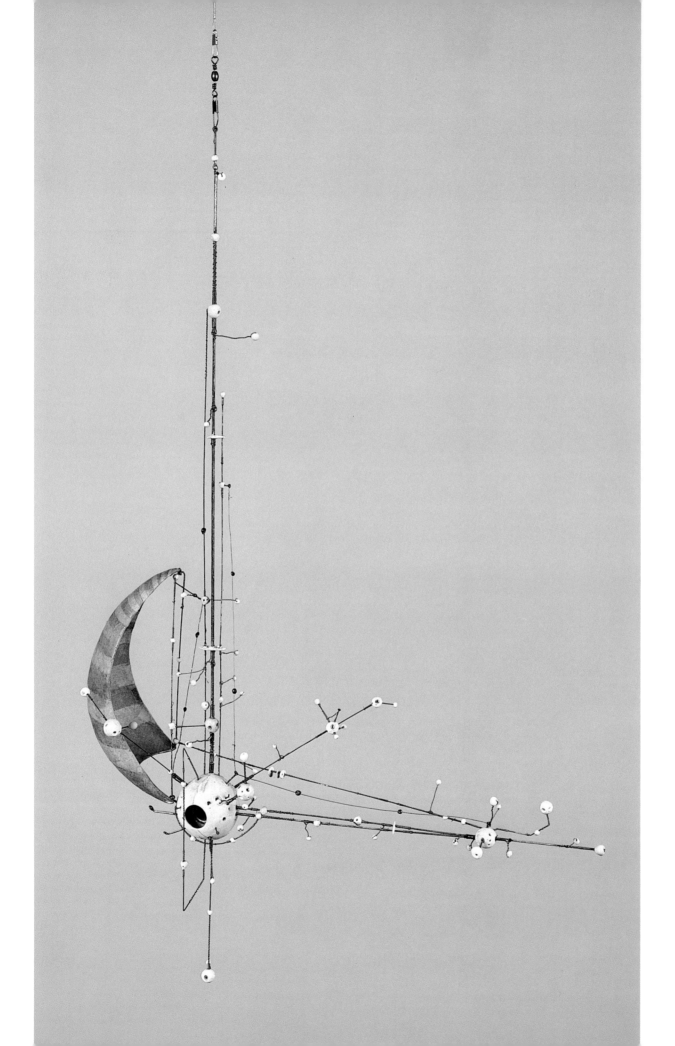

Plate 142
1994

OPPOSITE

Plate 141
1994

Plate 143
1995

OPPOSITE
Plate 144
1995

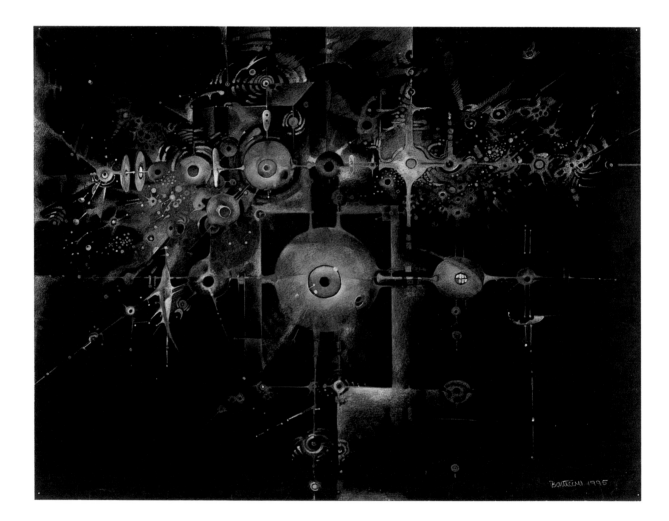

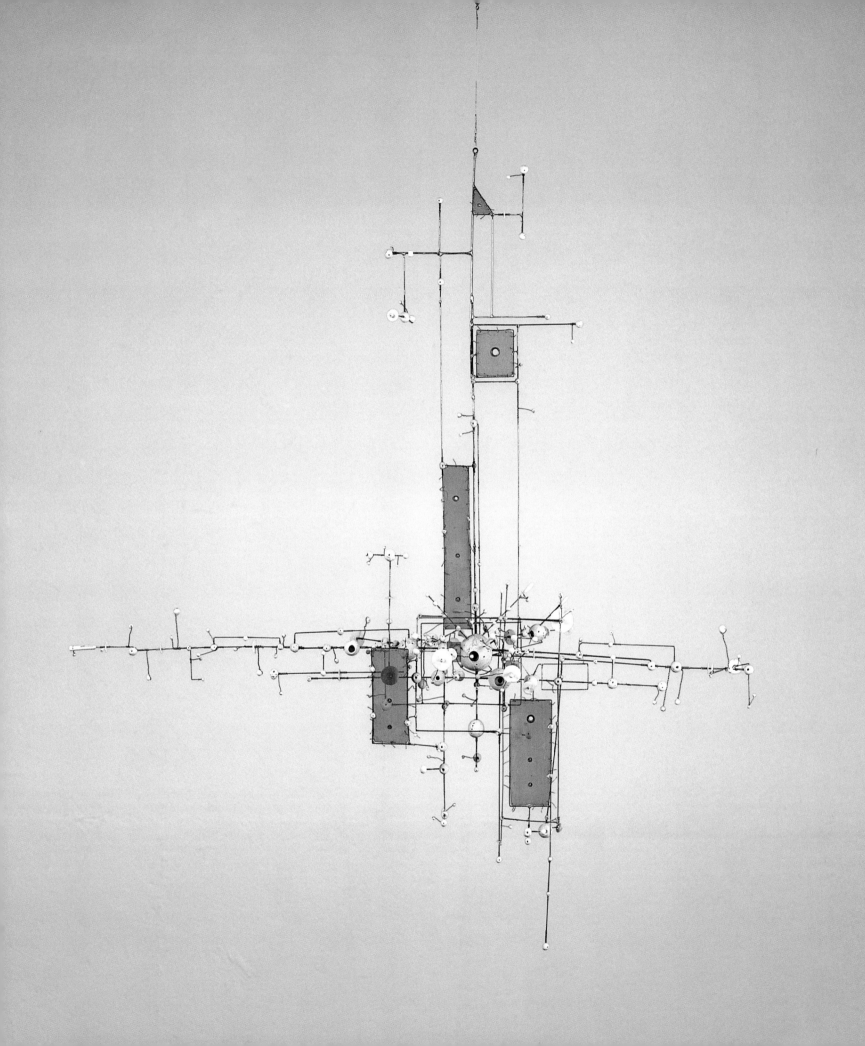

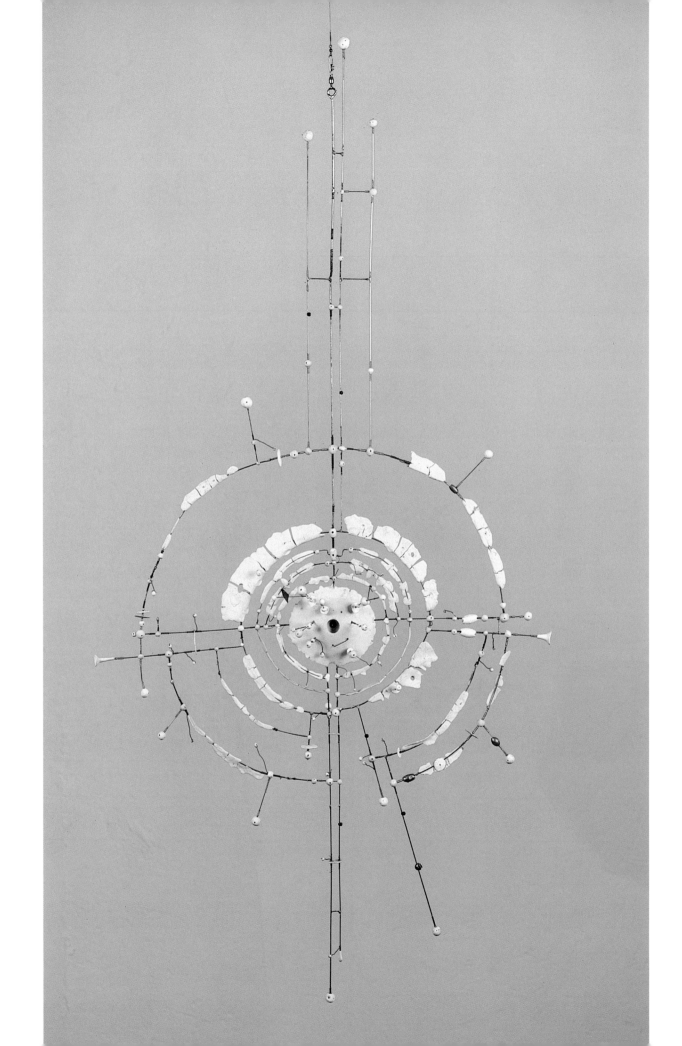

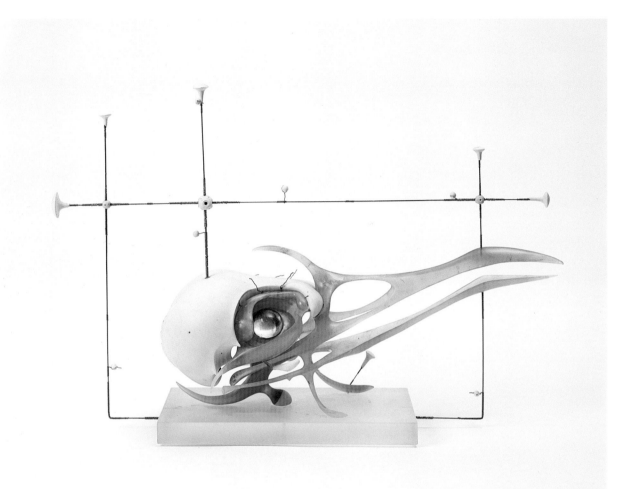

Plate 146
1986—2002

OPPOSITE

Plate 145
1986—1995

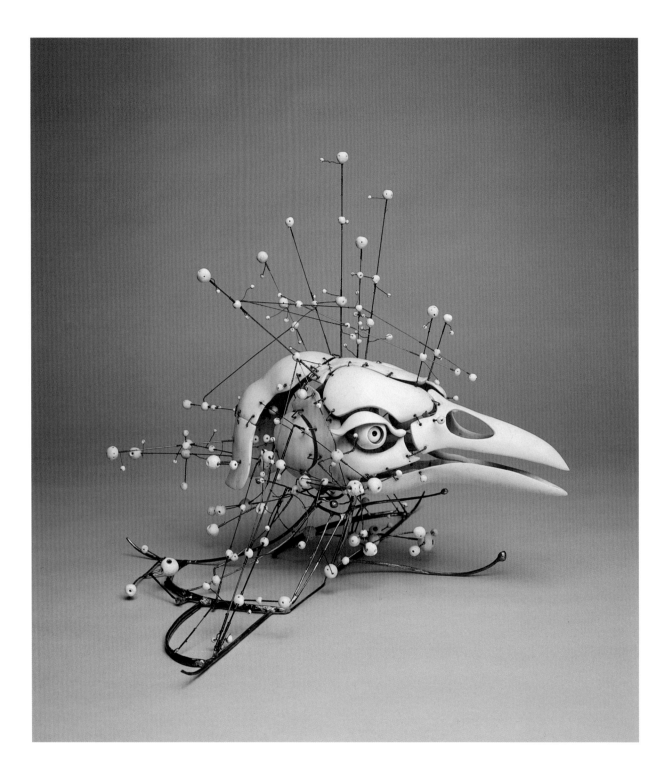

Plate 147
1986–2002

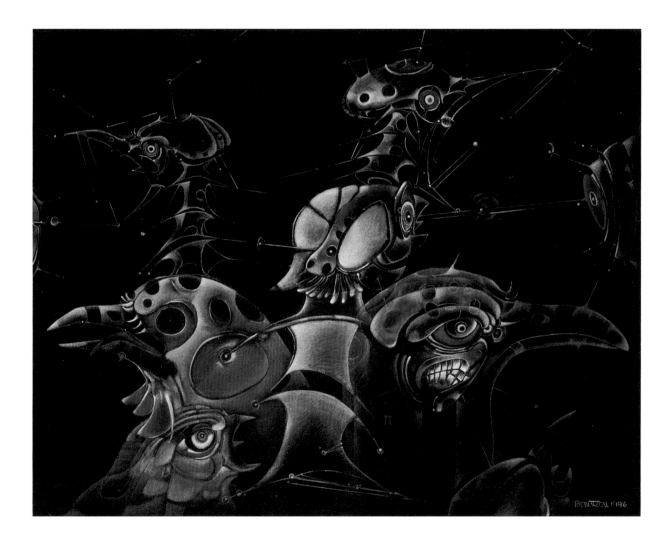

Plate 148
1996

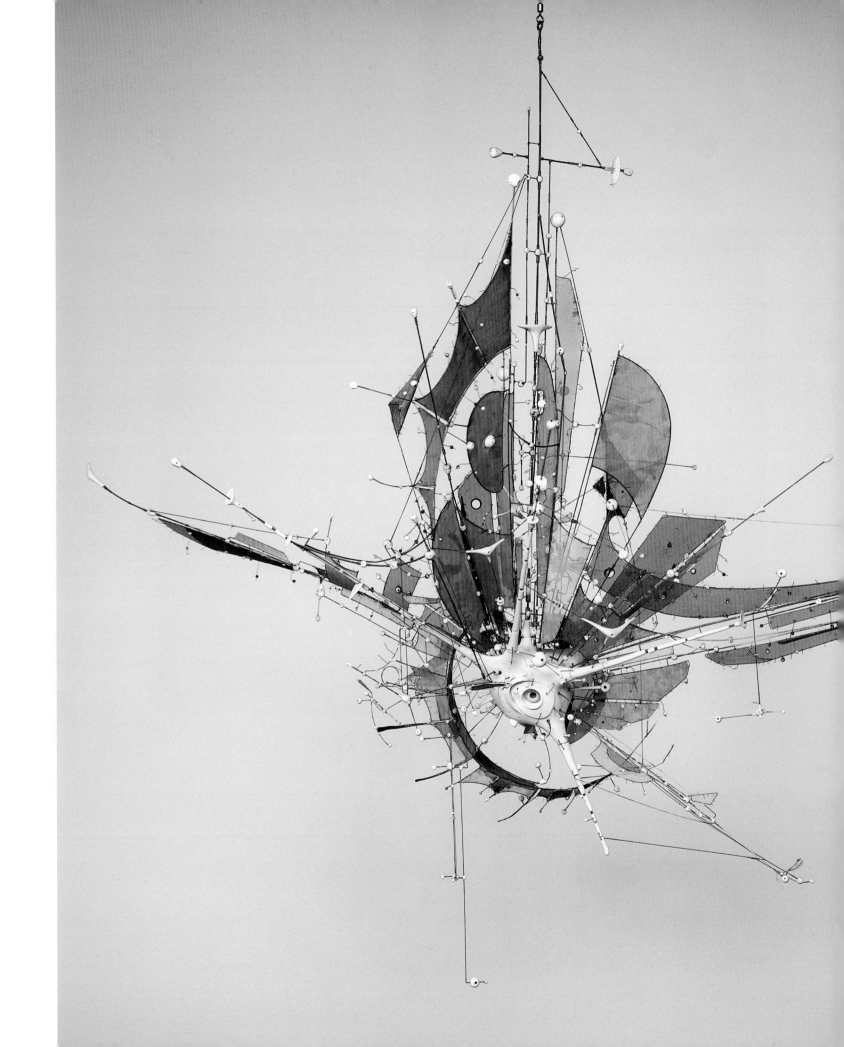

Plate 149
1996

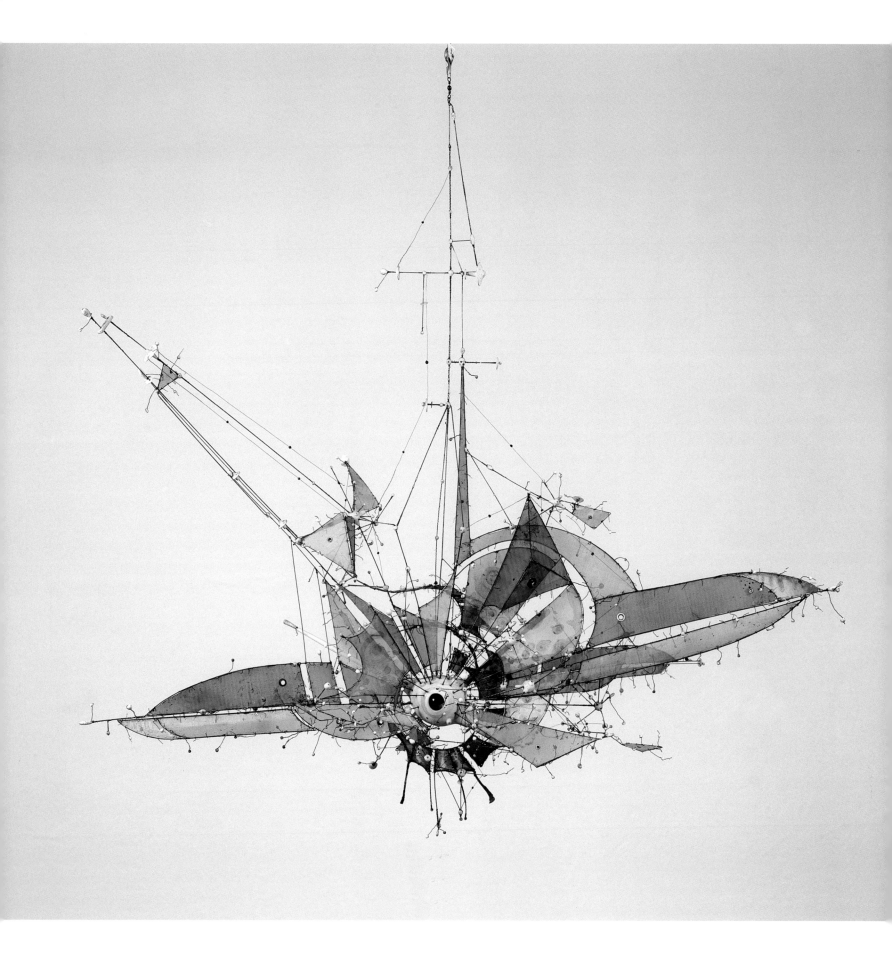

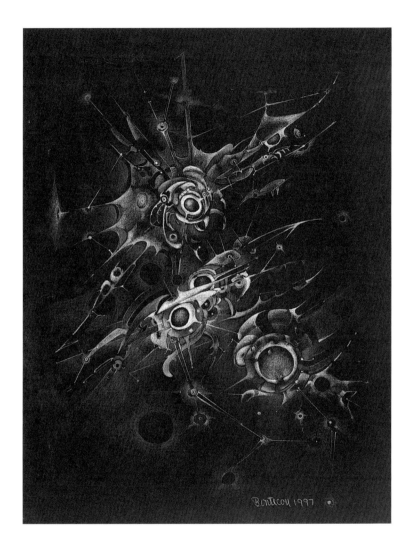

Plate 151
1997

OPPOSITE

Plate 150
1996

Plate 154
1997

OPPOSITE

Plate 155
1997

Plate 156
1997

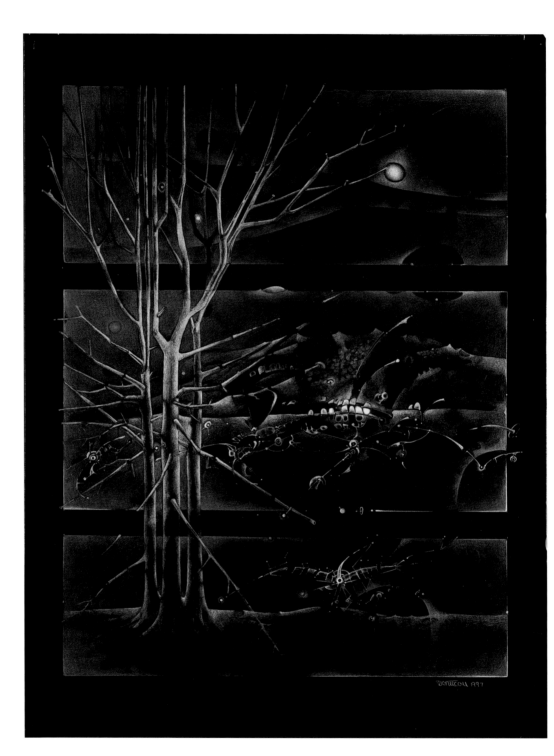

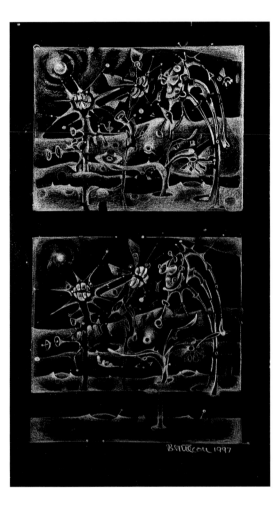

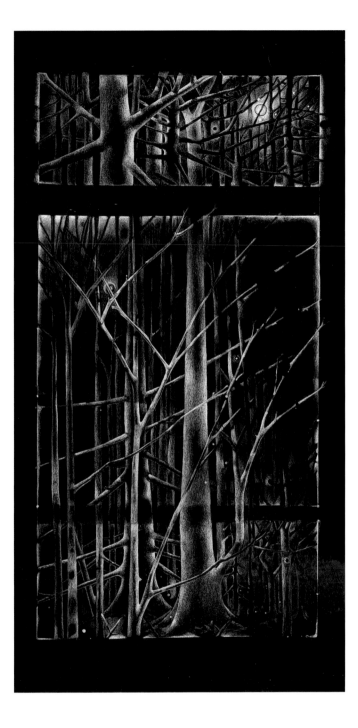

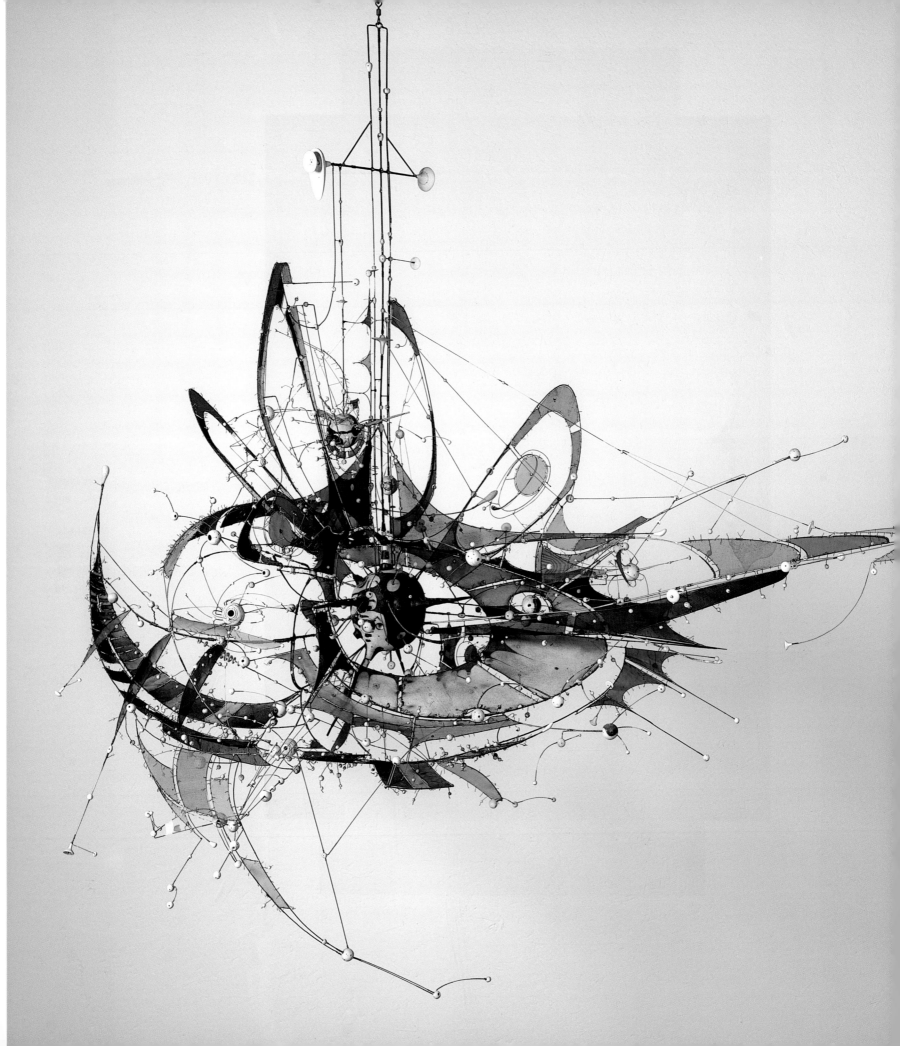

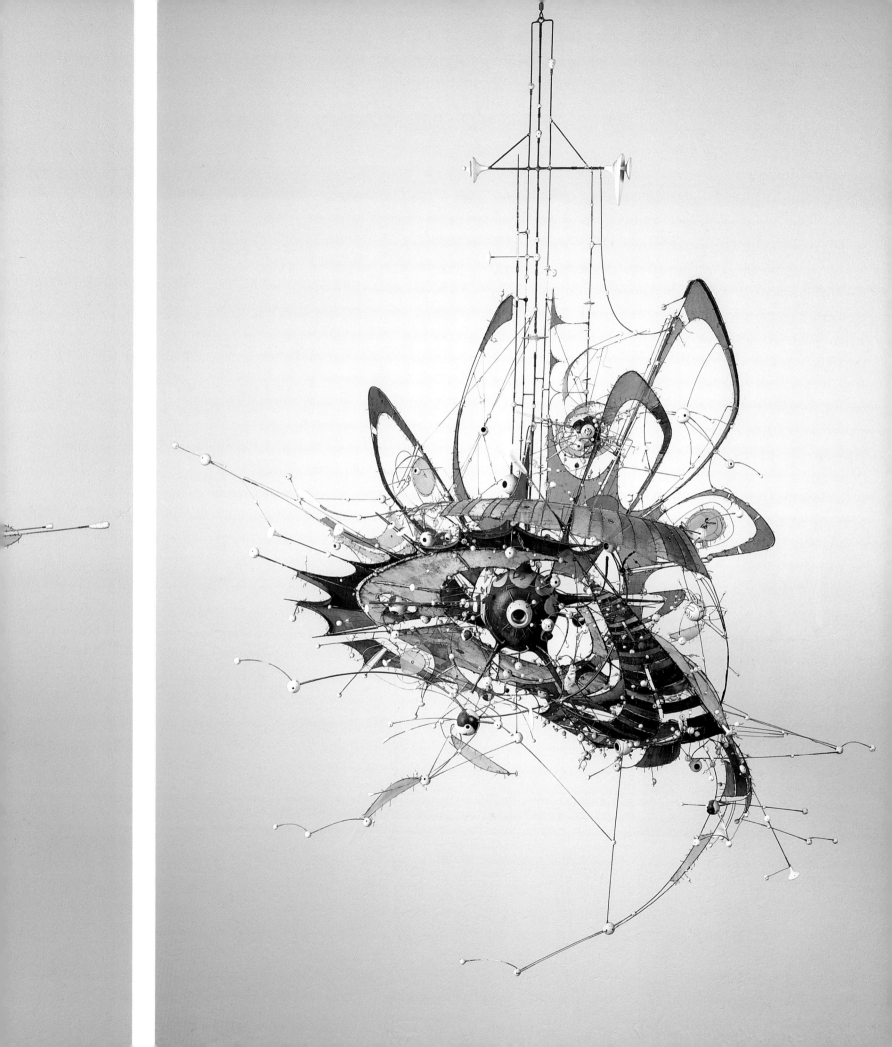

Plate 162
1999

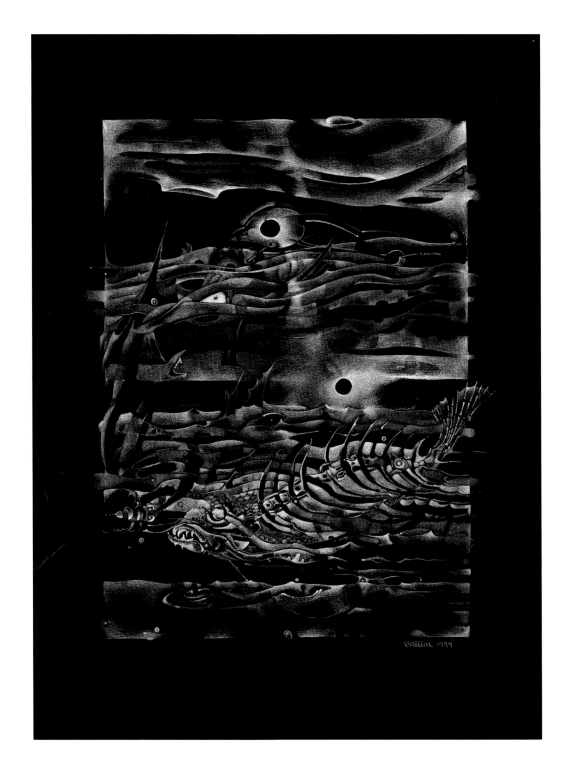

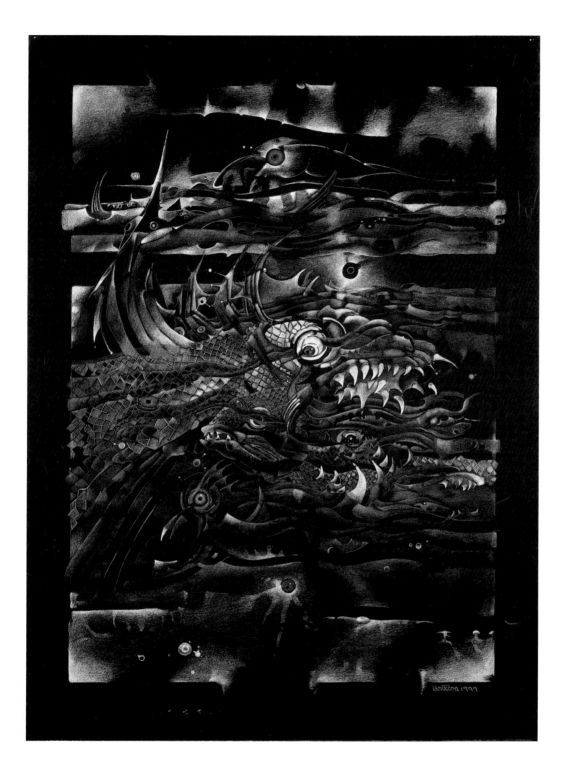

Plate 163
1999

Plate 164
1999

Plate 165
1990–2000

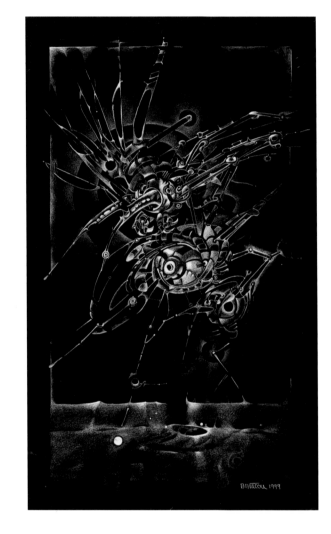

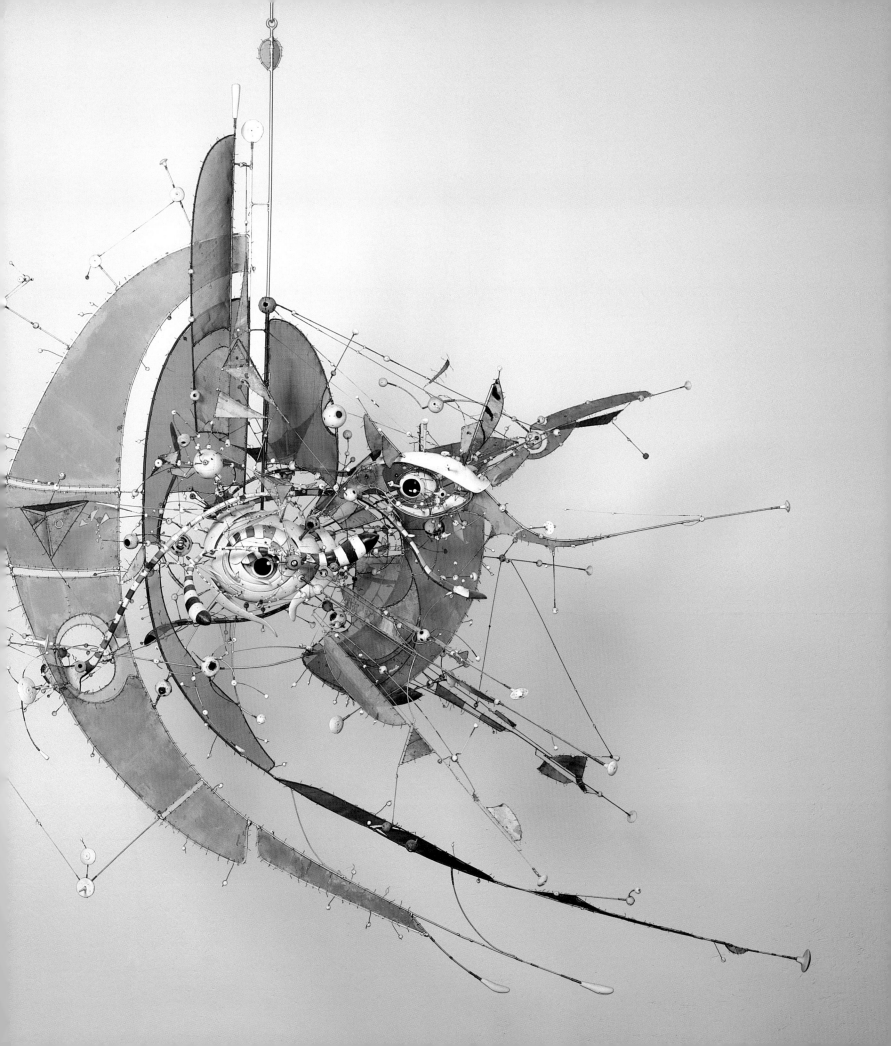

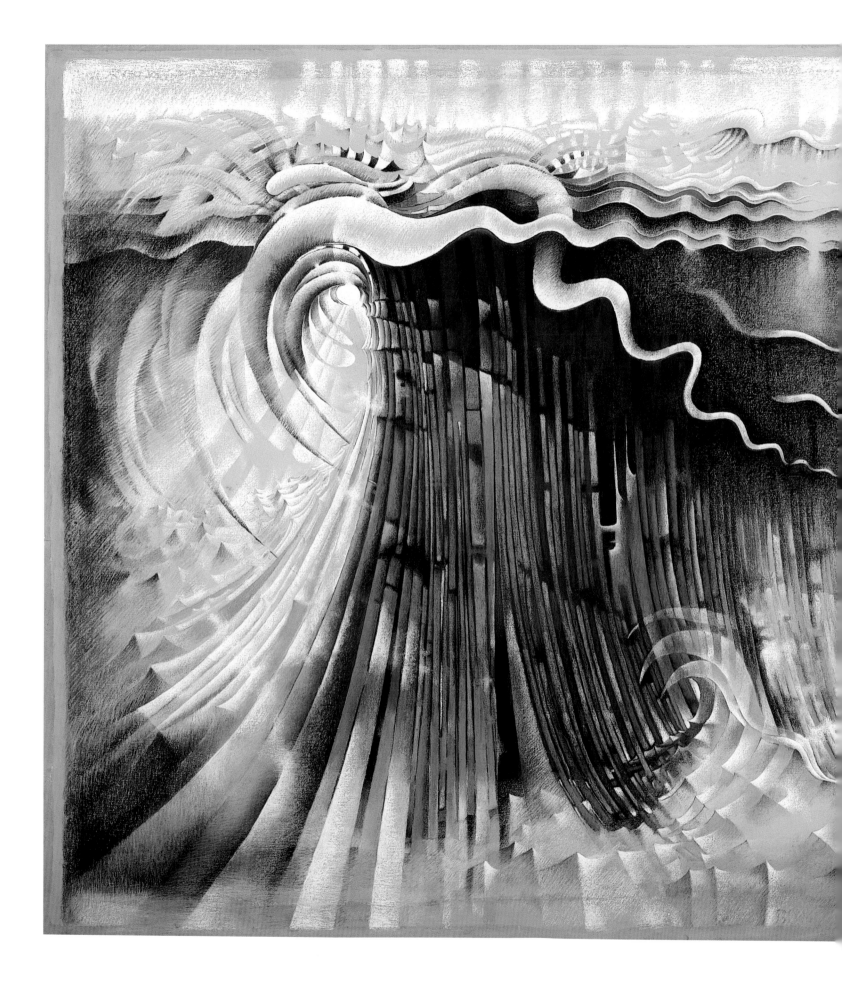

Plate 166
1985–2001

Plate 167
2001

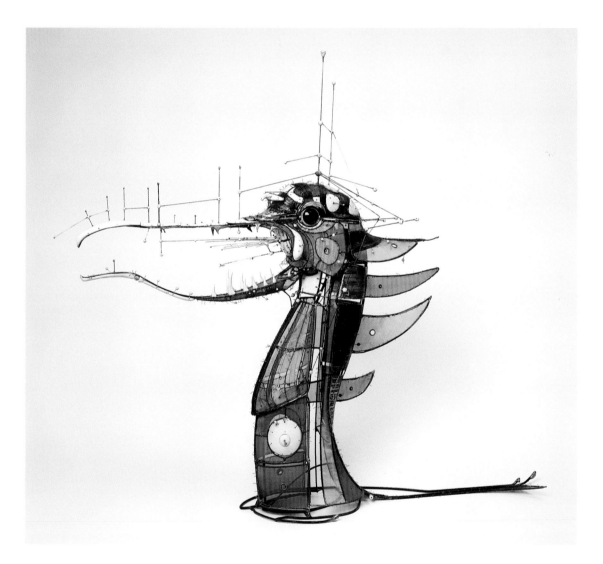

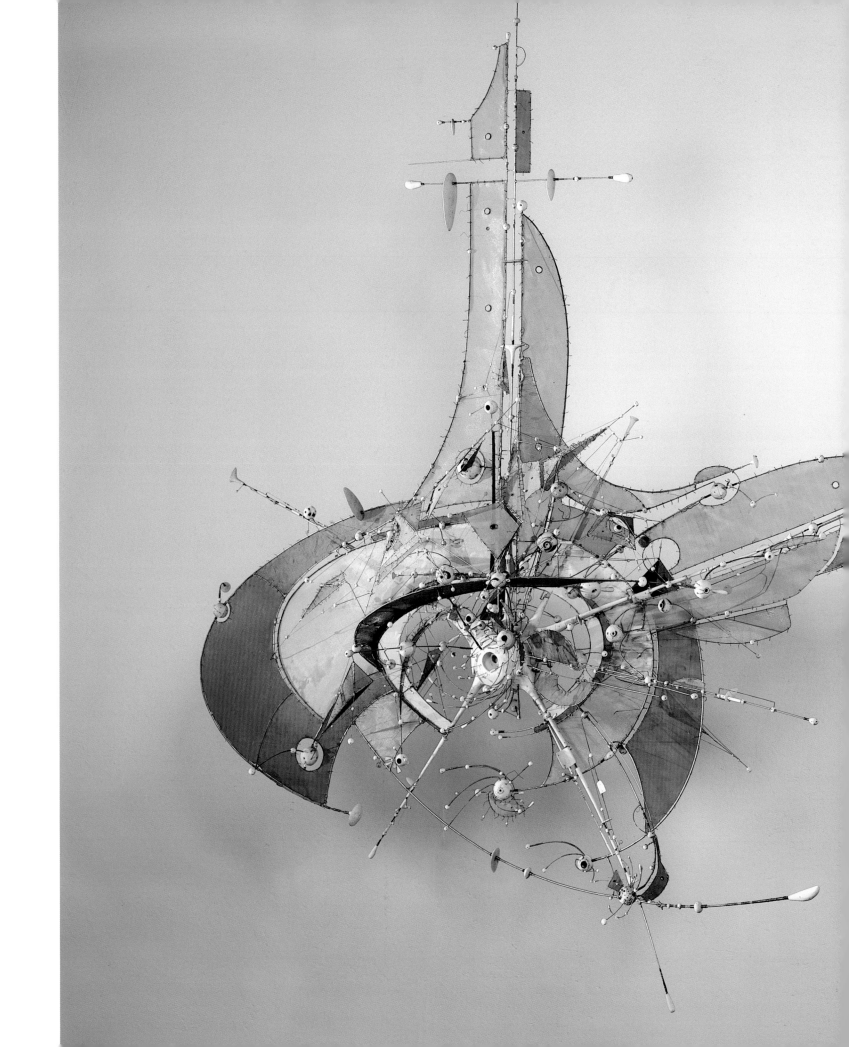

Plate 168
c. 1980–2001

All Freedom
in Every Sense

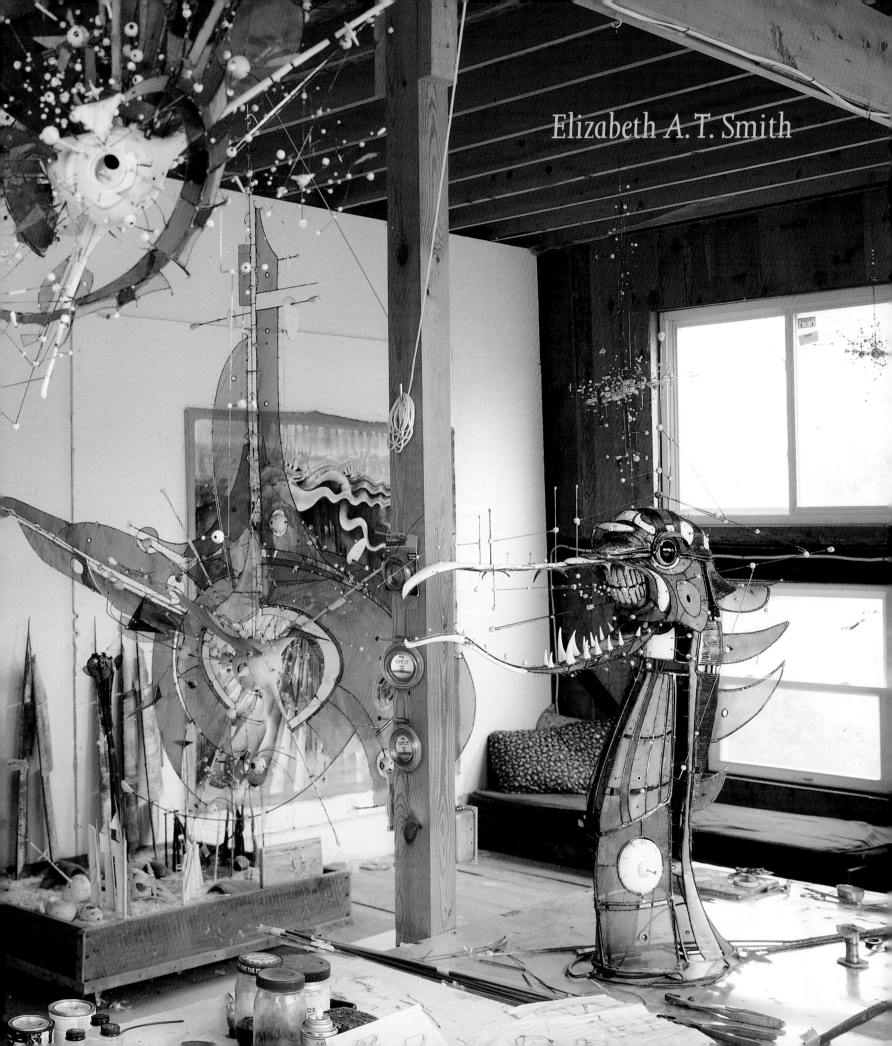

Elizabeth A. T. Smith

One of the few women artists to achieve broad recognition in the 1960s, Lee Bontecou created a strikingly original body of work in sculpture beginning in the late 1950s and continuing to the present. She has also made a substantial corpus of work in drawing, much of which is closely related to the ideas and imagery in her sculpture. The work for which she is best known, made between 1959 and approximately 1967 — wall-mounted, three-dimensional objects in which geometric fragments of canvas and other materials are stretched over and fastened onto welded metal framework — reveals an astoundingly rich spectrum of visual detail in cubist form. At times heroically scaled and other times intimate, her predominantly abstract work has consistently incorporated an array of figurative, organic, and mechanistic references that suggest various states of transformation between the natural and the man-made.

Artist-critic Donald Judd, writing about Bontecou's work in 1965, remarked on its ability to encompass "something as social as war to something as private as sex, making one an aspect of the other."[1] Despite his overriding

fascination with the powerful objecthood and materiality of Bontecou's sculpture, Judd could not help but point to its allusive qualities. The distinctive sensibility and highly personal vocabulary of forms and images in Bontecou's work have distinguished it even at points where it has coincided with directions explored by her contemporaries or resonated with the concerns and approaches of artists of a younger generation. As poet Tony Towle commented in 1971,

> Her work is always a synthesis, whether the general feeling is organic, that is the existence of living things; the enormity of space, its countless other planets and stars; our comparatively recent mechanical inventions; or the future ("in a positive and a negative way"). The qualities of these enormous subjects are distilled in Lee's work, then evoked strongly in the spectator. Specific situations of our existence, sex and violence, for example, the two that spring readily to my postwar mind, are always there, but only as a part of the general mystery of things. Her art is finally and irreducibly mysterious.[2]

While historians and critics have interpreted Bontecou's work in relation to various movements and artistic directions, ranging from feminist art to aspects of minimalism and postminimalism to a latter-day manifestation of surrealism, it has consistently eluded direct identification with any of these. Bontecou's approach has always been independent from affiliation with any particular artworld movement or community. Stressing the idea of freedom, she has staunchly resisted many of the interpretations

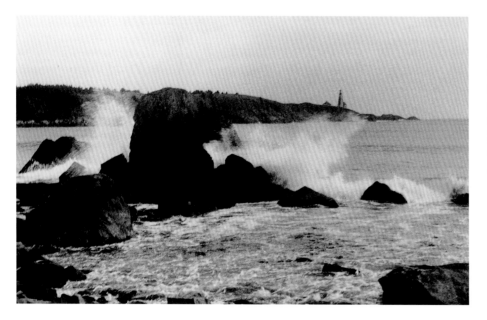

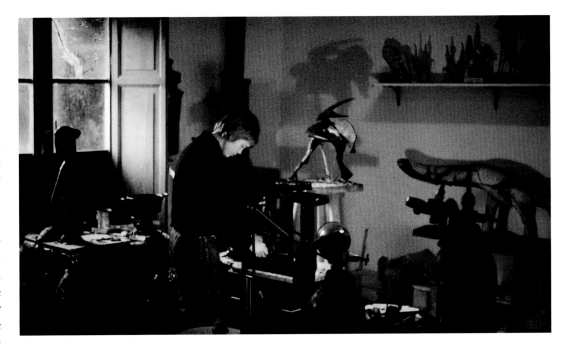

and readings that have been imposed on her work, especially her signature pieces of the early and mid-1960s. She has maintained that her greatest preoccupation as an artist has been to encompass "as much of life as possible — no barriers — no boundaries — all freedom in every sense."[3]

Born in 1931 in Providence, Rhode Island, and raised in Westchester County, New York, Bontecou grew up in a family with an inventive sensibility that undeniably influenced her development as an artist. Her father and uncle invented the first all-aluminum canoe, while her mother worked in a factory wiring submarine transmitters during World War II. Bontecou grew up with the feeling that she could make or do anything she set her mind to as long as she absorbed the necessary technical skills.[4] Her mother's Canadian roots led the family to spend summers in Nova Scotia, which fostered in Bontecou the seeds for a lifelong love of and fascination with nature, especially marine life.

After studying at Bradford College in Bradford, Massachusetts, Bontecou attended the Art Students League in New York from 1952 to 1955. Trained in academic painting techniques at the League, she later began studying sculpture under William Zorach, making a group of abstracted figurative works that reflected his approach to subject matter. Bontecou described the League as a place to work from models and to receive a good academic and technical foundation, as well as a place where she learned from other students. She spent the summer of 1954 at the Skowhegan School in Maine, where she continued to experiment with figurative sculpture and to pursue and define her artistic identity. That summer she also learned welding, a departure from the materials of plaster, clay, and cement with which she had worked at the League. She recalls her most memorable experiment as a thirteen-foot-high welded cast iron sculpture of an abstracted male figure she completed while standing atop a car.

Winner of a Fulbright scholarship in 1956, Bontecou spent the academic year 1956–57 in Rome, and stayed there until 1958. Focusing intently on the development of her sculpture, she periodically traveled around the country to view artworks and monuments but was especially impressed by the city itself — its architectural character and the aesthetic unity of its piazzas. Continuing to work in a vein of abstracted figuration, she increasingly turned to animal forms, a number of which she created in terracotta over a welded frame with wire mesh as well as in lost-wax bronze. These animals, many of them birds, were often quite large and highly cubist, revealing a different demeanor from each angle and composed as if the forms had been flayed, then laid flat and recomposed. Bearing some resemblance to the welding of Julio González, an artist Bontecou admired, these early sculptures were crude and vigorous, anticipating the direction and character of her subsequent work. She also began to experiment with drawing, creating a group of works whose weblike linearity seemed to correspond to the structures underneath the terracotta surfaces of her sculptures. While in Italy, Bontecou first began to exhibit her work, with pieces included in the exhibition *Sculture nelle città* in the Festival of Two Worlds in Spoleto in 1957.

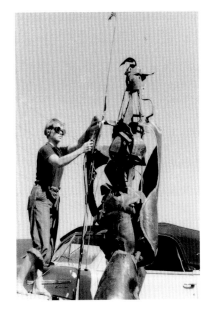

ABOVE

Bontecou in her Rome studio, 1958
Photograph by Jack Evans

LEFT

Bontecou in Skowhegan, Maine, 1954

Upon her return to New York, Bontecou had a solo exhibition at the G Gallery, presenting a number of the sculptures she had made while in Italy alongside some earlier pieces from her days at the Art Students League. Having moved into a Lower East Side loft on Avenue C, which Bontecou describes as "an old New York street of pushcarts, hustlers, thieves, street vendors, and mostly hardworking people," she found a harmonious and exciting working environment. She commented how, during the mid- and late 1950s, "the individual freedom inherent in abstract expressionism energized and electrified the art world, particularly [the abstract expressionists'] dual use of paint itself as both subject and object. It was from their spirit of individual expression the following generations would be influenced." It was in this

ambience of individual experimentation that Bontecou thrived. While some artists had earlier frequented such gathering spots as the Cedar Bar, which had been a mainstay of the abstract expressionist group, Bontecou preferred to work quietly in her loft, staying apart from the social life of this artist community, except for occasional outings with a small coterie of friends. She also enjoyed gallery hopping, and several times attended the Judson Church and other places where artists gathered for events and happenings. She described being drawn to the looseness, freedom, and sense of absurdity that characterized these performative events.[5]

Around this time an important breakthrough occurred in Bontecou's sculpture. While working on a drawing in Rome, she had found that the blowtorch—a tool she used

for welding—created a dispersal of rich black soot directly onto paper when the oxygen was turned off. Back in New York, she began using this technique to make a number of drawings, some at very large scale. She appreciated the velvety richness the soot created when she moved the torch rapidly across paper or canvas. At the same time, while experimenting with ways to move away from the naturalistic references she had previously employed in her sculpture, Bontecou arrived at the idea of creating lightweight welded frameworks resembling boxes and infilling them with wire mesh, canvas, and muslin. Within some of these transparent frames she built additional chambers, making objects with an uncanny resemblance to large-format cameras. In others she began to stretch pieces of canvas across the surfaces of the frames like skin, fastening them in place with small pieces of twisted wire. The resulting objects, while primarily geometric in form, resembled rough-hewn machines with a curiously handmade presence.

Bontecou's use of welding in creating her sculptural forms set the direction of the work she continued to make throughout

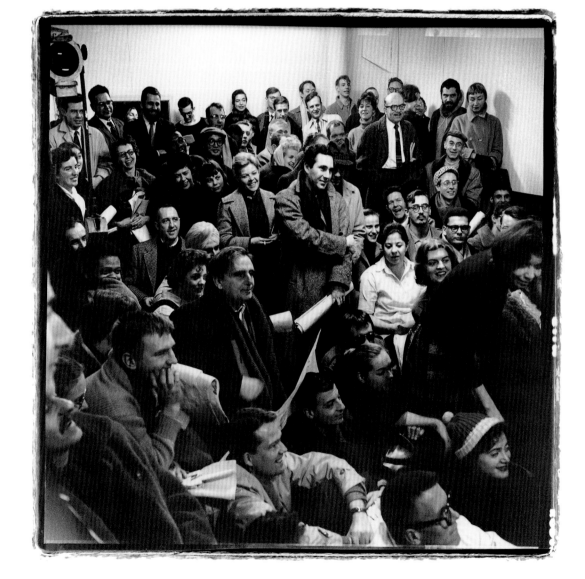

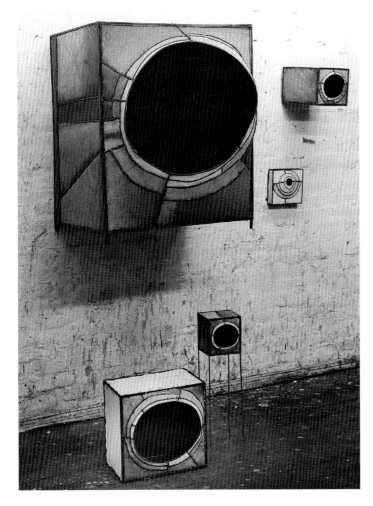

much of the 1960s. Welding enabled her to make the pieces increasingly large in scale and to lift them off the floor and onto the wall, liberating her further to manipulate the surfaces and infill of each work. Through trial and error she learned that lightweight materials were necessary to accomplish the composition she desired and she began using found materials. The location of her studio yielded a variety of items that she scavenged or purchased cheaply — laundry bags and canvas conveyor belts acquired from the owner of the laundry directly underneath her loft, metal bolts, gears, war helmets, shrapnel, knapsacks and an abundance of army surplus items, rope, and various other detritus found on Canal Street. In these cast-off materials she, like other artists of her generation influenced by what she calls the "real paint" of abstract expressionism, found a kind of rough poetry; yet her interest lay primarily in their form and compositional possibilities.

Developing compositions of increasing sophistication, Bontecou vacillated between works that were large and small, simple and complex. All were three-dimensional, some vigorously so. Cutting canvas into pieces and then affixing it to welded metal frames allowed her to break and manipulate the flatness of the surfaces and to impart a painterly sense of illusion and depth. A large circular opening, often irregular in shape, began to recur in her sculpture as an overarching motif projecting from the surface of the work itself and framing the opening of a dark, receding inset. By producing the inset either with black paint or by using pieces of dark velveteen, she created a sensation of depth and a suggestion of mystery, a blackness into which one could figuratively sink or enter.

In 1960 Bontecou was featured in a solo exhibition at Leo Castelli Gallery, where her work provoked extensive interest on the part of critics, collectors, and museum curators. An avalanche of publicity followed. *Art in America* included her in the "New Talent" issue of 1960, and she was profiled in popular magazines ranging from *Time* and *Life* to *Vogue*, *Mademoiselle*, and *Cosmopolitan*. As much as the arresting character of her sculptures, Bontecou's gender prompted much attention at this early stage of her career. Many writers commented on her diminutive size and youthful appearance as being incongruous with "the imposing scale and the intense implied violence in her dark and threatening reliefs."[6] Addressing the iconography of Bontecou's work, numerous critics read the imagery of her sculptures, particularly the dark circular projecting openings, as mouths or vaginas, which promoted an array of negative associations such as "menacing," "terrifying," and even "pain-inflicting" — terms frequently employed in discussions of her work.[7]

Taking issue with these interpretations of her sculpture either as products of an angry protofeminism or as "visual metaphors of the secrets and complications of the eternal Eve,"[8] Bontecou has consistently emphasized that her intention in the use of blackened voids as an integral and compelling element within her sculpture was to evoke mystery and a range of

LEFT

Installation in Bontecou's studio at Avenue C and Sixth Street, New York, 1959

BELOW

Bontecou in her Rome studio, 1958 Photograph by Jack Evans

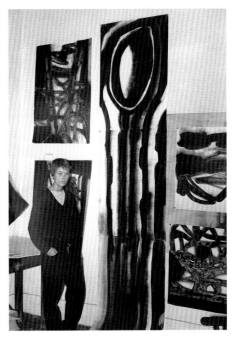

emotive responses to the unknown, the wondrous, and the sublime. At the same time, her work also refers to the underbelly of human nature, encompassing fear, violence, brutality, and war. As a young artist at work in the late 1950s, she was fascinated with the scientific and technological advances surrounding exploration of outer space. She wrote, "At one time I had a joy and excitement about outer space — nothing was known about the black holes — just huge, intangable dangerous, entities, and I felt great excitement when little Sputnik flew."[9]

Art historian Dore Ashton was one of the few writers who, throughout the 1960s, stressed the ambivalent and encompassing range of meaning in Bontecou's imagery. In an essay first published in 1963, she noted:

In this image-making prowess there is an originality that would be difficult to define in the logic of language, an originality in a quite literal sense: one is absorbed by the reigning image and knows instinctively that it had its origin deep in the artist's psyche. . . . The reigning image is the black tunneled hole central to anything Bontecou undertakes. This cavity bores deep and is, to my mind, far more significant than the obvious sexual connotations so often invoked for her work. . . . In contemplating the black vacant centers with their tiers of protective shelves, the mind could just as easily go to wells, tunnels, sequestered and mysterious places that are not necessarily menacing. The circularity of Bontecou's central shapes can be seen as an inspired evocation of a deep-seated human hunger of the axis mundi, the central point around which the cosmos circulates. . . . Not that Bontecou intends to relay a cosmic insight . . . but the intensity of her expression and the currents of authenticity that one feels so strongly lead one to sense for a moment the depth and inexpressible sources of her imagery.[10]

More recently, art historian Mona Hadler has convincingly likened Bontecou's persistent use of the dark crater-like void to that of a "heart of darkness," referring to the novel of the same title by Joseph Conrad to underscore the simultaneity of formal power and social message emanating from Bontecou's sculpture.[11] Indeed, the impetus behind much of her early work was the desire to respond to the menacing specter of global destruction in the Cold War era. In a statement published in the catalogue of The Museum of Modern Art's 1963 exhibition *Americans*, Bontecou said that her goal was to "build things that express our relation to this country — to other countries — to this world — to other worlds — in terms of myself. To glimpse some of the fear, hope, ugliness, beauty, and mystery that exists in all of us and which hangs over all the young people today."[12] She would often work in her loft while listening to short wave radio news broadcasts that fueled her sense of anger and frustration with world events, including violent conflicts in Africa and the outbreak of war in other parts of the world.

Early in her career, Bontecou's fiercely individualistic work began to be grouped by historians, critics, and curators with that of other sculptors who used conjoined parts — whether fabricated or welded — to create abstract or semi-abstract work. Yet Bontecou maintains that her sculpture was in uneasy company with that of other artists; despite her unconventional technique, she intended her sculptures to function in a classical way — as compositions in which subtleties of depth and illusion were paramount, almost painterly in their demeanor. In recent correspondence Bontecou wrote, "The closest parallel between my work and that of another artist during those years was with William Giles, now my husband, who was then as now a rebellious art maverick, whose dedication to total freedom is even greater than mine."[13]

Throughout the early 1960s Bontecou's work evolved with ever-greater complexity as she continued her formal experimentation. References to airplanes, the wings of birds, and other anthropomorphic and mechanomorphic elements began to reverberate more evidently within her sculpture and in numerous drawings. Detailed images of insects, helmets, tornadoes, and a host of other naturalistic references often metamorphose or transmute into mechanical imagery or abstraction in these works. Sculptor Tom Doyle has described how Bontecou made model airplanes, an activity that fueled her interest in incorporating similar forms within her sculpture; she had been

fascinated by airplanes since childhood and later marveled at the way they were built and engineered.[14] In an interview she commented, "I used to like to sit over the wing so you could see the propeller going as well as the jet part, and you could see the wing area and how it was all riveted together. You felt that incredible force. It would just about make my imagination go out of bounds."[15] She recalls how a decade later, while flying with her husband in his helicopter over the mountains of Pennsylvania, she often felt that force, which similarly caused her imagination to soar.

Bontecou's largest work to date — a 1964 sculpture for the entry hall of the New York State Theater at Lincoln Center (plate 61) — revealed the confluence of her aeronautic and avian interests. In this monumental sculpture she combined her characteristic canvas and welded metal framework with substantial areas of epoxy and actual airplane parts including the Plexiglas part of a canopy from a World War II aircraft, prompting *Life* magazine to headline its article on the work: "It's Art — But Will It Fly?"[16] She composed this expansive, winglike form in such a way that at first glance it appears almost perfectly symmetrical, but upon closer inspection reveals subtle asymmetry and passages of intriguing detail. Philip Johnson, the building's architect, described this work as so well-suited to the architecture of its setting that it resembled "a baroque statue in the niche of a baroque hall."[17]

By this time Bontecou had participated in a number of important group exhibitions nationally and internationally, including the 1961 São Paulo Bienal; *Americans 1963* at The Museum of Modern Art, New York; and the Corcoran Biennial, Washington, D.C., 1963; as well as the 1964 shows *Recent American Sculpture* at The Jewish Museum, New York; *New American Sculpture* at the Pasadena Art Museum in California; and *Documenta III* in Kassel, Germany, where she was one of only a very few women exhibitors. Over the next few years she continued to exhibit widely in Europe, with a show at Galerie Ileana Sonnabend in Paris

in 1965 and a survey exhibition of her work in 1968 that toured to the Stadtisches Museum, Leverkusen, Germany; the Museum Boijmans Van Beuningen, Rotterdam; and the Kunstverein in Berlin.

While these exhibitions primarily featured her sculpture, Bontecou also experimented with printmaking in 1963–64, creating a series of works at Universal Limited Art Editions (ULAE) at the invitation of its director. This series of lithographs, titled *First Stone* to *Thirteenth Stone,* was published along with text by Tony Towle. Towle also conducted two penetrating interviews with Bontecou in 1970 and 1971 that are among the few published documents in which she discusses her working process.[18] In these interviews she commented on the interconnectedness of her early drawings to the imagery of lithographs and etchings and to sculpture, as well as her process of going back and forth between drawing and sculpture. She also described the impetus for many of her pieces as the creation of "worldscapes," indicating the range of her visual and scientific interests in plants, airplanes and jets, and space exploration — both her early enthusiasm and her later disillusionment with it — as well as the art of earlier, non-Western cultures. While in Italy, for instance, she had encountered the work of the Etruscans, which she found particularly striking and compelling in its expressiveness.

Bontecou in her Wooster Street studio, New York, 1963 Photograph by Ugo Mulas

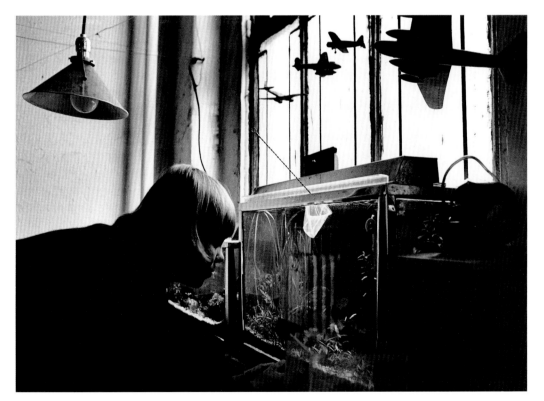

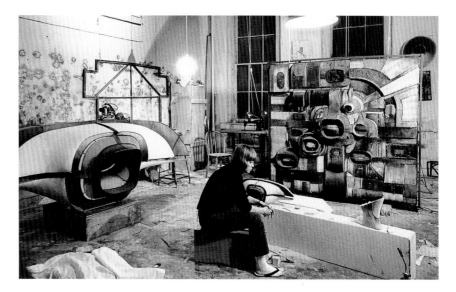

In 1965 Bontecou and William Giles moved to Greene Street where they lived together in his loft while Lee continued to work in her loft on Wooster Street. Bontecou's circle of artist friends included Bernice Epstein, Don and Pat Eaton, John Nesbitt and Ann Richardson, Harry and Clair Tobey, Jack Beal and Sondra Freckelton, Wilhelmina Van Ness, Doc and Spike Groupe, and Marilyn Roselius and Brian Maughn, her friends from the Art Students League, Brooklyn College associates and students, and acquaintances such as Joseph Cornell, Yves Klein, and Jean Tinguely. She had become personally acquainted with Cornell in the early 1960s, responding with interest to the magical and mysterious worlds he created within his intimate boxes. At one point she visited him in his home at Utopia Parkway; Cornell referred to Bontecou several times in his diaries of the period.[19] To the younger artist Eva Hesse, Bontecou's work was also deeply engaging. She wrote of Bontecou in 1965, "I am amazed at what that woman can do. . . . This was the unveiling to me of what can be done . . . the complexity of her structures, what is involved, absolutely floored me."[20] Furthermore, Hesse could not have failed to discern that Bontecou's work, as that of a woman artist, was achieving such acclaim and renown in the art world. In addition, Donald Judd eloquently championed Bontecou's work in his reviews and essays from 1960 through 1965 and, although they did not know each other personally very well, Judd's writings evince the highest respect for her approach and achievement, a barometer of the strong impact of her work on many of her contemporaries who were also pursuing new directions in the making of art, especially sculpture.[21]

Around the middle of the 1960s Bontecou began to shift the direction of her sculpture. A group of works made from painted metal with insets of industrial saw blades are part of a series she referred to as *Prisons*. These works are marked by striations that recall prison suits and the overwhelming sensation they convey is of figures trapped behind bars. The ominous character of these pieces is balanced by the luminosity of their primarily white surfaces, the asymmetry of their compositions, and their subtle tonal gradations from light to dark.[22] In the largest works from this series, a number of additional elements are embedded within the cagelike metal frameworks; these range from the mechanistic to the organic, as in the presence of a painted shell of a horseshoe crab that interjects a curiously naturalistic note with its graceful and ample curvature.

In 1967 Bontecou showed a group of suspended sculptures made of balsa wood and silk, resembling chrysalis forms (plates 86–88). Critic Charlotte Willard commented, "In a new series of small chrysalis shapes that are at once grub and primitive tribal masks, her sculptures have the quality of having been born rather than made."[23] The delicacy and fragility of these objects seemed in marked contrast with the brutally imposing character of her earlier welded pieces, as did their incorporation of color, ranging from pale to dark yellow. She also began to experiment with synthetic materials such as fiberglass adhered with airplane glue to metal frames and then covered with epoxy. The effect was a departure from the rugged textures and receding spaces of her earlier pieces in favor of ballooning forms that appeared more rounded, finished, and protective. Bontecou anticipated this aesthetic in a group of drawings she had made in 1964–65 (plates 64 and 65) and that she continued through 1967–68 (plates 79–84), in which clusters of sail-like forms, appearing precariously tethered, billow in full movement as if in a high wind.

As this body of her work evolved, Bontecou increasingly made reference to naturalistic phenomena by the use of forms with organic overtones as well as variations

in materials and an expanded color palette incorporating black, red, gold, ochre, and ivory. These three-dimensional works strongly evoke biological life — the shells of snails, sea creatures, and plant life. She developed several major pieces in this vein, the two largest and most complex of which she made in 1966 (plates 75 and 76). One of these works (plate 77) includes her only use of artificial light as an element incorporated within sculpture, in tandem with numerous other materials. A similar complexity characterizes a companion work (plate 78) of approximately the same size but with a much more vibrantly colorful palette, including red, orange, gold, white, and blue pieces of denim glued into place, producing effects that have been likened to the rich colorism of cloisonné or stained glass. The most important and dramatic characteristic of these pieces, however, is the exuberance and lyricism that differentiates them from Bontecou's earlier production in which mystery and a certain brooding ferocity are predominant elements.

This change in Bontecou's work represented an evolution over the span of one or two years in which she expanded the repertoire of materials that enabled the development of new forms. The shift in the tenor of her work resulted from the birth of a daughter, Valerie, and a change of setting as she, her husband, and their daughter moved from the city to the countryside. Together with Tom and Jane Doyle, they purchased separate parcels of land in the mountains of central Pennsylvania and began to spend several months of each year there beginning in 1967. Closely surrounded by the abundant animal and plant life of this bucolic setting, Bontecou's inherent and deep-seated love of nature was rekindled and increasingly manifest in both her sculpture and drawings.

Around this same time, Bontecou began to experiment with the use of vacuum-formed shapes, seeking to make a lighter-weight sculpture. In 1965 she and her friend Sandy Freckleton encouraged the sculptor Lindsay Decker to build a vacuum-forming machine for their communal use. He obliged them by inventing an industrial type machine that could be used in a loft. Later, making her own machine in a smaller version, Bontecou created a series of works in the shapes of flowers, plants, and fish by carving blocks of Styrofoam into the desired shapes for placement within the bed of the vacuum-forming machine. The result of the vacuuming action was a transparent plastic replica of the Styrofoam carving, the sections of which were then bolted and epoxied together, suggesting the overlapping of gills, the petals of flowers, plates of armor, or shells. These are among Bontecou's most enigmatic and arresting works. Frankly representational, they embody curiously disturbing interpretations of their subjects; the fish are sharply scaled, with ferocious teeth, and are shown in the act of swallowing and ingesting smaller species, while the flowers and plants, revealing affinities to internal organs, appear sinister and mutated — one wears a gas mask. Contemporary with the publication of Rachel Carson's influential late 1960s treatise on the dangers of pesticides, *Silent Spring*, this body of Bontecou's sculptures directly reflects the negative implications of humans' degradation of the natural world.

Shown in 1970, the vacuum-formed plastic sculptures met with a mixed critical reception, possibly because they departed so dramatically from her earlier signature pieces. Originally standing directly on the floor, the fish sculptures were installed together with the freestanding forms of works resembling large and small plants, suggesting a disquieting underwater environment. At the time of their creation and presentation, Bontecou's pieces were unlike any other work being shown in New York. Yet to a contemporary eye, they prefigure the later sculptures of artists from the 1980s onward who have also used plant and animal forms that convey strangely disturbing and surreal effects. The perplexed reactions Bontecou's vacuum-formed plastic sculptures evoked are noteworthy. The

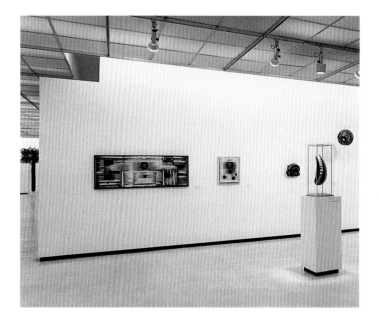

View of the exhibition *Lee Bontecou* at the Museum of Contemporary Art, Chicago, 1972

works' uncanny nature confounded the critics, several of whom expressed skepticism at the direction she was exploring. "They seem trapped between the claims of fantasy and realism," said one writer, while another commented that they seemed the least successful or imaginative of her output.[24] Tony Towle, however, discerned elements of continuity in these pieces with ideas that had consistently animated Bontecou's work. He remarked, "Even the recent works in plastic . . . which are recognized as flowers or fish, are not real species of flower or fish; they are syntheses. The bronze and terracotta birds of 1956 also verge on the representational, but they are less animals than they are the quality of *being an animal*."[25]

In 1972 the Museum of Contemporary Art in Chicago presented a survey of Bontecou's sculpture and drawing, curated by its director Stephen Prokopoff, which was heralded in the *Chicago Tribune* for the quality of authenticity that resonated throughout her work.[26] In 1975 Bontecou's prints and drawings were the subject of an extensive exhibition at Wesleyan University Gallery in Middletown, Connecticut. Her exhibition of vacuum-formed plastic sculptures in 1971, however, was to be her last solo show in New York for nearly thirty years. By the early 1970s, Bontecou was devoting herself to teaching. She joined the faculty of the Art Department at Brooklyn College, to which she commuted from various residences in New York state, including the Hamptons and Rockland County, and Pennsylvania, where she and her husband lived while their daughter was in school, spending summers at their farm in the Pennsylvania mountains.

For a period of approximately fifteen years, while teaching and together with her husband raising their daughter and caring for her aging father, Bontecou continued working in both sculpture and drawing, producing an abundant body of work. Her drawings of these years range widely and demonstrate significant development in imagery in which profound relationships to the natural world are manifest. Like her early activity in this medium, her later drawings encompass both finished images and apparent free associations in which restless transmutations occur between alternatively benign and menacing images. As early as 1975, curator-historian Richard Field analyzed the expansive range of imagery present in Bontecou's drawings, noting the shapes of flaming meteors or fireballs as well as the presence of meticulously detailed forms of insects, flowers and plants, eyes, and teeth.[27] More recently, references to landscapes, seascapes, and the imagery of birds have populated her drawings, sometimes with a directness and simplicity that approximates naturalistic renderings, at other times elaborated into expressive, exuberantly colored quasi-abstraction. Affinities to the drawings of Odilon Redon, Vincent van Gogh, and even Leonardo da Vinci can be discerned in many of these images, and surrealist precedents for her most recent drawings have also been cited. A critic observed recently that the imagery in her drawings encompasses "pits with teeth in minefields or landscapes that bite, as well as the centers of mutant flowers . . . some armored with bladelike petals. Elsewhere they appear as the center of small universes, the eyes of storms, and actual eyes with lashes that morph into feathers, scythes, and rotating wind currents."[28]

Following her retirement from teaching in 1991, Bontecou completed work on some of the sculptures she had begun during the previous decade, expanding a vocabulary she first explored in the late 1970s. A body of these works (plates 138–42) consists of small sculptures rendered in porcelain, made of interlocking parts that when pieced together evoke miniscule and mysterious landscapes or galaxies. The majority of her recent three-dimensional pieces are suspended sculptures which, in contrast to the brutal appearance of many of her early works, are highly delicate and intricately, even obsessively, detailed. She continues to make all aspects of her own work, firing the porcelain she uses as orbs and linkages within her newest sculptures, welding her own metal frameworks, and laboriously building up and embellishing, over a period of months or even years, the armature of her elaborate sculptures. Resembling airborne hybrids of organic and mechanistic forms — something between a helicopter and an insect — and dramatically complex in their formal and material organization, these works range from intimately scaled to large. Concurrently, she has labored on a series of more representational sculptures derived from the figures and heads of birds (plates 146 and 147) — in effect, coming

full circle to the subject matter of some of her earliest pieces of the mid- to later 1950s, but with a markedly different expression that is both graceful and surreal, comical and frightening, and compellingly intricate and intimate as opposed to the monumental, rough-hewn quality of much of her earlier sculpture. All the while she has continued to draw, producing numerous works on paper that are both studies for these sculptures and independent works.

Working quietly and privately for the last twenty-five years, a time during which she declined and even ignored invitations to participate in exhibitions or to show her work, Bontecou has remained an enigmatic figure in the art world. A 1994 exhibition of her sculpture and drawing of the 1960s, organized by The Museum of Contemporary Art in Los Angeles, rekindled interest in her work, introducing it to a younger generation of artists who found it powerful and intensely compelling. Her most recent body of sculpture, made during the past decade in solitude on a farm far removed from the art world, has never been publicly exhibited, nor have many of her drawings made since the late 1970s.

The distinctiveness of Bontecou's entire corpus of work lies in how it has consistently succeeded in mining the tension between a range of dualities: the biological and the mechanistic, historical reference and experimental impulse, objecthood and allusion, hardness and softness, simplicity and intricacy. The alignment of such polarities — the interplay between abstraction and representation and the simultaneous sense of vulnerability and aggression emanating from much of Bontecou's work — from her early signature welded steel and canvas pieces to her vacuum-formed plastics to her more recent sculptures in metal, wire, mesh, and porcelain — has been unparalleled in the work of other artists. As Richard Field wrote in 1975, "Lee Bontecou's position in the art of the last decade has never been clearly established.... In the blatantly theatrical aspects of Bontecou's imagery and in the assertive character of her reliefs as they build out into the spectator's space, there resides the aftershock of an abstract expressionist action. But the other side of Bontecou denies the evidence of the self. Her works are painstakingly crafted, there are no overt series of gestures generated by the artist's

hands.... They are not quite pure process and structure.... They are at once sculpture and painting."[29]

Bontecou's first decade of work, which remains her best known, indeed confounded classification and provoked a multiplicity of often divergent readings. The most persistent characteristic of her work as a whole, however, is the deep sense of interrelatedness and mutability between abstraction and forms found in nature, as well as her fascination with certain motifs over the course of decades. Her attention to the forms and imagery of birds, manifest in some of her earliest sculptures, recurs in the work she is making today, while the image of the airplane has also appeared within her work over time and in various ways. Working simultaneously in modes that span both representation and abstraction, whether in sculpture or drawing, Bontecou establishes conceptual and visual relationships that derive from her highly personal and enigmatic artistic vocabulary. In her work, a medieval helmet and a flower, the teeth of an industrial saw blade and those of a fish, the twist of a piece of wire precariously joining a corner of canvas to a steel fame and a sleek, metallic automobile motor, the stenciled lettering on a piece of canvas duffel bag and the cosmic implications of blackness at the bottom of a crater-like void, are interrelated and conjoined as kindred elements.[30]

Encompassing such a vast and varied terrain of references, Bontecou's work continues to elicit a wide spectrum of readings and responses. It is this very lack of specificity,

Bontecou's Wooster Street studio, New York, 1962
Photograph by Rudolph Burkhardt
© Estate of Rudolph Burkhardt / Licensed by VAGA, New York

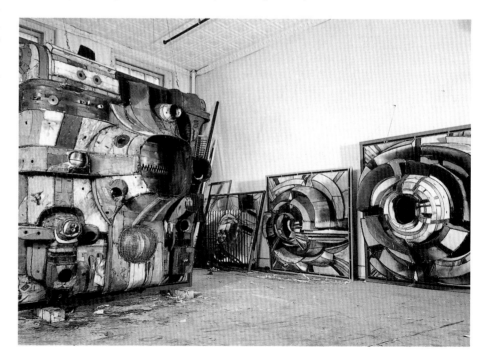

Bontecou's
Pennsylvania home,
1995

in fact, that constitutes its power and strength. Throughout her work, this innate sense of connection among nature, culture, and self animates her thinking and her approach as an artist most consistently. Writing on her exhibition of vacuum-formed plastic fish and flowers in 1971, critic James Mellow aptly pinpointed a deep-seated naturalism that he found throughout her work: "Even her unidentifiable, sinister images of the early and middle sixties now seem to carry hidden, naturalistic associations that give her work a sense of continuity it would otherwise lack. She is not, in other words, an object-maker gone wrong. She has, it seems, been a strange naturalist all along."[31]

This theme, already evident in the early 1970s, is now even more pronounced from the perspective of the almost fifty years of work Bontecou has created. Her attention to both the micro- and macrocosmic aspects of the world and her intuitive sense of their relationships, her rejection of barriers and boundaries, and her emphatic commitment to a wide range of sources has generated a profoundly original body of work that continues to evolve while eluding easy classification. She commented, "So you

take from the world, but then it goes into the dream. It's like when you read a book and the author speaks to you and you feel, here's a friend. It's the same when I look at what the cave painters did, and ancient African art, the building of Chartres Cathedral, a Brancusi sculpture or a van Gogh painting. They are friends."[32]

In 1996, Max Kozloff identified Bontecou as an artist whose work of the 1960s anticipated the aesthetics of recent decades, pointing to her as an artist ripe for rediscovery and reevaluation.[33] This opinion has been borne out by the responsiveness and interest on the part of artists, critics, collectors, and curators to examples of her latest drawings that have been recently exhibited, as well as to aspects of her new work in sculpture that is only gradually becoming known. The reestablishment of an artist like Bontecou, whose reputation was made in the 1960s, into the trajectory of thinking about recent art practice, has stemmed not only from a reconsideration of her earlier, better-known work but also to a growing awareness of what she has continued to create since that time. In part, it results from curiosity surrounding Bontecou's conspicuous absence from the art world for the past twenty-five years. More significantly, however, it arises from the compelling character of the work itself. Rather than having settled into a single style or working method, Bontecou's continuous experimentation with materials and modes of production — while consistent in her use of certain key images or motifs — endows her work with an uncommon vibrancy and vitality. The lyricism and cornucopic sense of visual abundance emanating from her recent sculpture and drawing, in which recognizable forms from nature fuse with the abstract, is simultaneously unsettling, otherworldly, surreal, and fundamentally mysterious.

1 Donald Judd, "Lee Bontecou," *Arts Magazine* 39, no. 7 (April 1965), p. 20. (Reprinted on pp. 194–99 of this volume.)

2 Tony Towle, "Two Conversations with Lee Bontecou," *Print Collector's Newsletter* 2, no. 2 (May–June 1971), p. 27.

3 Lee Bontecou in a letter to Jo Applin, 2002. I am grateful to Ms. Applin for sharing this material with me during the course of her research on Bontecou.

4 A wealth of information on Bontecou's childhood and early life is found in an interview published in Eleanor Munro, *Originals: American Women Artists* (New York: Simon and Schuster, 1979).

5 From a series of conversations and correspondence between Lee Bontecou and the author, January–April 2003.

6 Alan Soloman, *New York: The New Art Scene* (New York: Holt, Rinehart, and Winston, 1967), p. 98.

7 See, for example, "Lee Bontecou, Untitled," *Bulletin of the Cleveland Museum of Art* (February 1969), pp. 78–80.

8 Jean Lipman and Cleve Gray, "The Amazing Inventiveness of Women Painters," *Cosmopolitan* (October 1961), p. 69.

9 Bontecou in a letter to Jo Applin, 2002.

10 Dore Ashton, "Illusion and Fantasy: Lee [Magica Fantasia di Lee]," *Metro*, no. 8 (April 1963), pp. 28–33.

11 Mona Hadler, "Lee Bontecou — Heart of a Conquering Darkness," *Source: Notes in the History of Art* 12, no. 1 (fall 1992), pp. 38–44.

12 Bontecou in a 1960 letter, quoted in Dorothy Miller, *Americans 1963*, exh. cat. (New York: The Museum of Modern Art), p. 12.

13 Correspondence from Bontecou to the author, April 2003.

14 From a conversation between Tom and Jane Doyle and the author, January 2003.

15 Bontecou also described her fascination with airplanes in an interview published in Munro (note 4), p. 386.

16 "Young Sculptor Brings Jet Age to Lincoln Center: It's Art — But Will It Fly?" *Life* 56, no. 15 (April 1964), pp. 43–44.

17 Philip Johnson, "Young Artists at the Fair and at Lincoln Center" *Art in America* 52, no. 4 (summer 1964), pp. 112–127.

18 See Towle (note 2), pp. 25–27.

19 Joseph Cornell, "Celebrity File," microreel no. 1069, Archives of American Art, Smithsonian Institute, Washington, D.C. See also Mona Hadler, "Lee Bontecou's Warnings," *Art Journal* 53, no. 4 (winter 1994), pp. 56–61.

20 Quoted in Lucy Lippard, *Eva Hesse* (New York: New York University Press, 1976), p.56.

21 These reviews are reprinted in Donald Judd, *Complete Writings 1959–1975* (Halifax: Press of the Nova Scotia College of Art and Design; New York: New York University Press, 1975).

22 See Mona Hadler, "Lee Bontecou," in *Art since 1950: An Introduction to the Collection* (Akron, Ohio: Akron Art Museum, 2001).

23 Charlotte Willard, "Lee Bontecou," *New York Post* (October 1966), p. 107.

24 James R. Mellow, "Bontecou's Well-Fed Fish and Malevolent Flowers," *New York Times*, June 6, 1971, p. D19.

25 See Towle (note 2), p.27.

26 The exhibition *Lee Bontecou* took place at the Museum of Contemporary Art, Chicago, March 25–May 7, 1972.

27 Richard Field, *Prints and Drawings by Lee Bontecou* (Middletown, Conn.: Davison Art Center/ Wesleyan University Press, 1975), pp. 3–4.

28 Christopher Miles, "Lee Bontecou," *Artforum* 40, no. 4 (December 2001), p. 125.

29 Field (note 27), p. 3.

30 See Elizabeth A.T. Smith, "Abstract Sinister," *Art in America* 81, no. 9 (September 1993), pp. 82–87.

31 Mellow (note 24).

32 Correspondence from Bontecou to the author, March 2003.

33 Max Kozloff in Ann Landi, "Ripe for Rediscovery," *Art News* 95, no. 10 (November 1996), p. 120.

Seek and Hide

Robert Storr

Lee Bontecou

Donald Judd

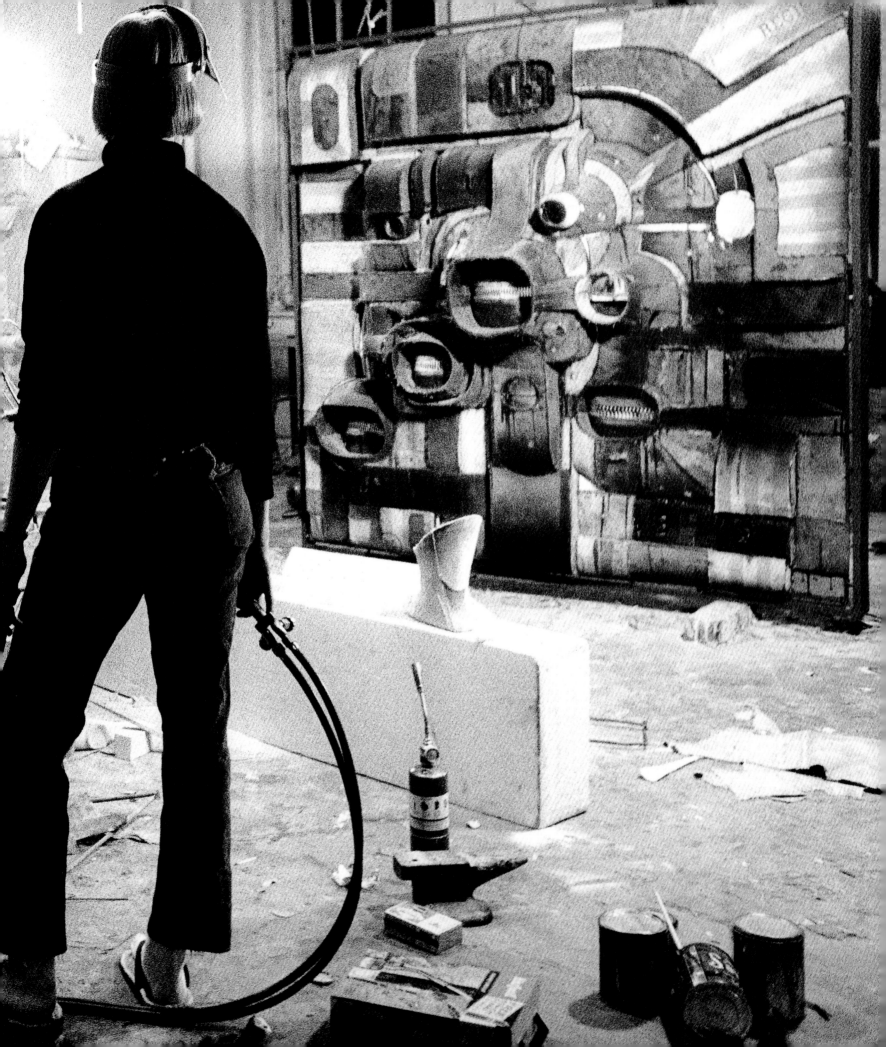

This essay was first
published in Arts
Magazine 39, no. 7
(April 1965).
Reproduced with
permission. © Donald Judd
Foundation / Licensed
by VAGA, New York

OVERLEAF

Bontecou in her
Wooster Street studio,
New York, 1963
Photograph by
Ugo Mulas
© Ugo Mulas Estate.
All rights reserved.

OPPOSITE

Bontecou working
on her sculpture for
the Lincoln Center
(plate 61) in her
Wooster Street studio,
New York, 1964
Photograph by
Hans Namuth
© Hans Namuth Ltd.

Lee Bontecou was one of the first to use a three-dimensional form that was neither painting nor sculpture. Her work is explicit and powerful.

Bontecou was born in Providence, Rhode Island, in 1931, and lived, more or less alternatively, in Westchester and Nova Scotia. In New York she studied sculpture at the Art Students League from 1952 through 1955 with [William] Zorach and John Hovannes. In 1956–57 she had a Fulbright in Rome, where she did birds and animals made by attaching terracotta sections to an armature (see plate 3). These are good, but, as she says, they could have been done at any time. The sections do not quite meet, as in loricate animals, and are blackened along the edges — all of which relates to the present sections and rods. The intention then was to float the sections somewhat. The present canvas forms around a cavity continue the flotation. The color then, as it still is, was gray. Some of the birds and animals were cement and some bronze. These works were shown at the G Gallery in 1959. Bontecou did drawings for pieces using canvas in 1958 and made some in 1959. The early reliefs are simple: a few trapezoidal pieces of canvas are attached to rods which extend from a rectangle of angle iron to the edge of a central cavity. The idea was unique. The first show at Castelli came in 1960 and the second in 1962. Bontecou will have a show at the Sonnabend Gallery in Paris in April. Last year a large relief was installed in the New York State Theater at Lincoln Center (plate 61). This and some other recent pieces have areas of epoxy and plexiglass as well as the canvas.

Often power lies in a polarization of elements and qualities, or at least in a combination of dissimilar ones. The power of Bontecou's reliefs is remarkably single. The three primary aspects, the scale, the structure and the image, are simple, definite and powerful. They combine exponentially. They do not contrast much; they have nearly the same quality and are nearly the same form. The scale, structure and image are most nearly identical in the simpler reliefs. Bontecou's complex ones are less powerful and less interesting.

In the last fifteen years or so a small number of American artists have developed a new scale. Until recently abstract painting and sculpture retained the scale and the type of unification necessary for the representation of objects in space. The new work has a larger internal scale and has fewer parts. The large scale and the several unusual forms in which it occurs have been intercausative. The scale and the economy are integral to the explicit, minatory power of Bontecou's reliefs. The scale, even considered separately and even more so as it occurs with the other aspects of the reliefs, is pragmatic, immediate and exclusive. Rather than inducing idealization and generalization and being allusive, it excludes. The work asserts its own existence, form and power. It becomes an object in its own right.

Bontecou was one of the first to make the structure of a three-dimensional work coextensive with its total shape. If a work is to assert its own values and existence, it is necessary that its essential parts be left alone. The essential parts must then occupy all the space available — which is why the greater scale and economy are mandatory. Ordinarily the structural parts lie within a field formed by the rectangle of the painting. They are portrayed; the field is the greater world. The slits in [Lucio] Fontana's canvasses, for example, are this way. The central

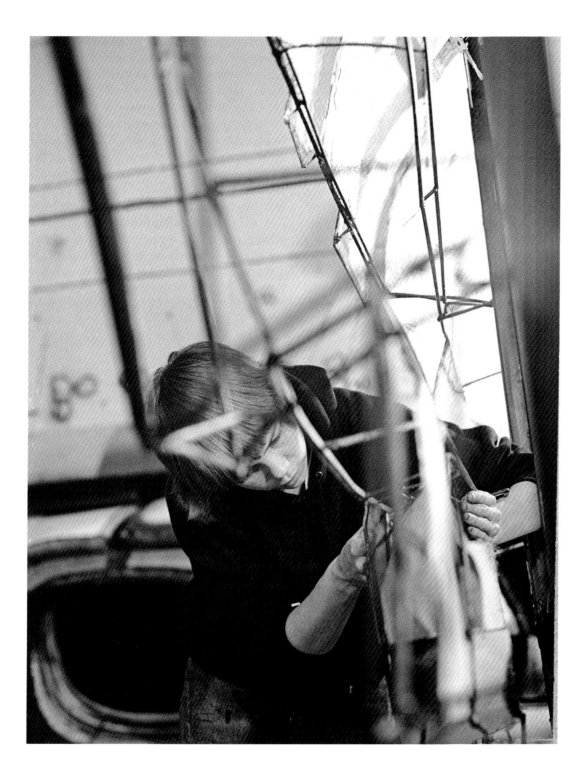

Lee Bontecou's Worldscapes

Mona Hadler

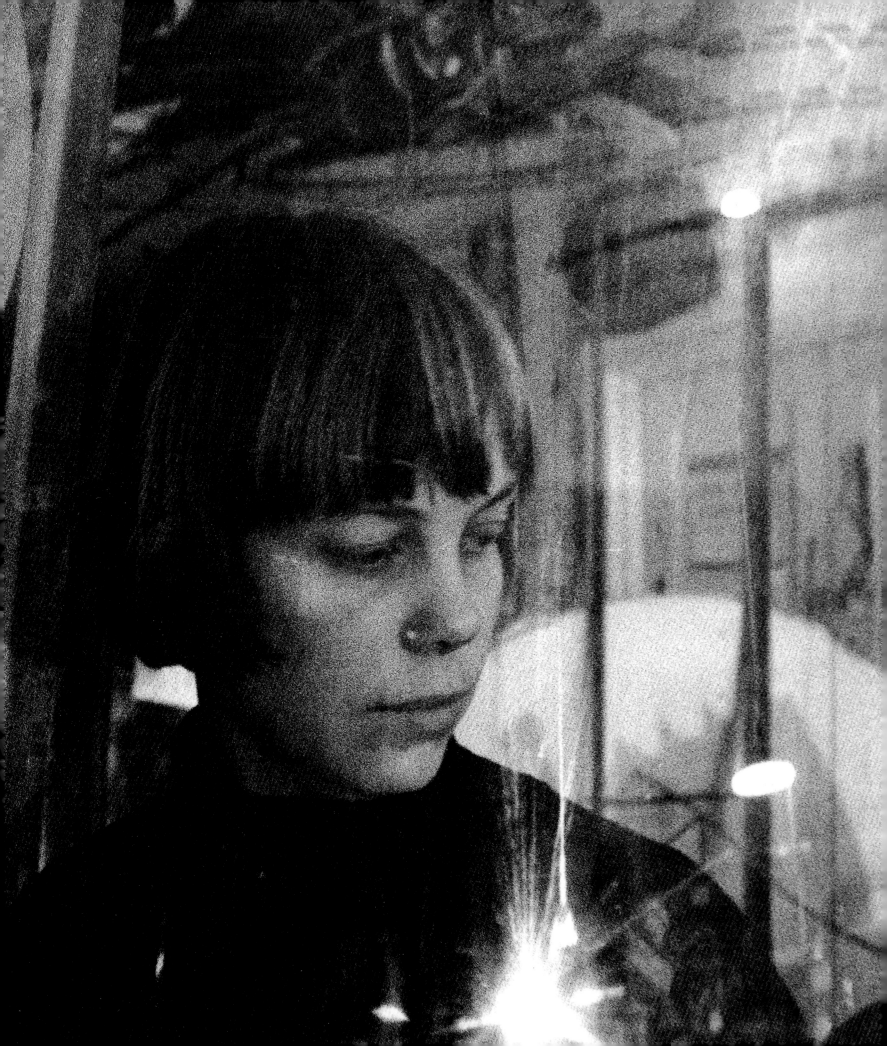

"Is it a pterodactyl? A Flash Gordon spaceship? An outsize artichoke or a monstrous whorl of giant flower corollas?"[1] asked one critic in the mid-1960s of Lee Bontecou's dramatic welded sculpture, shown in New York to a barrage of critical response. Americans and Europeans alike quickly lionized Bontecou. By 1964, she was exhibiting in Paris and Berlin, and at The Museum of Modern Art in New York, and had received a major commission for a wall relief in the New York State Theater at Lincoln Center. Her pioneering metal sculpture, incorporating such varied materials as canvas, denim, tarpaulin, epoxy, and Plexiglas, engaged critics with its formal power and complexity of messages. Rife with associations, her work engendered a multiplicity of responses, a quality Bontecou encouraged.[2] Divergent as the critical reactions may have been, their range of

references, from nature and prehistory to dashboards and spaceships, speaks not only to Bontecou's sources of inspiration but to the issues of her age. She lived in a time when dolphins morphed into nuclear submarines, dragonflies became satellites, and space imagery, with powerful correlates in nature, was ubiquitous.

The late 1950s and early 1960s was a period of extraordinary advances in space exploration, whose influence marked visual culture from automobile tail fins to satellite-shaped television sets triggered by remote controls that were in turn suggestive of the new study of cybernetics. The marvels of space, along with a pronounced military component — the memory of the carnage of World War II, the menace of the Cold War arms race, and the growing fear of nuclear devastation — pervaded the age. Bontecou's work embodies the paradox of the space age, especially in her pairing of the cosmic and the brutal. She speaks passionately of dichotomies and sees her sculpture as divided between optimistic works and angry war pieces, representing the positive and negative sides of science. Describing her excitement at the launching of Sputnik in 1957, followed by disillusionment at the "colonizing" of the moon in 1969, she said, "When they planted the flag on the moon, that was the end for me."[3] While Susan Sontag critiqued science-fiction films of the era as encouraging an abdication of responsibility by co-opting anger into entertainment,[4] Bontecou, on the other hand, engaged her time and harnessed her anger to create monumental welded sculptures in the 1960s, many of which rage against war or revel in the wonder of flight.

The advent of Sputnik coincided with a catalytic breakthrough in Bontecou's art — the creation of what she calls

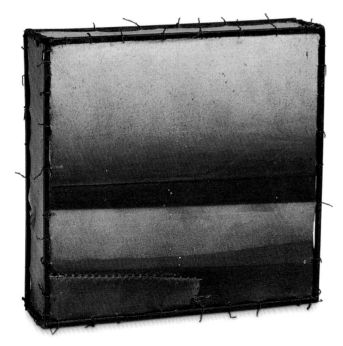

her "worldscapes" or "worldspaces." As the surrealists before her had adopted the term *inscape* for the psychological terrain, Bontecou's words articulate the scope of the outer limits. While on a Fulbright in Italy (a pilgrimage for many postwar artists[5]) in 1956–58, Bontecou began making soot drawings using an acetylene torch with the oxygen turned down. This inventive and original use of the torch for drawing produced works such as plate 7, in which the velvety blacks grade slowly and atmospherically toward a horizon line. These drawings, which she specifically called worldscapes, ultimately gave rise to her impressive welded sculpture of the 1960s. In Bontecou's words, "black" started it all: "Getting the black...opened everything up...I had to find a way of harnessing it."[6] The black of the soot assumed broad significance, evoking ideas of outer space, the finite and the infinite, mystery and conflict. In this context, she cited the "problems of Africa," as troubling to her and prominent in the news of the day.[7]

Bontecou maintains that world politics and events, more than artistic precedents, inspired her soot drawings and the boxes that followed them. When asked to elaborate on her experience of the launch of Sputnik, for example, she recalled the poetic imagery, the blackness of space, the vastness of the heavens, the sense of pressure from above and the world inside, which captivated her imagination and prompted her to conceive of the worldscapes, with their velvety black drawings that developed into small black boxes with mysterious internal hanging spheres.

In 1958–59, back in New York, Bontecou began to transform the imagery and formal properties of the drawings into sculpture. She produced a group of small boxes with welded frames filled in by pieces of muslin or canvas that had been sooted black by the torch. In one work, she placed folded mesh within the top half of the box, creating shading and a horizon line comparable to those in the soot drawings. In another (left), she fastened a soot drawing on muslin to the welded frame of the box with iron wire. She was attempting, through the gradation of light in the mesh or through subtle shadings of the soot, to open up the surface, thereby breaking up the solidity of sculpture, an achievement she believes Brancusi pioneered through his use of reflection. Envying the painter's

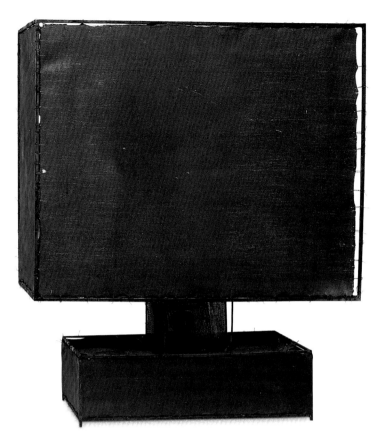

ability to "go for miles into the surface" (their own worldspace), she manipulated her surfaces like paintings by applying soot or varying the values of the canvas itself.

Several of the small welded boxes from 1958 to 1959 feature internal suspended miniature spheres suggesting caged worlds that extended her notion of the worldscape. In one example (above), a barely visible sphere wrapped in a translucent textured silk stocking hangs between two boxes as a tiny encased globe. Another work (plate 10), which resembles a rat cage or an old camera (like one her mother owned), houses a hanging ball barely visible through the opening. These works evince the sense of marvel central to the worldscapes but are also reminiscent of surrealist works such as Giacometti's mysterious suspended forms in *The Palace at 4 a.m.* (1932–33, p. 205) or his expressive spatial structures such as *Piazza* (1947–48), a cast of which Bontecou saw and admired in Italy. She was also drawn to the sculpture of Joseph Cornell, who was, as she put it, a "master of mystery."[8]

Lee Bontecou
Untitled, 1958–59
Steel, muslin, silk, and brass screen wire
4 × 4 × 2½ in.
(10.2 × 10.2 × 6.4 cm)
Collection of the artist

Bontecou's early works, generally composed of more than one box, gave rise to small, single rectangles with central holes. At times she placed them on legs (below), imparting a strange animal humor of walking machines, or in another work (plate 14), evoking a strong resemblance to the televisions of the era (she owned "one of the last round ones"). The early welded boxes with central black openings (see plate 13) were progenitors of works such as plates 15 and 21, in which she opened up the box into an asymmetrical, cubist-inspired, welded

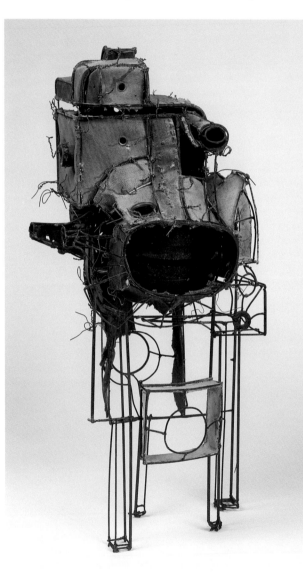

Lee Bontecou

Untitled Sculpture, 1958–59
Steel and canvas
19½ × 10 × 11 in.
(49.5 × 25.4 × 27.9 cm)
Collection of the artist

geometric structure filled in by tonally varied canvas attached with thin wire. Bontecou lived over a laundry, so material was readily available in the form of discarded, worn-out canvas conveyor belts. The detritus of the city, along with war equipment and airplane parts, formed free materials for her sculpture as it did for many artists of the day.

Born in 1931 and coming of age during World War II and the postwar era, Bontecou was witness to major breakthroughs in aerodynamics — from propeller planes to missiles and space probes. She also saw an explosion of science fiction in literature, television, and film. Postapocalyptic films responding to nuclear anxiety formed the subject of nearly a thousand films from 1945 to the present, with 1958 representing a peak year for bomb films.[9] She had seen the 1953 film of H. G. Wells's *War of the Worlds* and even had heard Orson Welles's notorious 1938 radio version of the story, but literature captured her attention more powerfully. H. G. Wells has been credited with infusing the image of early technology with a sense of wonder;[10] it was Wells's fiction that convinced atomic bomb physicist Leo Szilard that nuclear physics could "enable man not only to leave the earth but to leave the solar system."[11]

Science fiction "as a uniquely modern incarnation of an ancient tradition: the tale of wonder"[12] attempted, like Bontecou's art, to come to terms aesthetically and socially with the space age. Bontecou's sooted worldscapes and small boxes with their mysterious internal spaces are subtly inflected by a sense of awe comparable to that evinced by science fiction. "Canvas and wire are only a means towards a visionary end," as one critic aptly put it.[13] It is, however, in her vast two-dimensional oeuvre of drawings and prints that her cosmic and visionary imagination dominates. Beginning in 1962, Bontecou worked at Universal Limited Art Editions with Tatyana Grosman and produced a startling body of graphic work.[14] She continued to use soot on muslin as in one work (plate 59) from 1963, and draw privately in her studio. In her graphic work the blacks give birth to floating eyes, conjuring up imagery of the nineteenth-century visionary, Odilon Redon, whom she admires. Conversely, swirling holes emerge hauntingly from imaginary primeval mud banks or morph into strange magnetic fields (right). She remembers knowing in the 1960s about black holes as frightening magnetic

fields in the cosmos. Moreover, at that time persuasive ac-
counts of the big bang theory of the origin of the uni-
verse fed the popular imagination.[15] Bontecou was as
fascinated with evolution and missing links in prehistoric
life chains (paleontologist Roy Chapman Andrews, an In-
diana Jones prototype, was a hero) as with futuristic space
imagery; her work conflates the chthonic prehistoric with
the visionary cosmic.

The wealth of natural forms in prehistory or, more im-
portantly, in the visual world, was and is never far from
Bontecou's formal imagination. Growing up partly in the
mudflats and waters of Nova Scotia (her father and uncle
invented the aluminum canoe), she observed with great
relish the diversity of life forms. Working in the garden
one summer as an adult, she counted sixty varieties of in-
sect life. Her daughter, Valerie Giles, continued this family
tradition as an artist and also a field biologist. Natural forms
have become an increasingly central influence on Bonte-
cou's oeuvre, as in her exquisite recent drawings of waves
or fabulous insect life lurking in the interstices of black
paper. In the 1960s Bontecou created many small, crus-
tacean-like sculptures sporting claws with smooth surfaces
made shell-like through laborious applications of white
epoxy (plate 85).[16] Her astonishing vacuum-formed plas-
tic fish and flowers produced in the 1970s grew, in part,
out of her passion for life forms. As one reviewer put it,
"She has, it seems, been a strange naturalist all along." When
he later quipped that they were the work of a "mad doc-
tor's laboratory," he placed this work in the realm of sci-

ence fiction and touched on its allusions to the outsized
flora of the post-apocalyptic landscape.[17]

Although Bontecou's prints and soot drawings artic-
ulate most clearly her fantastic worldscape notions, the
early boxes with small hanging globes subtly convey this
imagery as well. Similarly, one could compare her "walk-
ing TV" (plate 14) to the robotic sci-fi creatures of the era
as described presciently by Wells: "striding hybrids ... a
great body of machinery on a tripod stand."[18] The con-
flation of the television with space age imagery is an apt
one for the period of the late 1950s. Advertisements pub-
lished in popular magazines underscore the instrumental
role the television set played in disseminating space age
imagery. A cursory glance at the pages of Life, a visual
encyclopedia of the times,[19] in 1959 reveals advertise-
ments for "space age portables." More visually intriguing
for Bontecou is an advertisement for Admiral television
(p. 206), which touted the invention of the world's first
portable television set with wireless remote control. The

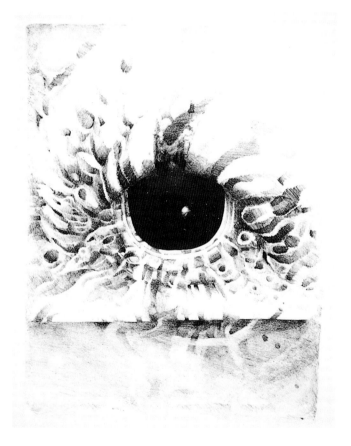

ADMIRAL ANNOUNCES THE WORLD'S FIRST
PORTABLE TV with WIRELESS REMOTE CONTROL!

Admiral SON-R wireless remote control, world's smallest and finest, tunes this new space age portable...the most versatile TV ever created! Take it to any room. Tune from anywhere in the room... from the comfort of your bed or easy chair. Wireless SON-R turns your new Admiral portable TV on-off, changes channels, adjusts volume to 4 levels! SON-R TV from $199⁹⁵.*

Admiral

Advertisement for
Admiral Television, *Life*
(March 16, 1959), p. 15

woman reclining in a typical organic chair of the 1950s watches the set — an eerie cousin, with prominent circular screen embedded in a cube, of plate 13. Most significant here is that the image on the set is of a missile launch, for it was on national television that a vast amount of information regarding the space race was disseminated.

With the launch of Sputnik, American networks dashed special reports into production to announce to the public the commencement of the Space Race.[20] By the spring of 1958, programs were aired on NBC and CBS — whose "eye" logo, designed in 1951 by William Golden,[21] could not have failed to gain Bontecou's attention for its conflation of the round shape of the eye with the camera lens. From this time on Americans watched rapt as satellites and cosmonauts were launched, or in the case of the Vanguard Rocket, exploded. Bontecou's description of her small sculptures, "there were beautiful worlds in those boxes," takes on added meaning in this context. Outer space was seen in a black box. Just as her work compressed large and small, the outer limits and the minimal cube, the vast expanse of limitless space was brought to the public in velvety shades of black encased in a box that seemed to open up through a central hole to an unknown worldscape.

In the Admiral television advertisement, the model holds her new wireless remote control. This device points to another issue central to the understanding of Bontecou's era: the relationship of humans and machines. Cybernetics, the field of study that "looks into the processes common to nervous systems and mathematical machines," was developed by Norbert Weiner in the late 1940s and tied directly to his World War II work with radar and missile guidance. As he described it in *Scientific American*, a popular magazine of the day: "In Isaac Newton's time the automaton became the clockwork music box. . . . The automaton of our day opens doors by means of photocells, or points guns to the place at which a radar beam picks up a hostile airplane."[22] Bontecou had no specific interest in cybernetics, and her work is not directly related to it. There is, however, a parallel in the conjoining of the organic and

technological and in their historical place in a lineage that stretches from eighteenth-century automata to modern notions of the cyborg. In fact, it was in 1960 that the word *cyborg* was coined to imagine a man-machine hybrid equipped to face the challenge of the space age.[23]

Bontecou enjoyed reading *Scientific American*, which by 1959 was rife with ads for anthropomorphic machines. Advertisements for the System Development Corporation of Santa Monica, California, tout large conflated illustrations of humans and machines to foster "Man-Machine Relationships a Growing Field for Operations Research."[24] The Cosmic Butterfly (right), a solar-powered proposed apparatus designed to carry ten passengers from one earth satellite to another, might have been particularly visually alluring for Bontecou. This modern futuristic creature blurs the boundaries of technology, science fiction, and futuristic sculpture. The reviewer who greeted Bontecou's 1964 Lincoln Center sculpture with the question "It's Art — But Will It Fly?"[25] lived in a visual culture populated by Cosmic Butterflies.

Indeed, Bontecou's mature welded sculpture of the 1960s combined biological with mathematical-mechanical form to produce a type of organic machine[26] not unlike Fernand Léger's paintings or Raymond Duchamp-Villon's *Horse* (p. 209), which she admired. We might now consider if her work, in its fluid boundaries, does not anticipate Donna Haraway's dream of a cyborg as a way out of a "maze of dualisms . . . building and destroying machines, identities, categories, relationships, space stories."[27] In fact, her early work evinced a marked openness to technology in both technique and imagery, and a vivid visual imagination that straddled the realms of both the organic and the mechanical.

Pointing out the relationship of the helicopter or of Sputnik to the dragonfly, Bontecou has stressed that she sees technology through nature. Like the popular author D'Arcy Thompson, who connected the structure of a powerful crane with the arrangement of bony trabeculae,[28] she recounts with enthusiasm how the inventors of the submarine first studied sharks and then turned their attention to dolphins. She also has poignant memories of her mother wiring submarine parts during World War II. Throughout the winter of 1963 Bontecou spent countless

hours at the airport watching planes and in her studio gluing plastic models of airplanes, helicopters, and submarines. At this time she made an intricate model of the SSN.585 Skipjack, the nuclear sub built like a dolphin that had been launched in 1958. It was, she felt, at once beautiful and threatening. A number of shaped-silk sculptures from the mid-1960s began with balsa wood models in mind. (She remembers the beautiful ones her brother made in his youth.) Hanging, plate 87 resembles both a cocoon and an airplane model. Indeed, lifting works in the air has been a leitmotif throughout Bontecou's oeuvre — culminating in her most recent work, which hangs from the ceiling. The shaped-silk work of 1967 is gentle in spirit and optimistic in tone and can be related to bolder, more commanding sculptures broadly inspired by flight such as her major 1964 wall relief in Lincoln Center (plate 61).

Conjuring natural and mechanical notions of flight, this vital work stretches magisterially more than twenty feet across the expanse of the wall. Like the architect Eero Saarinen's contemporaneous Trans World Airlines Terminal of 1956–1962 at John F. Kennedy International Airport (then known as Idlewild), its very structure forms an "architecture parlante" of flight.[29] Bontecou had, in fact, used the Plexiglas turret of an old World War II bomber for the larger horizontal shapes to the right and left of the central hole. One reviewer even noted her engagement with making airplane models at the time.[30] Marked by powerful thrusts, the work alternates deep recesses with dynamic winged struts as close to the futurism of Boccioni as it is to the cubism of Duchamp-Villon.

With its combination of advancing and receding forms, powerfully rendered and symmetrically organized, this work also recalls the bulging futuristic design of the late-1950s automobile: dashboards, front grills, and the omnipresent tail fin. Peaking in 1959 when the Cadillac tail fin reached three and a half feet above the pavement, this was a glorious moment in America's romance with the automobile. Although automobiles were not a direct influence on Bontecou, their protruding fins derived, like many of her works, in part from the structure of airplanes. In a *Saturday Evening Post* article from 1954, Harley Earl, the tail fin's inventor, described how the P-38 Lockheed Lightning inspired his creation and praised his car design (he

had already drawn the 1957 model): "I think we have them in exactly the right attitude of level alertness, like an airplane at take-off."[31] As historian Karal Ann Marling wrote, using language often attributed to Bontecou's sculptures, the late 1950s automobile is a complex signifier of postwar issues: "Breasts, teeth, wings, bombs, sharks: planes that were women, women who were missiles. These were metaphors, analogues for a whole series of preoccupations that Detroit and its customers shared with many artists in the aftermath of World War II."[32]

While some industrial designers criticized the design excesses of these wildly fanciful and popular automobiles at the time as "jukeboxes on wheels,"[33] Bontecou's taut and complexly constructed works were championed for their formal rigor. Minimalist sculptor Donald Judd credited Bontecou with being one of the first artists to "make the structure of the three-dimensional work coextensive with its total shape."[34] Her powerful imagination was articulated more forcefully by the rigor of complex geometry, which made her work both less literal and more expressive. Bulging avian forms were aligned nearly symmetrically around a central opening, suggesting the grid of the graph paper she always used for drawing. This underlying formal order calls to mind the art of the 1960s as her early boxes bear relationship to the minimalist sculpture of that decade. Similarly, Bontecou's respect for the cube in the late 1950s belied her classical side, evidenced by her love of Archaic Greek, ancient Mayan, and the purity of Brancusi's art.

In the Lincoln Center work, Bontecou used epoxy on some sections to create a smooth finish, applied soot to the canvas in other areas, and laboriously attached canvas and yellow chamois cloth to the welded structure with pieces of wire, leaving the sharp ends protruding. From the outset of her career she preferred an art of contrasts, "the balance of what we are up to." Her work exhibits a rough, hand-worked quality that coexists with a carefully composed geometric structure. For example, as in the Lincoln Center work, she intentionally leaves wire ends protruding to create a

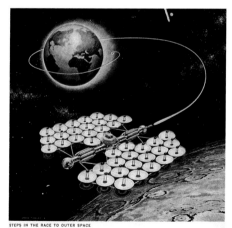

contrast of materials — sharp and smooth, sensuous and repellent that often results in a fetishistic, mesmerizing intensity. In this respect, it is not surprising that Eva Hesse credited Bontecou as an influence.[35] If Hesse's wrapped frame of *Hang Up* (1966) conjures bandages, Bontecou's sharp edges "mentally scrape the viewer." Moreover, the difficult, repetitive task of attaching cloth to the structure with wire, which emerged in Bontecou's work as early as 1959 when she meticulously fastened the soot drawing to the welded cube, anticipates works by the process artists of the 1960s. Just as Hesse inserted plastic tubing into the steel holes of *Accesion II* in 1969, or Robert Smithson walked the length of the *Spiral Jetty* in his 1970 film, Bontecou methodically marked the edges of her 1959 boxes and again attached the canvas to the metal rods in her monumental structures of the 1960s.

Bontecou's combinations of materials bear a striking analogy to the body, composed of skin, bones, various other materials and, of course, orifices. With their aggressively projecting and receding forms, these works, which are clearly body-oriented but not solely female in their references, slide out of easy categories and point to a multivalent concept of the erotic. Their combination of hand-worked and machine-welded forms questions the superficial gendering of these elements. In this sense they anticipate Haraway's cyborgs who exist in a "postgender world."[36] A psychosexual reading of the holes can be offset by visionary or technological references as in the Lincoln Center work. For example, Bontecou relates the holes to the *Mouth of Truth*, the sculpture of a river god from the church of Santa Maria in Cosmedin in Rome, which intrigued her: "If you put your hand in and tell a lie, something would bite it off," as she recounts the lore about the sculpture. Yet, conversely, she also links the chasms to the mysterious black holes of the cosmos, and reviewers have alternatively seen in them menacing or Duchampian machines.

While the large central hole was an important positive influence on feminist artists of the 1970s, such as Judy Chicago,[37] critics at the time often used it to reduce Bontecou's complex visual and symbolic work to "visual metaphors for the secrets of the eternal Eve."[38] More damning is a 1964 review: "Miss Bontecou exposes the great female archetype in its most ugly, destructive aspect. With this imagery, the noble earth mothers of Renoir, Maillol, and Moore become matriarchs *ex machina*."[39] Body references certainly abound in her work that relates to the political and social concerns of the 1960s, the decade of the sexual revolution.[40] Her art also points to a way the body can be interpreted as the site of social protest[41] and, as Miriam Schapiro maintains, her anger can cause discomfort: "[Bontecou's sculptures] were not sexual in the ways the men were then saying. Many of these works were about living in the world and being menaced by war. It was unusual at the time she produced them for women to express anger and rage in art. Women's rage is frightening to men, and so they metamorphosed it into the conventional idea of a *vagina dentata*, creating a myth that could contain the power of women's rage."[42]

Indeed, many of Bontecou's commanding works of the 1960s express her darker moods and anger at war. They embody a bold political art deeply expressive in form and content of the anxieties of her age. As she has stated:

I was angry. I used to work with the United Nations program on the short-wave radio in my studio. I used it like background music, and in a way, the anger became part of the process. During World War II we'd been too young. But at that later time [the 1950s and 1960s], all the feelings I'd had back then came to me again.... Africa was in trouble and we were so negative. Then I remembered the killings, the Holocaust, the political scene.[43]

Her canvas and steel works often incorporated Nazi helmets and gas masks, which surfaced in her drawings as well. Bontecou's indignation deepened with the outbreak of the war in Korea. Her persistent angry feelings are expressed clearly in *Prisons*, a group of small rectangular metal pieces executed in the early 1960s. One example (plate 51) has striations that recall prison uniforms,

Bocca della Verità (Mouth of Truth) Church of Santa Maria in Cosmedin, Rome Courtesy Photo Roma

as well as the motifs of Léger's work, which Bontecou had admired since her student years. It also incorporates garment racks that display the threatening grin, which appeared in larger outraged works such as one from 1961 (plate 39), of a figure trapped behind a vertical grid of iron bars. "A lot of those images were used in the big ones," Bontecou recalls. Although plate 39 is not part of the prison series, it exploits sharp metal elements and entrapping geometry to powerful effect. And given her sensitivity to World War II, could she have forgotten the prisons, the camps, the barbed wire? When one of her sculptures was displayed at the Jewish Museum, she considered it a "memorial to my feelings."[44]

It is in her formal language, above all, that Bontecou most effectively expressed her social concerns: the grid of entrapment, the sharp edges and wires that "mentally scrape the viewer," the mixture of materials that she feels reflect the dualities in society[45] and the omnipresent blacks: black of the mysterious caverns, black of the worldscape with its social significance and visionary potential.

"Getting the black…opened everything up. It was like dealing with the outer limits." Bontecou's art alternates between an abstract, monumental language of social protest to a visionary world expressing the awe and wonder of the "outer limits," and in this sense filters the issues of her age through her extraordinary formal imagination. Her works from the late 1950s on transcend dichotomies of the cosmic and terrestrial, infinite and finite, technological and natural, hopeful and brutal. "Harnessing that square of black" was the beginning, and it became the springboard to the formal power and social message of Bontecou's oeuvre.

Raymond Duchamp-Villon
The Horse, 1914 (cast c. 1930)
Bronze and patina
17³⁄₁₆ × 16¹⁄₈ × 11¹³⁄₁₆
(43.6 × 41 × 30 cm)
The Solomon R. Guggenheim Foundation, New York, Peggy Guggenheim Collection, Venice, 1976

1 "Cornucopia: Lee Bontecou," *Newsweek* 68 (October 24, 1966), p. 77.

2 See "Young Sculptor Brings Jet Age to Lincoln Center: It's Art — But Will It Fly?" *Life* 56, no. 15 (April 10, 1964), p. 43.

3 Bontecou in an interview with the author, July 19, 1986. The artist and the author spent a weekend at the Giles-Bontecou farm in Pennsylvania, photographing and discussing her early work. Unless otherwise noted, all primary information concerning her work and thoughts comes from this interview and other discussions over the years.

4 Susan Sontag, "Imagination of Disaster," 1965, in *Against Interpretation and Other Essays* (New York: Octagon Books, 1978), p. 225. This essay sparked a lively debate about science-fiction literature.

5 See Germano Celant, *Roma-New York, 1948–1964, An Art Experience* (New York: The Murray and Isabella Rayburn Foundation, 1993).

6 Bontecou also refers to her interest in worldscapes in Tony Towle, "Two Conversations with Lee Bontecou," *Print Collector's Newsletter* 2, no. 2 (May–June 1971), p. 26. See also Mona Hadler, "Lee Bontecou — Heart of a Conquering Darkness," *Source: Notes in the History of Art* 12, no. 1 (fall 1992), pp. 38–44, and Mona Hadler, "Lee Bontecou's 'Warnings,'" *Art Journal* 53, no. 4 (winter 1994), pp. 56–61.

7 See, for example, Robert Coughlin, "Black Africa Surges to Independence," *Life* 46, no. 4 (January 26, 1959), pp. 100–10. This was the first of two articles about Africa that *Life* featured at the time.

8 Joseph Cornell kept files on Bontecou, which are available in the Archives of American Art, Smithsonian Institution, Washington, D.C. See Hadler, "Lee Bontecou's 'Warnings'" (note 6) for more on Cornell.

9 Jerome F. Shapiro, *Atomic Bomb Cinema, The Apocalyptic Imagination on Film* (New York: Routledge, 2002), pp. 2, 6.

10 J. P. Telotte, *Science Fiction Film* (New York: Cambridge University Press, 2001), p. 67. Bontecou's favorite authors were Robert A. Heinlein and Ray Bradbury. She remembers avidly reading Heinlein's *Stranger in a Strange Land*, an immensely popular book first published in 1961. As a child, she loved Batman.

11 Szilard, quoted in Richard Rhodes, *The Making of the Atomic Bomb* (New York: Simon and Schuster, 1986), p. 25. See also Mona Hadler, "The Bomb in the Postwar Era: From the Sublime to Red Hot Candy," *Source: Notes in the History of Art* 21 (fall 2001), p. 30.

12 See Telotte (note 10), p. 64.

13 See Dore Ashton, "Lee Bontecou," *Recent American Sculpture*, exh. cat. (New York: The Jewish Museum, 1964), p. 13.

14 See Towle (note 6), and Richard S. Field, *Prints and Drawings by Lee Bontecou*, exh. cat. (Middletown, Conn.: Davison Art Center, Wesleyan University Press, 1975), for more on Bontecou's graphic oeuvre.

15 Eric J. Lerner, in *The Big Bang Never Happened* (New York: Random House, 1991), pp. 3–4, describes the popularity of big bang theories in the 1950s and 1960s.

16 This technical virtuosity remains evident today in shapes evocative of bones, shells, or teeth, which Bontecou painstakingly builds up in epoxy or glazed porcelain.

17 James R. Mellow, "Bontecou's Well-Fed Fish and Malevolent Flowers," *New York Times*, June 6, 1971. Elizabeth A. T. Smith, in "Abstract Sinister," *Art in America* 81, no. 9 (September 1993), p. 86, sees these works as among Bontecou's most fascinating and compares them to the work of contemporary process artists such as Lynda Benglis and Bruce Nauman.

18 H. G. Wells, *War of the Worlds* (London: Pan Books, Ltd., 1974), p. 51. Unbeknownst to Bontecou, Reg Butler drew on Wells's hybrids for his welded postwar sculpture. See Robert Burstow, "Butler's Competition Project for a 'Monument to the Unknown Political Prisoner': Abstraction and Cold War Politics," *Art History* 12 (December 1989), p. 484.

19 See Erica Doss, ed., *Looking at Life Magazine* (Washington, D.C.: Smithsonian Institution Press, 2001) for *Life*'s visibility in the postwar years.

20 See Mary Ann Watson, *The Expanding Vista, American Television in the Kennedy Years* (New York: Oxford University Press, 1990), p. 113. See John Alan Farmer, *The New Frontier: Art and Television, 1960–65* (Austin, Tex.: Austin Museum of Art, 2000) for a discussion of television and the art of the 1960s. A photograph of Bontecou watching television in her studio is printed inside the front cover.

21 See Ellen Lupton and J. Abbott Miller, "A Time Line of American Graphic Design 1829–1989," in *Graphic Design in America*, edited by Mildred Friedman (Minneapolis: Walker Art Center, 1989), p. 51.

22 Norbert Weiner, "Cybernetics," *Scientific American* 179, no. 5 (November 1948), p. 15. Marga Bijvoet, in *Art as Inquiry: Toward New Collaborations between Art, Science and Technology* (New York: Peter Land Publishing, Inc., 1997), p. 37, posits the importance of Weiner's popular 1950 book *The Human Use of Human Beings: Cybernetics and Society* to artists interested in cybernetics in the E.A.T. program. Bontecou had been approached by that group, but chose not to become involved.

23 Manfred E. Clynes and Nathan
S. Kline, "Cyborgs and Space,"
Astronautics (September 1960),
reprinted in *The Cyborg Handbook*,
edited by Chris Hables Gray
(New York: Routledge, 1995),
pp. 29–33.

24 *Scientific American* 200, no. 2
(February 22, 1959), p. 159.

25 "Young Sculptor Brings Jet Age
to Lincoln Center" (note 2), p.
43. Frank Tinsley, creator of the
Cosmic Butterfly, was known
for his illustrations of pulp avia-
tion heroes in the 1930s.

26 See Carter Ratcliff, *Lee Bontecou*,
exh. cat. (Chicago: Museum
of Contemporary Art, 1972),
unpag.

27 Donna J. Haraway, *Simians,
Cyborgs, and Women, The Reinvention
of Nature* (New York: Routledge,
1991), p. 181.

28 See D'Arcy Wentworth Thomp-
son, *On Growth and Form* (New
York: Cambridge University
Press, 1961), p. 232. This was a
new edition of his popular
1942 book.

29 Martin Filler, "Building Organic
Form: Architecture, Ceramics,
Glass, and Metal in the 1940s
and 1950s," *Vital Forms: American
Art and Design in the Atomic Age,
1940–1960* (New York: Brooklyn
Museum of Art, 2001), p. 128.

30 "Young Sculptor Brings Jet Age
to Lincoln Center" (note 2),
p. 43.

31 Harley J. Earl (with Arthur W.
Baum), "I Dream Automobiles,"
Saturday Evening Post 227 (August
7, 1954), p. 82.

32 Karal Ann Marling, "Organic
Glitz: Designing Popular Cul-
ture in the Postwar Era," in *Vital
Forms* (note 29), p. 211.

33 Raymond Loewy, "Jukebox on
Wheels," *Atlantic Monthly* (April
1955), p. 36, as discussed in
Karal Ann Marling, *As Seen on TV:
The Visual Culture of Everyday Life in
the 1950s* (Cambridge, Mass.:
Harvard University Press,
1994), pp. 138–53.

34 Donald Judd, "Lee Bontecou,"
Arts Magazine 39, no. 7 (April
1965), p. 17. (Reprinted on pp.
194–99 of this volume.)

35 Eva Hesse papers, December 13,
1965, Archives of American
Art, Smithsonian Institution,
Washington, D.C. Lucy Lippard
first referred to this journal
entry in *Eva Hesse* (New York:
New York University Press,
1976), p. 56. Hesse admired
Bontecou's technique above all.
I thank Anna Chave for her
thoughts on this connection.
Bontecou and Hesse met be-
cause their husbands, artists
William Giles and Tom Doyle,
were friends.

36 Haraway (note 27), p. 150.

37 See Lucy Lippard, "Judy
Chicago: Talking to Lucy R.
Lippard," *Artforum* 13
(September 1974), p. 64.
Like many women artists
whose art matured before
the 1970s, she was not open
to this interpretation and
found it to be reductive.

38 Cleve Gray, "Remburgers and
Hambrandts," *Art in America* 51,
no. 6 (December 1963), p. 129.

39 Edward T. Kelly, "Neo-Dada:
A Critique of Pop Art,"
Art Journal 23 (spring 1964),
p. 200.

40 See, for example, Maurice
Berger's discussion of Herbert
Marcuse's 1955 *Eros and Civilization*
in "Objects of Liberation:
The Sculpture of Eva Hesse," in
Eva Hesse: A Retrospective, exh. cat.
(New Haven, Conn.: Yale
University Art Gallery, 1992),
pp. 127–29.

41 See Hadler, "Lee Bontecou's
'Warnings'" (note 6),
pp. 60–61.

42 Miriam Schapiro, interviewed
in the summer of 1993 by
Norma Broude, in Norma
Broude and Mary D. Garrard,
*The Power of Feminist Art: The Ameri-
can Movement of the 1970s, History and
Impact* (New York: Harry N.
Abrams, Inc., 1994), p. 21.

43 Bontecou, quoted in Eleanor
Munro, *Originals: American Women
Artists* (New York: Simon and
Schuster, 1976), p. 384.

44 Ibid.

45 Bontecou was drawn to Mon-
drian for his dialectical mental-
ity and formal rigor, as well as
the Russian avant-garde. See
Hadler, "Lee Bontecou — Heart
of a Conquering Darkness"
(note 6), pp. 42–43.

Donna De Salvo

Inner and Outer Space

Bontecou's Sculpture through Drawing

world that we inhabit, working, that is, in the wake of postminimalism.

Like Bontecou's, many of young British artist Anish Kapoor's sculptures assert their materiality and incorporate a mysterious void, providing fertile ground for comparison. *Untitled* (2001, p. 218), for example, presents a rectangle of blood-red fiberglass with a massive central void. The void opens up in such a way as to make the surrounding space part of the work — what Kapoor sees as space turning itself inside out — and then recedes to connect to the wall behind. In its geometry and materiality, his sculpture is highly rational, but the void leads us somewhere else. Kapoor's sculptures are the embodiment of human concerns that readily acknowledge the technological present to which Bontecou once alluded.

A recent exhibition of the work of American artist Mike Kelley included a group of sculptures suspended by wires from the ceiling (p. 219) that invite comparison with Bontecou's hanging pieces. In Kelley's case, he refers to his structures as models, and in their configuration of suspended parts, they are reminiscent of Calder mobiles. A model, of course, is a stand-in, a reference, a link to things that are elsewhere, more like Smithson's non-sites than Bontecou's unique sculptures. Bontecou's "models" are less pedagogical, of course, than those of Smithson or Kelley. But they have in common the exploitation of a minimalist vocabulary to different ends. Her hanging sculptures, which developed later in her career, are constellations that point us elsewhere.

It is in the surfaces of Bontecou's drawings that we gain insight about her worldscapes, the inner and outer spaces of real and fictive worlds. Bontecou makes it tempting to remain in some of those imaginary spaces, the places we choose to construct in our own minds, but her work always brings us back to earth, the place we all inhabit. "If you don't watch out," she once proclaimed, "this is all we'll have to remember what flowers used to look like, this kind of flower made of plastic."[20] From the rugged to the fragile, Bontecou's materials and forms never relinquish their link to the real world, and in this way they are also a kind of stand-in, a staunch reminder that the worldscape we choose to construct is where we will have to live.

Bontecou in her
Pennsylvania studio, 2003
Photograph by Will Brown

1 Quoted in Mark Rosenthal, *Abstraction in the Twentieth Century: Total Risk, Freedom, Discipline* (New York: Solomon R. Guggenheim Foundation, 1999), p. 23. Rosenthal offers an excellent overview of developments in European and American abstraction.

2 Donna De Salvo, "Subjects of the Artists: Towards a Painting without Ideals," in *Hand-painted Pop: American Art in Transition, 1955–1962*, edited by Donna De Salvo and Paul Schimmel (Los Angeles: The Museum of Contemporary Art, 1992), p. 21.

3 Tony Towle, "Two Conversations with Lee Bontecou," *Print Collector's Newsletter* 2, no. 2 (May–June, 1971), p. 26.

4 Bontecou quoted in Mona Hadler, "Lee Bontecou's 'Warnings,'" *Art Journal* 53, no. 4 (winter 1994), p. 56.

5 Towle (note 3), p. 26.

6 Newman made few works with voids, but his use of the void here is emblematic of a generational attitude. For an excellent discussion of this and related works, see Ann Temkin, *Barnett Newman* (Philadelphia: Philadelphia Museum of Art, 2003).

7 Speaking about her earliest experiments with clay, which she first laid over metal frames in a wet state, cementing them after being fired, Bontecou commented, "That way, I can extend the surface way beyond what it naturally will do. I get involved with space." Eleanor Munro, *Originals: American Women Artists* (New York: Simon and Schuster, 1979), p. 383.

8 "The Loft-Waif" *Time* 81, no. 5 (February 1, 1963), p. 59.

9 Donald Judd, "Lee Bontecou," *Arts Magazine* 39, no. 7 (April 1965), p. 17. This text is also printed on pp. 194–99 of this volume.

10 Donald Judd, *Complete Writings, 1959–1975*. (Halifax: Press of Nova Scotia College of Art and Design; New York: New York University Press, 1975), p. 182.

11 Hadler (note 4), p. 59.

12 Stuart Preston, "What's New at the Modern," *New York Times*, November 25, 1962, section 2, p. 25.

13 Bontecou said, "I do not want to tell others . . . what to see or experience in my work. I hope the scope of my work is wide enough to awaken in the beholder some dormant reality of his own of which he had been unaware before. I wish one could, through my work, partake in the mystery my sculpture reveals to me." Quoted in *Artist's Reality, International Sculpture Exhibition* (New York: New School Art Center, 1961).

14 Quoted in Towle (note 3), p. 25.

15 For a thorough discussion of Smithson's early works, see Eugenie Tsai, *Robert Smithson Unearthed: Drawings, Collages, Writings* (New York: Columbia University Press, 1991). Tsai notes that Smithson retreated into figuration after a conscious rejection of abstract expressionism.

16 Hadler (note 4), p. 57.

17 Although now *Untitled*, at one point Bontecou titled this work *Insects and Craters*.

18 The film is based on John Wyndham's book of the same time. First published in 1951, the story reflects Cold War anxieties with its references to Russia and satellite weapons systems.

19 Hadler (note 4), p. 56.

20 Bontecou quoted in Munro (note 7), p. 386.

The author wishes to acknowledge Linda Norden for her critical reading of this text.

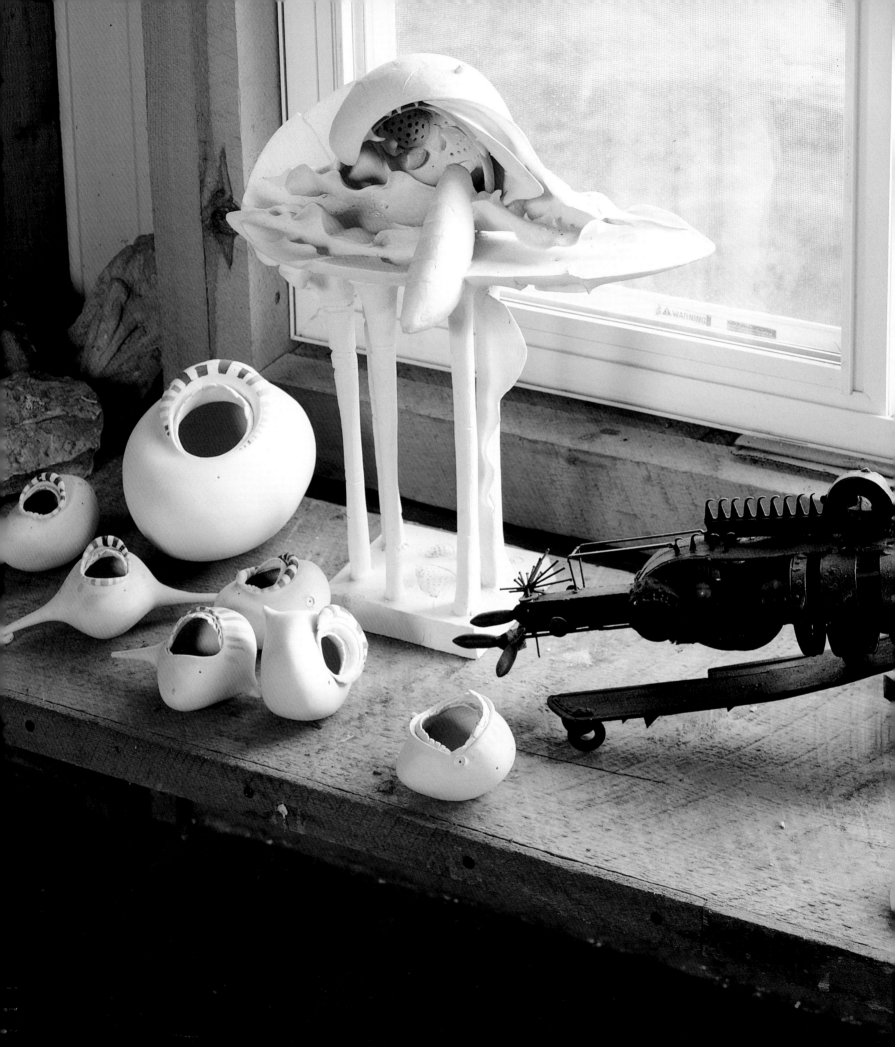

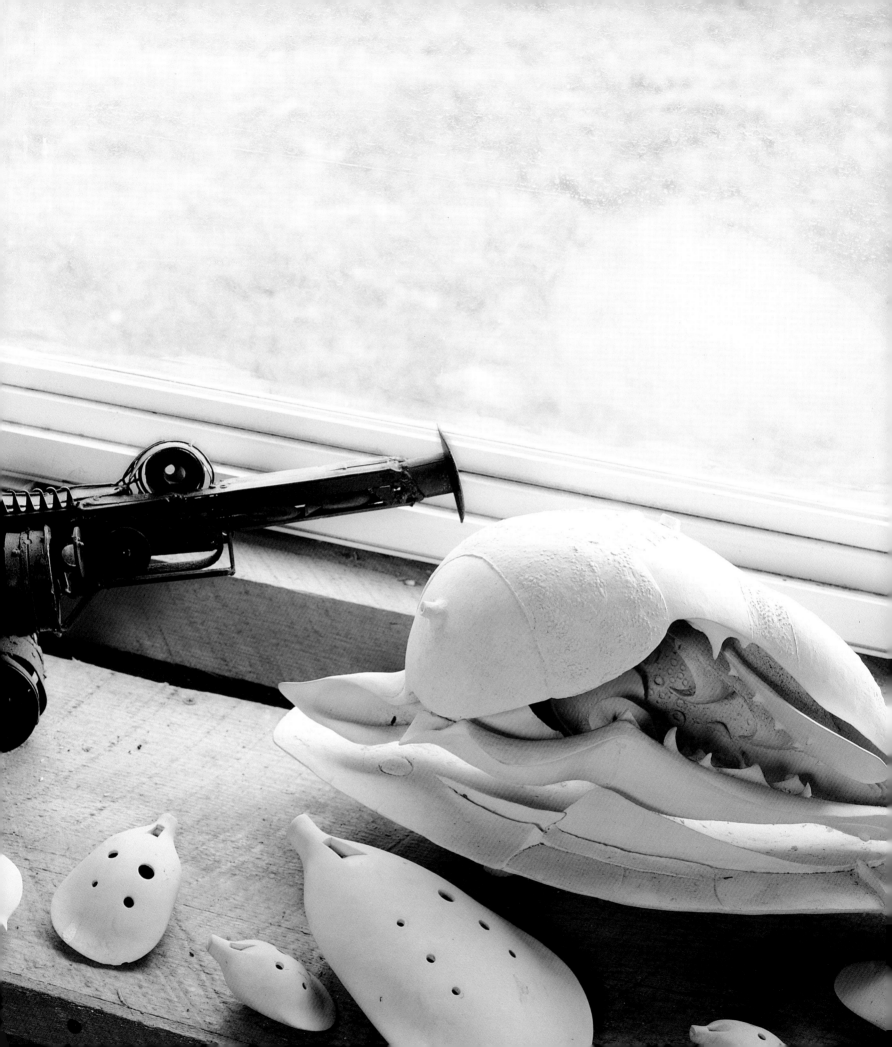

List of Plates

All of Lee Bontecou's works are untitled. Throughout this book, plate numbers are provided as references. Unless otherwise noted, works are collection of the artist and courtesy of Knoedler & Co., New York. Works marked with an asterisk are not included in the exhibition.

OVERLEAF

Bontecou's Penn-sylvania Studio, 2003 Photograph by Will Brown

Plate 1, 1957
Bronze
55 × 25 × 18 in.
(139.7 × 63.5 × 45.7 cm)

Plate 2, 1957
Bronze
20 × 20 × 10 in.
(50.8 × 50.8 × 25.4 cm)
Collection of
Dora G. Flash

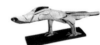

Plate 3, 1957
Terracotta over
reinforced cement
20 × 63 × 19 in.
(50.8 × 160 × 48.3 cm)
Private collection

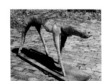

Plate 4, 1957
Bronze
27 × 12 × 57 in.
(68.6 × 30.5 × 144.8 cm)
Private collection

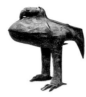

Plate 5, 1957*
Bronze
21¾ × 11¾ × 31 in.
(55.2 × 29.8 × 78.7 cm)
Collection of Terese
and Alvin S. Lane

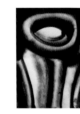

Plate 6, 1958
Soot on paper
39 × 27 in.
(99.1 × 68.6 cm)

Plate 7, 1958
Soot on paper
27 × 39 in.
(68.6 × 99.1 cm)

Plate 8, c. 1958
Soot on paper
30½ × 40 in.
(77.5 × 101.6 cm)

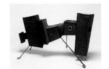

Plate 9, c. 1958
Soot on paper
27 × 39 in.
(68.6 × 99.1 cm)

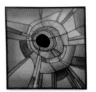

Plate 10, 1958
Welded steel, muslin,
soot, and wire
17 × 31 × 26 in.
(43.2 × 78.7 × 66 cm)

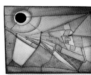

Plate 11, 1959
Welded steel and plastic
9 × 27 × 7 in.
(22.9 × 68.6 × 17.8 cm)

Plate 12, 1959
Welded steel, canvas,
and wire
31 × 27 × 27 in.
(78.7 × 68.6 × 68.6 cm)

Plate 13, 1959
Welded steel, canvas,
and wire
13 × 14 × 9 in.
(33 × 35.6 × 22.9 cm)

Plate 14, 1959
Welded steel, canvas,
and wire
20 × 6¼ × 8½ in.
(50.8 × 15.9 × 21.6 cm)
Private collection

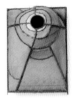

Plate 15, 1959
Welded steel, canvas,
and wire
58½ × 58⅛ × 17⅜ in.
(147.6 × 148.6 × 44.1 cm)
The Museum of Modern
Art, New York; gift of
Mr. and Mrs. Arnold H.
Maremont

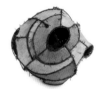

Plate 16, 1959
Welded steel, canvas,
and wire
44 × 60 × 17 in.
(111.8 × 152.4 × 43.2 cm)

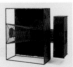

Plate 17, 1958
Welded steel, canvas,
and wire
25½ × 30 × 11 in.
(64.8 × 76.2 × 27.9 cm)

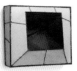

Plate 18, 1959
Welded steel, canvas,
and screen
26 × 31 × 12½ in.
(66 × 78.7 × 31.8 cm)
Private collection,
New York

Plate 19, 1959
Welded steel, canvas,
and wire
16½ × 14 × 11¾ in.
(41.9 × 35.6 × 29.8 cm)
Collection of Claudia R.
Luebbers, Chicago

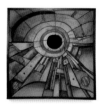

Plate 20, 1959
Welded steel with
chamois
7½ × 8½ × 9 in.
(19 × 21.6 × 22.9 cm)

Plate 21, 1960*
Welded steel and canvas
72 × 72 × 18 in.
(182.9 × 182.9 × 45.7 cm)
The Art Institute of
Chicago; gift of the
Society for Contem-
porary Art

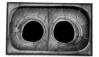

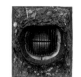

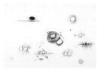

Plate 22, 1959/1960
Welded steel, canvas,
wire, and velvet
58 × 99 × 15 in.
(147.3 × 251.5 × 38.1 cm)
Collection of Maxine and
Stuart Frankel Foundation
for Art

Plate 26, 1961
Welded steel, canvas,
epoxy, and plastic
32 × 27½ × 14 in.
(81.3 × 69.8 × 35.6 cm)
Private collection

Plate 29, 1961
Graphite on paper
27 × 39¼ in.
(68.6 × 99.7 cm)
The Museum of
Contemporary Art, Los
Angeles; purchased with
funds provided by The
Gene J. Burton Acqui-
sitions Endowment and
Betye M. Burton

Plate 33, 1961
Welded steel, soot on
canvas, and wire
28½ × 15½ × 17¾ in.
(72.4 × 39.4 × 45.1 cm)
Elvehjem Museum of
Art, University of
Wisconsin – Madison;
Edna G. Dyar, Humanistic
Foundation Fund and
National Endowment for
the Arts Fund purchase
(1973.5)

Plate 36, 1961
Graphite on paper
22⅝ × 28¾ in.
(57.5 × 73 cm)
The Menil Collection,
Houston

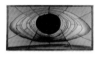

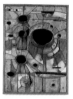

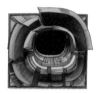

Plate 23, 1960*
Welded steel and canvas
49 × 96 × 14 in.
(124.5 × 243.8 × 35.6 cm)
Collection Museum
Boijmans Van
Beuningen, Rotterdam

Plate 27, 1960*
Welded steel and canvas
72 × 56 × 20 in.
(182.9 × 142.2 × 50.8 cm)
Virginia Museum of
Fine Arts, Richmond;
gift of Sydney and
Frances Lewis (85.364)

Plate 30, 1961
Graphite on paper
27 × 39 in.
(68.6 × 99.1 cm)
Collection of
Barbara Jakobson

Plate 37, 1961
Graphite on paper
22½ × 28½ in.
(57.2 × 72.4 cm)
Courtesy of Michael
Rosenfeld and halley k
harrisburg, New York

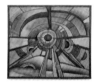

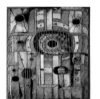

Plate 24, 1960
Welded steel, canvas,
and wire
43¼ × 51½ × 12 in.
(109.8 × 130.8 × 30.5 cm)
Collection of Albright-
Knox Art Gallery,
Buffalo, N.Y.;
gift of Seymour H.
Knox Jr., 1961

Plate 28, 1961*
Welded steel, canvas,
and wire
52 × 47⅞ × 12 in.
(132 × 121.6 × 30.5 cm)
Contemporary
Collection of the
Cleveland Museum of
Art (1967.77)

Plate 31, 1961
Graphite on paper
26¾ × 38¹⁵⁄₁₆ in.
(68 × 99 cm)
The Art Institute of
Chicago; gift of the
Society for Contem-
porary American Art

Plate 34, 1961
Welded steel, canvas,
and wire
80¼ × 89 × 34¾ in.
(203.6 × 226 × 88 cm)
The Museum of Modern
Art, New York; Kay Sage
Tanguy Fund

Plate 38, 1961
Graphite on paper
28½ × 22½ in.
(72.4 × 57.2 cm)
Private collection,
New York

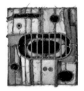

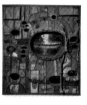

Plate 25, 1960
Welded steel, canvas,
and wire
7¾ × 7 × 3 in.
(19.7 × 17.8 × 7.6 cm)
Collection of
Robert H. Halff

Plate 32, 1961
Charcoal on paper
22⅝ × 28½ in.
(57.5 × 72.4 cm)
The Museum of Modern
Art, New York; gift
of John S. Newberry
(124.1962)

Plate 35, 1961
Welded steel, canvas,
wire, and velvet
56 × 39½ × 21⅛ in.
(142.2 × 100.3 × 53.6 cm)
Collection Walker Art
Center, Minneapolis;
gift of the T.B. Walker
Foundation, 1966

Plate 39, 1961
Welded steel, canvas,
wire, and rope
72⅝ × 66 × 25⁷⁄₁₆ in.
(184.5 × 167.6 × 64.6 cm)
Whitney Museum of
American Art, New York;
purchase (61.41)

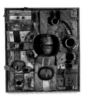

Plate 40, 1962
Welded steel, canvas,
and wire
76 × 70½ × 27 in.
(193 × 179.1 × 68.6 cm)
David Winton Bell
Gallery, Brown Uni-
versity, Providence, R.I.;
gift of Vicki List from
the Albert A. List Family
Collection

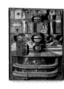

Plate 41, 1962
Welded steel, canvas,
and wire
43¼ × 34½ × 15 in.
(109.8 × 87.6 × 38.1 cm)
Moderna Museet,
Stockholm

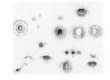

Plate 42, 1962
Graphite on paper
19¾ × 25½ in.
(50.2 × 64.8 cm)
The Museum of Modern
Art, New York; gift of
Sarah-Ann and Werner
H. Kramarsky

Plate 43, 1962
Graphite on paper
18¾ × 23¾ in.
(47.6 × 60.3 cm)
The Menil Collection,
Houston

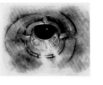

Plate 44, 1962
Graphite on paper
25½ × 19¾ in.
(64.8 × 50.2 cm)
Collection Herbert F.
Johnson Museum,
Cornell University,
Ithaca, N.Y.; gift of Mr.
and Mrs. James Berry
Hill, Class of 1967

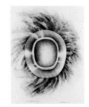

Plate 45, 1962
Soot on paper
10 × 13 in.
(25.4 × 33 cm)
Collection of
Marc Selwyn

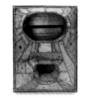

Plate 46, c. 1962
Graphite on paper
23½ × 18½ in.
(59.7 × 47 cm)
Collection of
Maxine and Stuart
Frankel

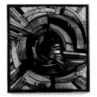

Plate 47, 1962
Welded steel, canvas,
and wire
57 × 54½ × 22 in.
(144.8 × 138.4 × 55.9 cm)
Private collection

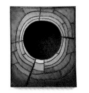

Plate 48, 1962
Welded steel, canvas,
and wire
25⅜ × 21½ × 6¼ in.
(64.5 × 54.6 × 15.9 cm)
Collection of
Maxine and Stuart
Frankel

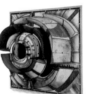

Plate 49, 1962
Welded steel, canvas,
and wire
68 × 72 × 30 in.
(172.7 × 182.9 × 76.2 cm)
The Museum of Fine
Arts, Houston.
Gift of D. & J. de Menil

Plate 50, 1962
Welded steel, canvas,
wire, and grommets
14½ × 10 in.
(36.8 × 25.4 cm)
Collection of Tony and
Gail Ganz, Los Angeles

Plate 51, 1963
Welded and painted
steel, soot, and velvet
16¾ × 12⅛ × 3¾ in.
(42.5 × 30.8 × 9.5 cm)
Private collection

Plate 52, 1963
Graphite and soot
on paper
14 × 11⅝ in.
(35.6 × 29.5 cm)
Collection of Tony and
Gail Ganz, Los Angeles

Plate 53, 1963
Graphite and soot
on muslin
47¼ in. diameter
(120 cm)
Whitney Museum of
American Art, New York;
purchase, with funds
from the Friends of the
Whitney Museum of
American Art (64.12)

Plate 54, 1963
Graphite and soot
on muslin
81⅞ in. diameter
(208 cm)
Princeton University Art
Museum. Museum
purchase, Laura P. Hall
Memorial Fund

Plate 55, 1963
Graphite and soot
on paper
10 × 13 in.
(25.4 × 33 cm)

Plate 56, 1963
Graphite and soot
on paper
10 × 13 in.
(25.4 × 33 cm)

Plate 57, 1963
Graphite and soot
on paper
10 × 13 in.
(25.4 × 33 cm)

Plate 58, 1963
Graphite and soot
on paper
10 × 13 in.
(25.4 × 33 cm)

Plate 59, 1963
Soot on muslin
11 × 19 in.
(27.9 × 48.3 cm)
Private collection, Los
Angeles, courtesy of the
Daniel Weinberg Gallery,
Los Angeles

Plate 60, 1963
Graphite and soot
on muslin
17 × 15 in.
(43.2 × 38.1 cm)
Private collection,
Los Angeles

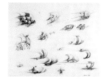

Plate 61, 1964*
Welded steel, canvas,
epoxy, resin, and
Plexiglas
21⅓ × 5½ × 2 ft.
(6.5 × 1.7 × 0.6 m)
Lincoln Center for the
Performing Arts, Inc.,
New York State Theater,
a gift of Albert A. List
Foundation, Inc.

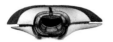

Plate 62, 1964
Welded steel, canvas,
epoxy, and wire
9 × 27 × 14 in.
(22.9 × 68.6 × 35.6 cm)
Collection of Joel Wachs

Plate 63, 1964
Graphite on paper
22½ × 28½ in.
(57.2 × 72.4 cm)
Collection of Maxine
and Stuart Frankel
Foundation for Art

Plate 64, 1964
Graphite on paper
22½ × 28½ in.
(57.2 × 72.4 cm)
Collection Neuberger
Museum of Art
Purchase College, State
University of New York;
gift of Roy R. Neuberger

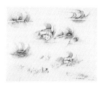

Plate 65, 1964
Graphite on paper
36 × 28 in.
(91.4 × 71.1 cm)
Collection of Dorothy J.
Flash, Newton, Mass.

Plate 66, 1964
Welded steel, canvas,
and wire
72 × 80 × 18 in.
(182.9 × 203.2 × 45.7 cm)
Honolulu Academy of
Arts; purchase, 1968
(3545.1)

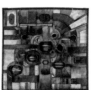

Plate 67, 1964
Graphite on paper
27 × 19¾ in.
(68.6 × 50.2 cm)
Collection of
Marc Selwyn

Plate 68, 1964
Soot, graphite, and
aniline dye on muslin
17 × 13 in.
(43.2 × 33 cm)
Collection of Barbara
Lee, Boston

Plate 69, 1964
Graphite on paper
28½ × 22½ in.
(72.4 × 57.2 cm)
Collection of Tony and
Gail Ganz, Los Angeles

Plate 70, 1965*
Welded steel
21 × 60 × 3 in.
(53.3 × 152.4 × 7.6 cm)
Collection of Roberta
Roth Goodman, New
York

Plate 71, 1965
Welded and painted
steel, and soot
19⅜ × 17⅛ × 3⅜ in.
(49.2 × 43.5 × 8.6 cm)
Des Moines Art Center's
Louise Noun Collection
of Art by Women

Plate 72, 1966
Welded and painted
steel, and soot
73 × 88 × 9 in.
(185.4 × 223.5 × 22.9 cm)
Solomon R. Guggen-
heim Museum, New
York; gift, Mr. and
Mrs. Leo Castelli, 1974
(74.212)

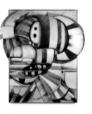

Plate 73, 1964
Graphite on muslin
18 × 14 in.
(45.7 × 35.6 cm)
Private collection,
New York

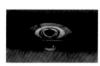

Plate 74, 1966
Graphite and soot
on paper
19¾ × 27⅛ in.
(50.2 × 68.9 cm)
Museum of Art, Rhode
Island School of Design,
Providence; Albert
Pilavin Memorial
Collection of Twentieth-
Century American Art

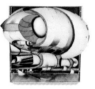

Plate 75, 1966
Welded steel, canvas,
chamois, epoxy,
and wire
33¼ × 33½ × 14½ in.
(84.4 × 85.1 × 36.8 cm)
Collection of Sydney
and Frances Lewis

Plate 76, 1966*
Welded steel, paint,
fiberglass, and leather
100 × 90 × 26 in.
(254 × 228.6 × 66 cm)
The Governor Nelson A.
Rockefeller Empire State
Plaza Art Collection

Plate 77, 1966
Welded steel, canvas,
epoxy, leather, wire,
and light
78½ × 119 × 31 in.
(199.4 × 302.3 × 78.7 cm)
Museum of Contem-
porary Art, Chicago;
gift of Robert B. Mayer
Family Collection
(1991.85)

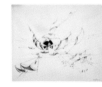

Plate 78, 1966
Welded steel, canvas,
epoxy, fabric, leather,
and wire
72¼ × 109¼ × 22 in.
(183.5 × 277.5 × 55.9 cm)
Fonds National d'Art
Contemporain, Paris
Ministère de la Culture
et de le Communication,
France

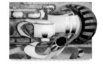

Plate 79, 1967*
Graphite and ink
on paper
20 × 26 in.
(50.8 × 66 cm)
Virginia Museum of Fine
Arts, Richmond; The
John Barton Payne Fund

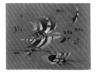

Plate 80, 1967
Colored pencil on paper
15⅜ × 20⅝ in.
(39 × 52.4 cm)
Collection of Sydney and
Frances Lewis

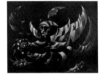

Plate 81, 1967
Colored pencil on paper
18 × 24 in.
(45.7 × 61 cm)
Collection of Daniel
Weinberg, Los Angeles

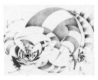

Plate 82, 1967
Graphite and ink on
velour paper
20 × 26 in.
(50.8 × 66 cm)
The Museum of
Modern Art, New York;
gift of Wilder Green
(583.1970)

Plate 83, 1967
Graphite and ink on
velour paper
20⅜ × 25⅞ in.
(51.7 × 65.9 cm)
Courtesy of the Fogg Art
Museum, Harvard
University Art Museums,
Margaret Fisher Fund

Plate 84, 1967
Graphite and ink on
velour paper
20 × 26 in.
(50.8 × 66 cm)
Hirshhorn Museum and
Sculpture Garden,
Smithsonian Institution;
Joseph H. Hirshhorn
Purchase Fund, 1981

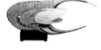

Plate 85, 1967
Balsa wood, epoxy,
and silk
11½ × 25 × 7½ in.
(29.2 × 63.5 × 19 cm)

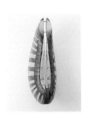

Plate 86, 1967
Paper and wood
35 × 13 × 12 in.
(88.9 × 33 × 30.5 cm)
Collection of Tony and
Gail Ganz, Los Angeles

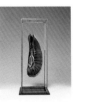

Plate 87, 1967
Welded steel, wood,
and silk
26½ × 11 × 11 in.
(67.3 × 27.9 × 27.9 cm)
Courtesy of Michael
Rosenfeld and halley k
harrisburg, New York

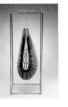

Plate 88, 1967
Welded steel, wood,
and silk
55½ × 22⅜ × 22⅜ in.
(141 × 56.8 × 56.8 cm)
Hirshhorn Museum and
Sculpture Garden,
Smithsonian Institution;
gift of Joseph H.
Hirshhorn, 1972

Plate 89, 1969
Vacuum-formed plastic
19 × 9½ × 5 in.
(48.3 × 24.1 × 12.7 cm)

Plate 90, 1967
Vacuum-formed plastic
27 × 15 × 9 in.
(68.6 × 38.1 × 22.9 cm)

Plate 91, 1969
Vacuum-formed plastic
21 × 7 × 9 in.
(53.3 × 17.8 × 22.9 cm)

Plate 92, 1968
Vacuum-formed plastic
21 × 10 × 9 in.
(53.3 × 25.4 × 22.9 cm)

Plate 93, 1969
White charcoal on paper
18 × 24 in.
(45.7 × 61 cm)
Courtesy of Michael
Rosenfeld and halley k
harrisburg, New York

Plate 94, 1969
Vacuum-formed plastic
30 × 13 × 12 in.
(76.2 × 33 × 30.5 cm)
Collection of Tony and
Gail Ganz, Los Angeles

Plate 95, 1969
Vacuum-formed plastic
12 × 12½ × 13½ in.
(30.5 × 31.8 × 34.3 cm)
Collection of Tony and
Gail Ganz, Los Angeles

Plate 96, 1969*
Vacuum-formed plastic
8 × 8 × 2½ ft.
(2.4 × 2.4 × 0.8 m)
Location unknown

Plate 97, 1970
Graphite on paper
29 × 23 in.
(73.7 × 58.4 cm)
Courtesy of the Fogg Art
Museum, Harvard
University Art Museums,
Cambridge, Mass.;
Margaret Fisher Fund

Plate 98, 1970
Colored pencil on paper
35¼ × 23 in.
(89.5 × 58.4 cm)
Collection of Tony and
Gail Ganz, Los Angeles

Plate 99, 1969
Vacuum-formed plastic
30 × 57 × 21 in.
(76.2 × 144.8 × 53.3 cm)

Plate 100, 1970
Vacuum-formed plastic
13 × 15 × 8½ in.
(33 × 38.1 × 21.6 cm)
Collection of
Valerie Giles

Plate 101, 1969*
Vacuum-formed plastic
17½ × 35 × 13 in.
(44.4 × 88.9 × 33 cm)
Los Angeles County
Museum of Art; pur-
chased with funds pro-
vided by the Modern
and Contemporary Art
Council, the Richard
Florsheim Art Fund,
Tony and Gail Ganz, the
Frederick R. Weisman
Philanthropic Foun-
dation, Betty and Brack
Duker, Mark and Ellie
Lainer, the Richard and
Hinda Rosenthal Foun-
dation, Jack and Bonnie
Wilke, Sharleen Cooper
Cohen and Martin Cohen,
Phyllis Wayne, Dianne
Carr and Bob Crewe

Plate 102, 1970
Vacuum-formed plastic
9 × 10 × 7 in.
(22.9 × 25.4 × 17.8 cm)
Collection of William
Giles

Plate 103, 1971
White charcoal on paper
18 × 24 in.
(45.7 × 61 cm)
Collection of Peggy
Brooks

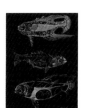

Plate 104, 1970
White charcoal on paper
26⅛ × 20 in.
(66.4 × 50.8 cm)
The Museum of Modern
Art, New York; gift of
Lily Auchincloss
(265.1973)

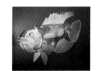

Plate 105, 1970
Vacuum-formed plastic
30 × 57 × 21 in.
(76.2 × 144.8 × 53.3 cm)
Private collection,
New York

Plate 106, 1970
White charcoal on paper
26 × 40⅜ in.
(66 × 102.6 cm)
Collection of Tony and
Gail Ganz, Los Angeles

Plate 107, 1970
Colored pencil on paper
12⅜ × 18 in.
(31.4 × 45.7 cm)
Collection of Tony and
Gail Ganz, Los Angeles

Plate 108, 1970
Colored pencil on paper
24 × 18 in.
(61 × 45.7 cm)
Collection of Tony and
Gail Ganz, Los Angeles

Plate 109, 1974–75
Graphite on gessoed
plastic paper
38 × 25 in.
(96.5 × 63.5 cm)
Arkansas Arts Center
Foundation Purchase:
Museum Purchase
Plan of the NEA and the
Tabriz Fund, 1978

Plate 110, 1972
Graphite on paper
17⅛ × 25 in.
(43.5 × 63.5 cm)
Corcoran Gallery of Art,
Washington, D.C.; gift of
William H.G. FitzGerald,
Desmond FitzGerald and
B. Francis Saul, II

Plate 111, 1973
Graphite on paper
25 × 38 in.
(63.5 × 96.5 cm)
Collection of Tony and
Gail Ganz, Los Angeles

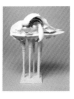

Plate 112, 1977
Clay
17 × 16 × 10 in.
(43.2 × 40.6 × 25.4 cm)

Plate 113, 1982
Colored pencil on paper
24 × 36 in.
(61 × 91.4 cm)

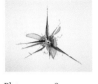

Plate 114, 1982
Casein on paper
11 × 12½ in.
(27.9 × 31.8 cm)

Plate 118, 1983
Pastel on paper
12 × 9 in.
(30.5 × 22.9 cm)
Collection of
Peggy Brooks

Plate 122, 1985
Welded steel, porcelain,
silk, wire mesh,
and wire
22 × 26 × 19 in.
(55.9 × 66 × 48.3 cm)
Collection of
Dora G. Flash

Plate 126, 1986–87
Colored pencil on
primed plastic paper
11⅝ × 14⅛ in.
(29.5 × 35.9 cm)
Courtesy of the
Daniel Weinberg
Gallery, Los Angeles

Plate 130, 1989
Graphite on paper
18 × 24 in.
(45.7 × 61 cm)

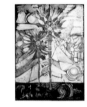

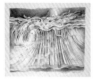

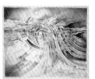

Plate 115, 1982
Casein on primed
plastic paper
14 × 14 in.
(35.6 × 35.6 cm)

Plate 119, 1983
Welded steel, porcelain,
cloth, wire mesh, and
wire
23 × 23 × 23 in.
(58.4 × 58.4 × 58.4 cm)

Plate 123, 1985
Welded steel, porcelain,
screen wire, silk, and
wire
55 × 23 × 20 in.
(139.7 × 58.4 × 50.8 cm)

Plate 127, 1987
Paint on primed plastic
paper
13¼ × 9¾ in.
(33.6 × 24.8 cm)
Collection of Daniel
Weinberg, Los Angeles

Plate 131, 1989
Graphite on paper
14 × 17 in.
(35.6 × 43.2 cm)
Collection of
Mrs. Catherine Jones

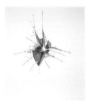

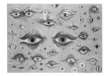

Plate 116, 1984
Pastel on paper
19½ × 25½ in.
(49.5 × 64.8 cm)

Plate 120, 1982
Casein on primed
plastic paper
19 × 20 in.
(48.3 × 50.8 cm)

Plate 124, 1987
Graphite and colored
pencil on paper
9½ × 12½ in.
(24.1 × 31.8 cm)

Plate 128, 1987
Printer's ink on
primed plastic paper
11½ × 10⅜ in.
(29.2 × 26.4 cm)
Private collection,
New York

Plate 132, 1989
Graphite on paper
14 × 17 in.
(35.6 × 43.2 cm)

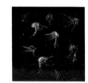

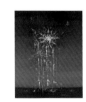

Plate 117, 1982
Casein painting on
wood board
12 × 15 in.
(30.5 × 38.1 cm)

Plate 121, 1984
Casein on primed
plastic paper
15 × 12 in.
(38.1 × 30.5 cm)

Plate 125, 1987
Graphite and colored
pencil on paper
9½ × 12½ in.
(24.1 × 31.8 cm)

Plate 129, 1987
Printer's ink on primed
plastic paper
12 × 12 in.
(30.5 × 30.5 cm)
Collection of Tony and
Gail Ganz, Los Angeles

Plate 133, 1989
Colored pencil on paper
20 × 28 in.
(50.8 × 71.1 cm)

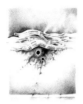

Plate 134, 1992
Graphite on paper
13 × 10 in.
(33 × 25.4 cm)
Collection of Dora G.
Flash and Russell Bourne

Plate 135, 1993
Colored pencil on paper
9 × 13½ in.
(22.9 × 34.3 cm)
Courtesy of the
Daniel Weinberg
Gallery, Los Angeles

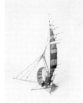

Plate 136, 1993
Welded steel, porcelain,
wire mesh, epoxy,
and wire
31½ × 22 × 13 in.
(80 × 55.9 × 33 cm)

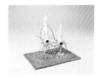

Plate 137, 1993
Welded steel,
porcelain, and wire
8½ × 9¾ × 7 in.
(22.6 × 24.8 × 17.8 cm)

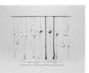

Plate 138, 1994
Welded steel, porcelain,
and string
14½ × 15½ × 4 in.
(36.8 × 39.4 × 10.2 cm)

Plate 139, 1994
Steel, porcelain, string,
and wire
10½ × 15½ × 13½ in.
(26.7 × 39.4 × 34.3 cm)

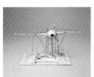

Plate 140, 1993
Steel, porcelain, wire
mesh, and wire
9 × 16½ × 8 in.
(22.9 × 41.9 × 20.3 cm)

Plate 141, 1994
Welded steel, porcelain,
wire mesh, silk,
and wire
22 × 29 × 17 in.
(55.9 × 73.7 × 43.2 cm)

Plate 142, 1994
Welded steel, porcelain,
cpoxy, and wire
22 × 17 × 12 in.
(55.9 × 43.2 × 30.5 cm)

Plate 143, 1995
Colored pencil on paper
18 × 24 in.
(45.7 × 61 cm)
Courtesy of the
Daniel Weinberg
Gallery, Los Angeles

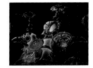

Plate 144, 1995
Welded steel, porcelain,
wire mesh, and wire
31 × 29 × 12 in.
(78.7 × 73.7 × 30.5 cm)

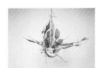

Plate 145, 1986–1995
Welded steel,
porcelain, and wire
38 × 20 × 4 in.
(96.5 × 50.8 × 10.2 cm)

Plate 146, 1986–2002
Epoxy, porcelain,
wire, and steel
on Plexiglas base
16 × 24 × 9 in.
(40.6 × 61 × 22.9 cm)

Plate 147, 1986–2002
Welded steel, porcelain,
and wire
13 × 20 × 16 in.
(33 × 50.8 × 40.6 cm)

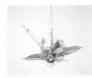

Plate 148, 1996
Pastel and colored
pencil on paper
20 × 26 in.
(50.8 × 66 cm)

Plate 149, 1996
Welded steel, porcelain,
wire mesh, silk,
and wire
61 × 55 × 74 in.
(154.9 × 139.7 × 188 cm)

Plate 150, 1996
Welded steel, porcelain,
wire mesh, cloth,
and wire
30 × 32 × 14 in.
(76.2 × 81.3 × 35.6 cm)

Plate 151, 1997
Colored pencil on paper
15 × 12 in.
(38.1 × 30.5 cm)
Courtesy of the
Daniel Weinberg
Gallery, Los Angeles

Plate 152, 1997
Graphite on paper
22½ × 30 in.
(57.2 × 76.2 cm)
Collection of Tony and
Gail Ganz, Los Angeles

Plate 153, 1997
Graphite on paper
22 × 30 in.
(55.9 × 76.2 cm)

Plate 154, 1997
Colored pencil on paper
26 × 20 in.
(66 × 50.8 cm)

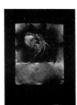

Plate 158, 1998
Colored pencil on paper
24 × 18 in.
(61 × 45.7 cm)

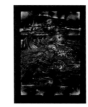

Plate 163, 1999
Colored pencil on paper
24 × 18 in.
(61 × 45.7 cm)

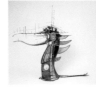

Plate 167, 2001
Welded steel, wire
mesh, porcelain, and
wire
45 × 47 × 21 in.
(114.3 × 119.4 × 53.3 cm)

Plate 155, 1997
Graphite and colored
pencil on paper
9 × 5½ in.
(22.9 × 11.4 cm)

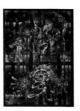

Plate 159, 1998
Pastel and colored
pencil on paper
29½ × 22 in.
(74.9 × 55.9 cm)

Plate 164, 1999
Colored pencil on paper
18 × 11 in.
(45.7 × 27.9 cm)

Plate 168, c. 1980–2001
Welded steel,
porcelain, wire mesh,
silk, and wire
8½ ft. × 8½ ft. × 6½ in.
(2.6 m × 2.6 m
× 16.5 cm)

Plate 156, 1997
Colored pencil on paper
18 × 10 in.
(45.7 × 25.4 cm)

Plates 160 and 161,
c. 1980–1998
Welded steel, porcelain,
wire mesh, canvas,
and wire
7 × 8 × 6 ft.
(2.1 × 2.4 × 1.8 m)

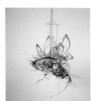

Plate 165, 1990–2000
Welded steel,
porcelain, wire mesh,
silk, and wire
6⅔ ft. × 8 ft. × 5½ in.
(2 m × 2.4 m × 14 cm)

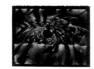

Plate 157, 1998
Pastel and colored
pencil on paper
11 × 15 in.
(27.9 × 38.1 cm)
Courtesy of the
Daniel Weinberg
Gallery, Los Angeles

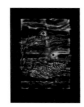

Plate 162, 1999
Colored pencil on paper
24 × 18 in.
(61 × 45.7 cm)

Plate 166, 1985–2001
Pastel on canvas
66 × 77 in.
(167.6 × 195.6 cm)

Exhibition History

Solo Exhibitions

1959

G Gallery, New York

1960

Leo Castelli Gallery, New York

1962

Leo Castelli Gallery, New York

1965

Galerie Ileana Sonnabend, Paris

1966

Leo Castelli Gallery, New York

1968

Kunstverein Giannozzo, Berlin, Germany

Museum Boijmans Van Beuningen, Rotterdam, Netherlands

Stadtisches Museum, Schloss Morsbroich, Leverkusen, Germany

1971

Leo Castelli Gallery, New York

1972

Museum of Contemporary Art, Chicago

1975

Davison Art Center, Wesleyan University, Middletown, Conn.

1976

Halper Gallery, Palm Beach, Fla.

1977

Lee Bontecou in Retrospect, Hathorn Gallery, Skidmore College, Saratoga Springs, N.Y.

1993

Sculpture and Drawings of the 1960s, The Museum of Contemporary Art, Los Angeles; traveled to The Nelson-Atkins Museum of Art, Kansas City, Mo., and The Parrish Art Museum, Southhampton, N.Y.

1995

Lee Bontecou, Early Drawings, Daniel Weinberg Gallery, San Francisco

1996

Reliefs 1959–1960, Bonnefanten Museum of Maastricht, Netherlands

1999

Lee Bontecou 1958–1972, Leo Castelli Gallery, New York

2001

Lee Bontecou: Drawings 1962–1998, Daniel Weinberg Gallery, Los Angeles

Group Exhibitions

1957

Sculture nelle Citta, Spoleto, Italy

1960

New Media: New Forms I and II, Martha Jackson Gallery, New York

1961

The Art of Assemblage, The Museum of Modern Art, New York; traveled to Museum for Contemporary Arts, Dallas, and San Francisco Museum of Art

Le Nouveau Realisme, Galerie Rive Droite, Paris

New York Scene, New London Gallery (Marlborough Fine Arts Limited), London

The Pittsburgh International Exhibition, Carnegie Institute, Pittsburgh, Penn.

Six Sculptors, Dwan Gallery, New York

Sixth São Paulo Bienal, The São Paulo Museum of Modern Art, São Paulo, Brazil

Whitney Annual Exhibition: Sculpture and Drawings, Whitney Museum of American Art, New York

1962

Art since 1950, Seattle World's Fair, Seattle, Wash.

Brandeis University, Waltham, Mass.

Continuity and Change, The Wadsworth Antheneum, Hartford, Conn.

Drawings, Leo Castelli Gallery, New York

Galerie Ileana Sonnabend, Paris

Sixty-Fifth Annual American Exhibition, The Art Institute of Chicago

1963

Americans 1963, The Museum of Modern Art, New York

Aspetti dell'Arte Contemporanea, L'Aguilla, Italy

Donner a Voir, Galerie Creuze, Paris

Mixed Media and Pop Art, Albright-Knox Art Gallery, Buffalo, N.Y.

Premier Salon International de Galeries Pilotes, Musée Cantonal Des Beaux-Arts, Lausanne, Switzerland

Sixty-Sixth Annual American Exhibition, The Art Institute of Chicago

The South County State Bank, Saint Louis, Mo.

Twenty-Eighth Biennial Exhibition, The Corcoran Gallery of Art, Washington, D.C.

Whitney Annual Exhibition — Sculpture and Drawing, Whitney Museum of American Art, New York

1964

The Artists' Reality: The New School, New York, Morris International Gallery, Toronto

Documenta III, Kassel, Germany

International Drawing Show, Hessisches Landesmuseum, Darmstadt, Germany

International Prize, Instituto Torcuato di Tella, Buenos Aires, Argentina

New American Sculpture, Pasadena Art Museum, Pasadena, Calif.

New York State Theater, Lincoln Center for the Performing Arts, New York

One Hundred American Drawings, Byron Gallery, New York

Painting and Sculpture of a Decade: 1959–1964, Tate Gallery, London

Whitney Annual Exhibition, Whitney Museum of American Art, New York

1966

Drawings, University of Texas, Austin

Flint Invitational, Flint Institute of the Arts, Flint, Mich.

Harry N. Abrams Family Collection, The Jewish Museum, New York

National Institute of Arts and Letters (first prize), New York

Sculpture Annual, Whitney Museum of American Art, New York

1967

Sculpture — A Generation of Innovation, The Art Institute of Chicago

Ten Years, Leo Castelli Gallery, New York

1968

Sculpture Annual, Whitney Museum of American Art, New York

1969

An American Report on the Sixties, Denver Art Museum, Denver, Colo.

Ars '69 Helsinki, Ateneum, Helsinki, Finland

Contemporary Drawing Show, Fort Worth Art Center, Fort Worth, Tex.

1970

The Drawing Society National Exhibition, American Federation of the Arts, New York

Kaiser Wilhelm Museum, Krefeld, Germany

L'Art Vivant Americain, Foundation Maeght, Saint Paul-de-Vence, France

Pittsburgh International Exhibition, Carnegie Institute, Pittsburgh, Penn.

1971

Art on Paper, Weatherspoon Gallery, University of North Carolina, Greensboro, N.C.

1972

Drawings, Leo Castelli Gallery, New York

1973

American Drawing: 1970–73, Yale University Art Gallery, New Haven, Conn.

Say It with Flowers, The Emily Lowe Gallery, Hofstra University, Hempstead, N.Y.

1974

Drawings, Leo Castelli Gallery, New York

In Three Dimensions, Leo Castelli Gallery, New York

1975

Thirty Artists in America, Part I, Michael Walls Gallery, New York

1976

American Artists '76: A Celebration, Marion Koogler McKnay Art Institute, San Antonio, Tex.

1980

Drawings to Benefit the Foundation for Contemporary Performance Art, Inc., Leo Castelli Gallery, New York

The Eclectic Mood in Black, Aaron Berman Gallery, New York

Ed Ruscha, Billy Benston, Edward Kienholz, Lee Bontecou, Ed Moses, Craig Kauffman Paintings, Asher/Faure Gallery, Los Angeles

From Reinhardt to Christo, Allen Memorial Art Museum, Oberlin College, Oberlin, Ohio

New York Collection Portfolio, Tyler Museum of Art, Tyler, Tex.

Reliefs, Kunsthaus Zurich, Zurich, Switzerland

1981

The New Dimensions in Drawing, Aldrich Museum of Contemporary Art, Ridgefield, Conn.

Selections from Castelli, Neil G. Ovsey Gallery, Los Angeles

1982

The Americans: College 1950–1982, Contemporary Art Museum, Austin, Tex.

Castelli and His Artists: Twenty-Five Years (organized by the Aspen Center for the Visual Arts), La Jolla Museum of Contemporary Art, La Jolla, Calif.; traveled to Aspen Center for the Visual Arts, Aspen, Colo.; Portland Center for the Visual Arts, Portland, Ore.; and Laguna Gloria Art Museum, Austin, Tex.

Universal Limited Art Editions: A Tribute to Tatyana Grosman, Whitney Museum of American Art, downtown at Federal Reserve Plaza, New York

Women's Art: Miles Apart, Aaron Berman Gallery, New York; traveled to Valencia Community College, Orlando, Fla.

1983

Nocturne, Seigel Contemporary Art, New York

1984

Dorthy C. Miller: With an Eye to American Art, Smith College Museum of Art, Northampton, Mass.

Socialites and Satellites, Ronald Feldman Gallery, New York

The Third Dimension, Whitney Museum of American Art, New York; traveled to Fort Worth Art Museum, Fort Worth, Tex.; Cleveland Museum of Art, Cleveland, Ohio; and Newport Harbor Art Museum, Newport Beach, Calif.

1986

Definitive Statements: American Art 1964–66, Bell Gallery, Brown University, Providence, R.I.

1987

Alternative Supports: Contemporary Sculpture on the Wall, Bell Gallery, Brown University, Providence, R.I.

Leo Castelli and His Artists: Thirty Years of Promoting Contemporary Art, Centro Cultural Arts Contemporaneo, Mexico City

Twentieth-Century Art in the Museum Collections: Direction and Diversity, The Museum of Fine Arts, Houston

1993

The Second Dimension: Twentieth-Century Sculptors' Drawings, Brooklyn Museum, Brooklyn, N.Y.

1994

Animal Farm, James Corcoran Gallery, Santa Monica, Calif.

Bontecou, Higgins, Moskowitz — Work from the 1960s, Leo Castelli Gallery, New York

Fine Lines, Anthony Slayter-Ralph, Santa Barbara, Calif.

Jay Gorney Modern Art, New York

The Mary and Leigh Block Gallery, Northwestern University, Evanston, Ill.

Printmaking in America: Collaborative Presses and Prints, 1960–1990, The Jane Voorhees Zimmerli Art Museum, Rutgers: The State University of New Jersey, New Brunswick

Selections from the Collection, Akron Art Museum, Akron, Ohio

1996

'50/50: Fifty Artists from Fifty Years of Skowhegan, Anniversary Exhibition & Raffle, PaceWildenstein Gallery, New York

Kingdom of Flora, Shoshana Wayne Gallery, Santa Monica, Calif.

The Museum of Fine Arts, Houston

National Museum of American Art, Smithsonian Institution, Washington D.C.

1999

The American Century: Art and Culture 1900–2000, Whitney Museum of American Art, New York

2000

Sculpture by Richard Artschwager, Lee Bontecou, John Chamberlain, Daniel Weinberg Gallery, Los Angeles

True Grit: Lee Bontecou, Louise Bourgeois, Jay DeFeo, Claire Falkenstein, Nancy Grossman, Louise Nevelson, Nancy Spero, Michael Rosenfeld Gallery, New York

Selected Bibliography

1959

Munsterberg, Hugo D. "In the Galleries: Lee Bontecou." *Arts Digest* 33, no. 6 (March), p. 64.

1960

Hamilton, George-Heard. "Painting in Contemporary America." *The Burlington Magazine* 102 (May), pp. 192–97.

Judd, Donald. "Lee Bontecou at Leo Castelli." *Arts Magazine* 35 (December), p. 56.

Willard, Charlotte. "Market Letter — Find of the Year." *Art in America* (March), p. 4.

1961

Craig, Martin. "Notes on Sculpture in a Mad Society." *Art News* 60 (September), p. 61.

"Les Machines: Terreur de Lee Bontecou." *Metro*, no. 3, pp. 80–82.

Lipman, Jean and Cleve Gray. "The Amazing Inventiveness of Women Painters." *Cosmopolitan* (October), p. 69.

Norland, Gerald. "West Coast in Review." *Arts Magazine* 36 (December), p. 64.

Seitz, William. *The Art of Assemblage.* Exh. cat. New York: The Museum of Modern Art.

Six Sculptors. Exh. cat. Los Angeles: Dwan Gallery.

1962

Ashton, Dore. "Exhibition of Drawings at the Leo Castelli Gallery." *Studio* 164 (September), pp. 106–7.

Janis, Harriet and Rudi Blesh. *Collage: Personalities, Concepts, Techniques.* Philadelphia, Penn.: Chilton Co.; Toronto, Canada: Ambassador Books, Ltd.

Preston, Stuart. "What's New at the Modern." *New York Times,* November 25, section 2, p. 25.

1963

Ashton, Dore. "Art." *Arts & Architecture* 80 (January), p. 5.

———. "Illusion and Fantasy: Lee [Magica Fantasia di Lee]." *Metro,* no. 8 (April), pp. 28–33.

———. "New York Letter." *Das Kunstwerk* 16 (April), p. 32.

Baro, Gene. "A Gathering of Americans." *Arts Magazine* 37, no. 10 (September), pp. 28–33.

Campbell, Lawrence. "Lee Bontecou." *Art News* 61, no. 9 (September), p. 11.

Canaday, John. "Art: Fifteen Exhibit at Modern." *New York Times,* May 22, p. 38.

———. "Americans Once More: Museum of Modern Art Makes New Choices." *New York Times,* May 26, section 2, p. 11.

Judd, Donald. "Lee Bontecou." *Arts Magazine* 37, no. 4 (January), p. 44.

"Leo Castelli, New York: la Sua storia, la Sua galleria." *Domus,* no. 406 (September), p. 43.

"The Loft-Waif." *Time* 81, no. 5 (February 1), pp. 58–59.

Miller, Dorothy. *Americans 1963.* Exh. cat. New York: The Museum of Modern Art.

Women in Contemporary Art. Exh. cat. Durham, N.C.: Duke University.

1964

Alfieri, Bruno, ed. *Metro International Directory of Contemporary Art.* Milan: Metro.

Ashton, Dore. "Lee Bontecou." *Recent American Sculpture.* Exh. cat. New York: The Jewish Museum.

Coplans, John. "Higgins, Price, Chamberlain, Bontecou, Westermann." *Artforum* 2, no. 10 (April), pp. 38–40.

Documenta III: Internationale Ausstellung. Exh. cat. Kassel, Germany: Kassel Alte Galerie.

Faison, Lane S. *Art Tours and Detours in New York State.* New York: Random House.

"Fifty-six Painters and Sculptors." *Art in America* 52, no. 4 (summer), p. 75.

Hopps, Walter. "Boxes." *Arts International* 8, no. 2 (March), pp. 38–40.

Johnson, Philip. "Young Artists at the Fair and at Lincoln Center." *Art in America* 52, no. 4 (summer), p. 123.

Judd, Donald. "Local History." *Arts Yearbook 7: New York: The Art World.* New York: The Art Digest. Pp. 22–36.

Kelly, Edward T. "Neo-Dada: A Critique of Pop Art." *The Art Journal* 23 (spring), pp. 192–201.

Monte, James. "Americans, 1963, San Francisco Museum of Art." *Artforum* 3, no. 1 (September), pp. 43–44.

New American Sculpture. Exh. cat. Pasadena, Calif.: Pasadena Art Museum.

"Young Sculptor Brings Jet Age to Lincoln Center: It's Art, But Will It Fly?" *Life* 56, no. 15, pp. 43–44.

1965

Ashton, Dore. "Unconventional Techniques in Sculpture." *Studio International* 169 (January), pp. 22–25.

Boudaille, Georges. "Peinture Fraiche." *Lettres Francaises,* April 22.

Judd, Donald. "Lee Bontecou." *Arts Magazine* 39, no. 7 (April), pp. 17–21. See also pp. 194–199 of this volume.

———. "Specific Objects." *Arts Yearbook 8: Contemporary Sculpture.* New York: The Art Digest. Pp. 74–83.

"Lee Bontecou." *Das Kunstwerk* (April–June), p. 10.

1966

Ashton, Dore. "Art." *Arts & Architecture* 8, no. 11 (December), p. 5.

"Cornucopia: Lee Bontecou." *Newsweek* (October 24), p. 107.

Hunter, Sam, ed. *New Art around the World: Painting and Sculpture.* New York: Harry N. Abrams.

"On the New York Scene." *Harper's Bazaar* (July).

Willard, Charlotte. "Lee Bontecou." *New York Post* (October).

1967

Dienst, Rolf-Gunter. "Lee Bontecou." *Das Kunstwerk* 20 (June), pp. 3–4.

Kuh, Katharine. "Pittsburgh's Mini-International." *Saturday Review* (December 2), pp. 45–47.

Solomon, Alan. *New York: The New Art Scene.* New York: Holt, Rinehart, and Winston. Pp. 98–113.

1968

Ashton, Dore. *Lee Bontecou: Sculpturen, tekeningen, litho's.* Exh. cat. Rotterdam: Museum Boijmans Van Beuningen.

Battcock, Gregory, ed. *Minimal Art: A Critical Anthology.* New York: E. P. Dutton.

Lebel, Robert. "L' Irruption des Femmes dans la Sculpture." *XXe Siecle,* no. 30 (June), pp. 133–42.

Lee Bontecou. Exh. cat. Leverkusen, Germany: Stadtisches Museum, Schloss Morsbroich.

Weller, Allen S. *The Joys and Sorrows of Recent American Art.* Urbana, Ill.: University of Illinois Press.

1969

Kozloff, Max. "Whitney Annual, Sculpture." *Artforum* 8, no. 1 (February), p. 64.

"Lee Bontecou; Buffy Sainte-Marie; Barbara Jo Rubin." *Vogue* (May), pp. 194–95.

"Lee Bontecou, Untitled." *Bulletin of the Cleveland Museum of Art* (February), pp. 78–80.

1970

Field, Richard S. "Lee Bontecou's Aquatints." *Art International* 14 (November), pp. 25–28.

Spahr, P. Andrew. *Abstract Sculpture in America: 1930–1970.* New York: American Federation of the Arts.

1971

Canaday, John. "All New Talent in Printmaking Show." *New York Times*, May 22, p. 27.

Mellow, James R. "Bontecou's Well-Fed Fish and Malevolent Flowers." *New York Times*, June 6, p. D19.

Perrault, John. "Art." *Village Voice*, October 6, p. 28.

Piccard, Lil. "Leo Castelli gallery, New York; austellung." *Das Kunstwerk* 24 (September), p. 74.

Towle, Tony. "Two Conversations with Lee Bontecou." *Print Collector's Newsletter* 2, no. 2 (May–June), pp. 25–28.

Welish, Marjorie. "Art." *Manhattan East* 1 (June), p. 2.

1972

American Women: Twentieth Century. Exh. cat. Peoria, Ill.: Lakeview Center for the Arts and Sciences.

Pincus-Witten, Robert. "Rosenquist and Samaras: The Obsessive Image and Post-Minimalism." *Artforum* 11, no. 1 (September), pp. 63–69.

Ratcliff, Carter. *Lee Bontecou*. Exh. cat. Chicago: Museum of Contemporary Art.

1973

Chicago, Judy and Miriam Schapiro. "Female Imagery." *Woman-space Journal* (summer), p. 13.

Hunter, Sam. *American Art of the Twentieth Century: Painting, Sculpture, Architecture*. New York: Harry N. Abrams.

1974

Johnson, Lincoln F. "A Diversity of Approaches in Contemporary Art: Rauschenberg, Bontecou, and Noland." *Honolulu Academy of Arts Journal* 1, pp. 51–67.

Lippard, Lucy. "Judy Chicago: Talking to Lucy R. Lippard," *Artforum* 13, no. 1 (September), pp. 60–65.

Waves. Exh. cat. Grand Rapids, Mich.: Cranbrook Academy of Art / Museum and Grand Rapids Art Museum.

1975

Field, Richard. *Prints and Drawings by Lee Bontecou*. Exh. cat. Middletown, Conn.: Davison Art Center, Wesleyan University Press.

Garretson, Julia. "Tatyana Grosman's Universal Limited Art Editions." *Craft Horizons* 35, no. 1 (February), pp. 52–54, 69–70.

Munsterberg, Hugo. *A History of Women Artists*. New York: Clarkson N. Potter.

1976

Johnson, Ellen H. *Modern Art and the Object: A Century of Changing Attitudes*. New York: Harper Collins. Pp. 14–15.

Lippard, Lucy. *Eva Hesse*. New York: New York University Press. Pp. 55–56.

1977

Lee Bontecou in Retrospect: Paintings and Drawings. Exh. cat. Saratoga Springs, N.Y.: Hathorn Gallery, Skidmore College.

1978

Perspective '78: Works by Women. Exh. cat. Reading, Penn.: Albright Gallery, Freedman College. P. 8.

1979

Munro, Eleanor. *Originals: American Women Artists*. New York: Simon & Schuster. Pp. 377–87.

1980

"Prints and Photographs Published." *Print Collector's Newsletter* 11, no. 2 (May–June), p. 53.

1982

Rigby, Ida K. "Castelli Discovers." *Artweek* 13, no. 20 (May), p. 4.

1984

Phillips, Lisa. *The Third Dimension: Sculpture of the New York School*. Exh. cat. New York: Whitney Museum of American Art.

1986

Dreishpoon, Douglas. *The Sculptural Membrane*. Exh. cat. New York: Sculpture Center. Pp. 2–15.

1987

Heller, Nancy G. *Women Artists: An Illustrated History*, third ed. New York: Abbeville Press. Pp. 189–91.

1989

Sparks, Esther. *Universal Limited Art Editions: A History and Catalogue — The First Twenty-Five Years*. Chicago and New York: The Art Institute of Chicago and Harry N. Abrams. Pp. 50–54.

1990

Chadwick, Whitney. *Women, Art, and Society*. London: Thames and Hudson. Pp. 334–35.

Myers, Terry R. "From the Junk Aesthetic to the Junk Mentality." *Arts Magazine* 64, (February) no. 7, pp. 60–64.

Rubinstein, Charlotte Streifer. *American Women Sculptors*. Boston: Hall, pp. 404–8.

1991

Colpitt, Frances. "The Shape of Painting in the 1960s." *Art Journal* 50, no. 1 (spring), p. 540.

Wheeler, Daniel. *Art Since Mid-Century: 1945 to the Present*. New York: Vendome. P. 170.

1992

Hadler, Mona. "Lee Bontecou — Heart of a Conquering Darkness." *Source: Notes in the History of Art* 12, no. 1 (fall), pp. 38–44.

1993

Knight, Christopher. "Bontecou 'Sculpture': Hybrid Eruptions." *Los Angeles Times*, April 5, pp. F1, F10 (calendar).

Myers, Terry R. "Lee Bontecou." *Flash Art* 26, no. 172 (October), pp. 75–76.

Smith, Elizabeth A.T. "Abstract Sinister." *Art in America* 81, no. 9 (September), pp. 82–87.

———. *Lee Bontecou: Sculpture and Drawings of the 1960s*. Exh. broch. Los Angeles: The Museum of Contemporary Art.

Smith, Roberta. "Haunting Works from the 60s." *New York Times*, October 3, section 2, p. 42.

1994

Hadler, Mona. "Lee Bontecou's 'Warnings.'" *Art Journal* 53, no. 4 (winter), pp. 56–61.

McEvilley, Thomas. "Lee Bontecou." *Artforum* 32, no. 6 (February), pp. 90–91.

Rubenstein, Raphael. "Bontecou, Higgins and Moskowitz at Leo Castelli." *Art In America* 82, no. 12 (December), pp. 99–100.

Sterling, Colleen. "Lee Bontecou: Sculpture and Drawings of the 1960s." *Art Papers* 18, no. 4 (July–August), p. 59.

1996

Dreishpoon, Douglas. *From A Curator's Point of View: Making Selections and Forging Connections.* Greensboro, N.C.: Weatherspoon Art Gallery. Pp. 9–31.

harrisburg, halley k *Fiber and Form: The Woman's Legacy.* Exh. cat. New York: Michael Rosenfeld Gallery. Pp. 6–7.

Landi, Ann. "Ripe for Rediscovery." *Art News* 95, no. 10 (November), pp. 118–21.

1997

Rembert, Virginia Pitts. "Fiber and Form: The Woman's Legacy." *Publication* 18, no. 1 (spring/summer), pp. 64–65.

1999

Greben, Deidre Stein. "Drawings from the 1960s." *Art News* 98, no. 8 (September), p. 149.

Kastner, Jeffrey. "Cruise Control." *Art Monthly,* no. 231 (November), pp. 1–5.

2000

Meyer, James Sampson, ed. *Minimalism.* London: Phaidon, pp. 209–10 and 221.

Nadelman, Cynthia. "Lee Bontecou." *Art News* 99, no. 3 (March), pp. 144–45.

Reilly, Maura. "Lee Bontecou at Leo Castelli." *Art in America* 88, no. 2 (February), p. 122.

True Grit: Lee Bontecou, Louise Bourgeois, Jay DeFeo, Claire Falkenstein, Nancy Grossman, Louise Nevelson, Nancy Spero. Exh. cat. New York: Michael Rosenfeld Gallery.

2001

Ceruti, Mary. "Personal Abstractions: Lee Bontecou, Diana Cooper, Gay Outlaw." Exh. broch. New York: Sculpture Center.

Hadler, Mona. "Lee Bontecou." *Art since 1850: An Introduction to the Collection.* Exh. cat. Akron, Ohio: Akron Art Museum.

Miles, Christopher. "Lee Bontecou." *Artforum* 40, no. 4 (December), p. 125.

Pagel, David. "Singularity of Purpose." *Los Angeles Times,* October 26, p. F24.

Rapaport, Brooke K. and Kevin L. Stayton. *Vital Forms: American Art and Design in the Atomic Age, 1940–1960.* Exh. cat. New York: Brooklyn Museum of Art.

2002

Duncan, Michael. "Lee Bontecou at Daniel Weinberg." *Art in America,* no. 7 (July), pp. 103–4.

Muchnic, Suzanne. "Lee Bontecou." *Art News* 101, no. 3 (March), p. 128.

Nixon, Mignon, ed. *Eva Hesse.* Massachusetts: MIT Press, 2002. Pp. 44 and 117.

Susman, Elisabeth, ed. *Eva Hesse.* Exh. cat. San Francisco: Museum of Modern Art; New Haven, Conn.: Yale University Press.

2003

Smith, Roberta. "Art in Review: John Newman." *New York Times,* May 30, section E, p. 36.

Reproduction Credits

Cover and pages 5, 16–18, 22–28, 30–32, 34, 60, 61, 88, 92, 93, 100, 104, 111–15, 117–19, 121–23, 128–131, 135–141, 143–150, 153–55, and 156–167, 202–4, 205 (bottom) (plates 1, 6–13, 16, 17, 20, 22, 55–58, 85, 89–92, 99, 112–17, 119–125, 130-33, 136–142, 144–150, 153–56, and 158–168), photographs by Will Brown, courtesy of Knoedler & Co., New York

Page 19 (plate 2), photograph courtesy of Cascadilla Photography, photograph by Andrew Gillis

Page 20 (plates 3 and 4), photographs © Malcom Varon

Pages 28, 46, 56, 66, 102, and 116 (plates 14, 38, 42, 51, 62, 103, and 118), photographs by Robert Lorenzson

Pages 29, 41, 43, 50, 86, 103, 192, and 205 (plates 15, 32, 34, 82, and 104), digital images © 2003 The Museum of Modern Art, New York

Pages 31 and 77 (plates 18 and 73), photographs © Jon & Anne Abbott, NYC

Page 32 (plate 19), photograph by James Isberner

Page 33 (plate 21), photograph © 1994, The Art Institute of Chicago. Photograph by Robert Hashimoto

Page 37 (plate 25), photograph by Peter Brenner

Pages 37, 97, and 190 (plates 26 and 96), photographs courtesy Leo Castelli Gallery

Pages 38 and 84 (plates 27 and 79), © Virginia Museum of Fine Arts. Photographs by Katherine Wetzel

Page 39 (plate 28), image © Contemporary Collection of the Cleveland Museum of Art

Page 40 (plate 29), photograph by Paula Goldman

Page 41 (plate 31), image © The Art Institute of Chicago

Pages 45 and 50 (plates 36 and 43), photographs by Hester + Hardaway, Houston

Page 47 (plate 39), photograph © 1996: Whitney Museum of American Art, New York. Photograph by Geoffrey Clements

Page 48 (plate 40), photograph by Cameron Shaw

Page 49 (plate 41), photograph © Per-Anders Allsten, Moderna Museet

Pages 52 and 71 (plates 45 and 67), photographs courtesy Grant Selwyn Fine Art

Pages 52, 54, and 67 (plates 46, 48, and 63), photographs by Tim Thayer

Page 56 (plate 50), photograph by Ed Glendinning

Page 58 (plate 53), photograph by Sheldan C. Collins

Page 59 (plate 54), photograph by Bruce M. White

Pages 62, 85, 124, 125, 133, 142, 152, and 156 (plates 59, 81, 126, 127, 135, 143, 151, 157, and 158), photographs courtesy Douglas M. Parker Studio, Los Angeles

Pages 64–65 (plate 61), photograph by Jerry L. Thompson

Page 68 (plate 64), photograph by Jim Frank

Page 69 (plate 65), photograph by David Carmack

Page 74 (plate 70), photograph courtesy Greene Naftali, New York, photograph by Oren Slor

Page 75 (plate 71), photograph by Ray Andrews

Page 77 (plate 74), photograph by Erik Gould

Page 79 (plate 76), photograph courtesy of Michael Fredericks

Pages 80–81 (plate 77), photograph © Museum of Contemporary Art, Chicago

Pages 82–83 (plate 78), photograph © Bruno Scotti

Pages 85 and 212–13 (plate 80), photograph by Jay Paul

Pages 86 and 98 (plates 83 and 97), © President and Fellows of Harvard College. Photograph by Katya Kallsen

Pages 87 and 91 (plates 84 and 88), photographs by Lee Stalsworth

Pages 95 and 96 (plates 94 and 95), courtesy of Daniel Weinberg Gallery, Los Angeles

Page 185, photograph by Brad Goda

Page 186, photograph by Ben Blackwell

Pages 187 and 209 © The Solomon R. Guggenheim Foundation, New York. Photographs by David Heald

Page 188 © The Solomon R. Guggenheim Foundation, New York. Photograph by David Heald and Myles Aronowitz

Page 191, photograph by Bill Jacobson

Page 215, image © 2003 Board of Trustees, National Gallery of Art, Washington

Page 217, photograph © Museum of Contemporary Art, Chicago

Back cover and pages 104–5 (plate 105), photograph by Christopher Burke

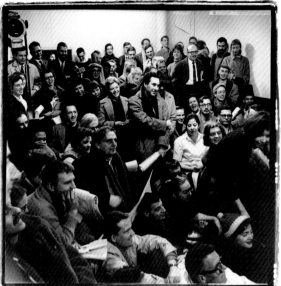

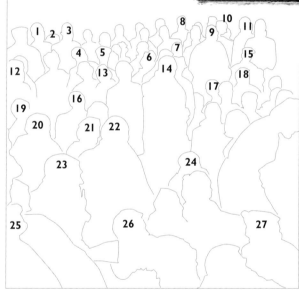

Bontecou in the
audience of a performance
of Claes Oldenburg's
Ray Gun, Judson Gallery,
Thompson Street,
New York, 1960
© Fred McDarrah
See also p. 172.

1 George Segal

2 Marcia Marcus

3 Allan Kaprow

4 Carmen Moore

5 Wallace Ting

6 Sari Dienes

7 Neil Welliver

8 Charles Washburn

9 Reg Neal

10 Phyllis Yampolsky

11 Peter Furakus

12 Dore Ashton

13 Lee Bontecou

14 Frank Bartell

15 Robert Watts

16 Lewis Hawes

17 John Cage

18 Remy Charlip

19 Irving Sandler

20 Bob Thompson

21 Sylvia Stone

22 Aristodemus Kaldis

23 Stan Van Der Beer

24 Jerrold Heiserman

25 David Weinrib

26 George Brecht

27 Gloria McDarrah

Also present but not pictured:
Richard Bellamy, Sy Boardman,
Merce Cunningham, Red
Grooms, and Al Hansen

Lenders to the Exhibition

Albright-Knox Art Gallery, Buffalo, N.Y.

Arkansas Art Center

The Art Institute of Chicago

Lee Bontecou

Peggy Brooks

Russell Bourne

Corcoran Gallery of Art, Washington, D.C.

David Winton Bell Gallery, Brown University, Providence, R.I.

Des Moines Art Center, Des Moines, Iowa

Elvehjem Museum of Art, University of Wisconsin–Madison

Dora G. Flash

Dorothy J. Flash, Newton, Mass.

Fogg Art Museum, Harvard University Art Museums

Fonds National d'Art Contemporain, Paris, Ministère de la Culture et de le Communication, France

Maxine and Stuart Frankel

Maxine and Stuart Frankel Foundation for Art

Tony and Gail Ganz, Los Angeles

Valerie Giles

William Giles

Robert H. Halff

Herbert F. Johnson Museum, Cornell University, Ithaca, N.Y.

Hirshhorn Museum and Sculpture Garden, Smithsonian Institution, Washington, D.C.

Honolulu Academy of Arts

Barbara Jakobson

Mrs. Catherine Jones

Knoedler & Co., New York

Barbara Lee, Boston

Sydney and Frances Lewis

Claudia R. Luebbers, Chicago

The Menil Collection, Houston

Moderna Museet, Stockholm

Museum of Art, Rhode Island School of Design, Providence

Museum of Contemporary Art, Chicago

The Museum of Contemporary Art, Los Angeles

The Museum of Fine Arts, Houston

The Museum of Modern Art, New York

Neuberger Museum of Art, Purchase College, State University of New York

Princeton University Art Museum, Princeton, N.J.

Michael Rosenfeld and halley k harrisburg, New York

Marc Selwyn

Solomon R. Guggenheim Museum, New York

Joel Wachs

Walker Art Center, Minneapolis

Daniel Weinberg

Daniel Weinberg Gallery, Los Angeles

Whitney Museum of American Art, New York

Other private collections